The Light of Nature

Landscape Drawings and Watercolours by Van Dyck and his Contemporaries

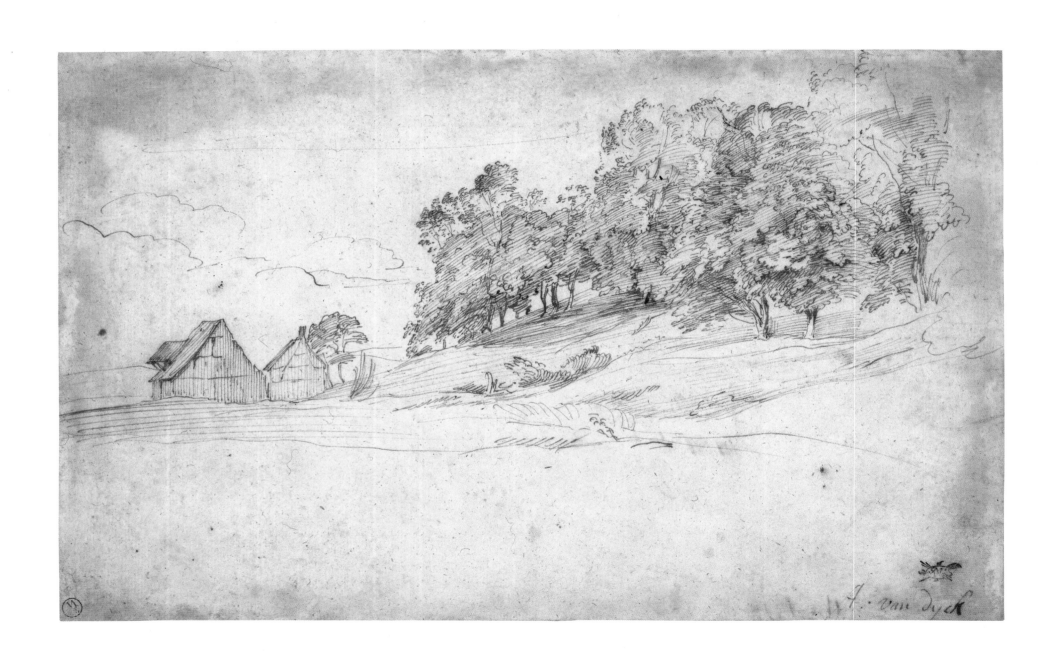

The Light of Nature

Landscape Drawings and Watercolours by Van Dyck and his Contemporaries

Martin Royalton-Kisch

Published for The Trustees of The British Museum by BRITISH MUSEUM PRESS

in association with ANTWERPEN OPEN/Blondé Artprinting International

The Trustees of the British Museum
and ANTWERPEN OPEN
gratefully acknowledge generous
assistance towards the production
of the exhibition and this book
from the Generale Bank
and the Flemish Government

Generale Bank

FLANDERS

with the support of the
Flemish Government

The Light of Nature

This exhibition was organized by The British
Museum, London, Antwerpen Open and the
Rubenshuis, Antwerpen

First published in 1999 by British Museum Press
A division of The British Museum Company Ltd
46 Bloomsbury Street, London WC1B3QQ

A catalogue record for this book is available from
the British Library

ISBN 0 7141 2618 7 (cased)
ISBN 0 7141 2621 7 (paperback)

Designed by James Shurmer
Printed and bound in Belgium by
Blondé Artprinting International

Frontispiece: Van Dyck, *A wooded slope with
farm buildings* (see cat. 18).

CONTENTS

PREFACE

The 400th anniversary of Van Dyck's birth falls in 1999 and the present exhibition has been arranged to commemorate that event. Although one of the most prodigiously gifted artists of his generation, Van Dyck's achievements were cut short by his premature death in 1641 at the age of forty-two. His posthumous reputation, although he never fell from fashion, has been overshadowed by that of his master, Rubens, and by his longer-lived contemporaries, including Poussin and Rembrandt, both represented in the exhibition.

The 1990s have seen a reassessment of his importance. Major exhibitions of his paintings have already been held in Washington (1991) and Genoa (1997) and a third coincides with the present display organized by Dr Christopher Brown, who in 1991 was responsible for a comprehensive exhibition of Van Dyck's drawings held in the Pierpont Morgan Library in New York and at the Kimbell Art Museum, Fort Worth.

There seemed to be little point in repeating that exercise in 1999. But for many years I had hoped to mount a display of Van Dyck's landscape drawings, believing that quite apart from their aesthetic qualities, already savoured enthusiastically by Sir Oliver Millar in his remarkable catalogue of 1982–3, *Van Dyck in England* (Sir Oliver having first catalogued some of the drawings thirty years before for the 1953–4 Royal Academy exhibition of *Flemish Art 1300–1700*), their position in the history of the development of landscape was worthy of investigation. For an artist of the earlier seventeenth century who was not a specialist landscape painter to have left a corpus of some thirty drawings from nature, including watercolours, is highly unusual, and in quality I thought that they could stand comparison even with drawings by such a master of landscape as Claude Lorrain.

This publication is in no sense a catalogue *raisonné* of Van Dyck's landscape drawings. Although they are all discussed, a few of his most cursory sketches, and others in poor condition, have been omitted; and more than half the exhibits are by his contemporaries. The thrust of the argument explored in the introduction and catalogue concerns the place of Van Dyck's landscape sketches in the traditions of Europe in his time. Unlike most art-historical publications, the result points up the similarities more than the differences between various artists and schools. There are also some reattributions to Van Dyck (cats 1–3) that have repercussions for our understanding of his rôle as an assistant of Rubens early in his career.

Van Dyck's landscape drawings are now widely dispersed and the quarter-centenary celebrations alone could have provided the necessary impetus to bring the majority of them together. For this I am greatly indebted to all the lenders – there are twenty – headed by Her Majesty the Queen. Of equal importance has been the backing, both financial and organizational, of Antwerpen Open and the Alderman of Antwerp, Eric Antonis, and the Flemish Government in Belgium, joined by many generous commercial sponsors. It is they who have made it possible to realize the project, for which I thank them very warmly. In this context I must mention Bruno Verbergt, the head of the foundation, and his assistant Carl Depauw, who has taken the brunt of my importunity.

The following friends and colleagues have also been of the greatest possible assistance: Giovanni Agosti, Arnout Balis, Ben van Beneden, Edwin Buijsen, Alan Donnithorne, William Griswold, Margret Klinge, Catherine Legrand, Carolyn Logan, Ger Luijten, Jan de Maere, Deanna Petherbridge, Madeleine Pinault-Sørensen, Laurence Quinchon-Adam, Peter Schatborn, Dr H. G. Schmitz-Dräger, Bent Sørensen, Katlijne van der Stighelen, Christopher White and Hans Vlieghe. Clifford Bloomfield was generous with his knowledge of Rye. At the Warburg Institute, discussions with Paul Taylor, François Quiverger and Elizabeth McGrath have, as always, been fruitful. I have also been fortunate to deepen my acquaintance with Horst Vey, who has been unstintingly generous with his time and knowledge. The same may be said of my colleagues at the British Museum, especially Hugo Chapman, Antony Griffiths and Kim Sloan, as well as Michael Bury of Edinburgh University, who has been based here for several months. Bill Lewis's photographs are up to his usual high standard. At the British Museum Press, Coralie Hepburn, Julie Young, Geoff Barlow and Emma Way have, yet again, produced a handsome publication, designed by James Shurmer.

A special mention must be made of Michael Kitson. Into two letters to me, running to seven pages and written shortly before he died last year, he compressed a phenomenal amount of his knowledge of the history of sketching directly from nature. Conscious that my exhibition deadline has cut short the research I would ideally have wished to undertake – and I apologize for the shortcomings of the catalogue – above all, I would like to think that this catalogue would have earned his approbation.

Martin Royalton-Kisch
British Museum

ANTHONY VAN DYCK (1599–1641): OUTLINE BIOGRAPHY

Antwerp (1599–1620)

1599

22 March, Van Dyck born in Antwerp. His father is a wealthy merchant and the family is devout – four of his sisters became beguines, one a nun, and his brother a canon of St Michael.

1607

Death of Van Dyck's mother, Maria Cuypers.

1609

October, Van Dyck is an apprentice to Hendrik van Balen (1575–1632), with whom he remains until around 1616.

1613

Van Dyck's first dated painting, *An elderly man* (Musées Royaux des Beaux-Arts de Belgique, Brussels; it is inscribed with the artist's age, fourteen).

1618

11 February, registered as a master of the Antwerp painters' guild, the Guild of St Luke. 12 May, work completed on Rubens' *Decius Mus* cartoons for tapestry, on which (according to a document of 1661) Van Dyck assisted. Thus he was employed by Rubens as a studio assistant, while also executing independent commissions. In April Rubens referred to him as 'the best of my pupils'.

1620

Rubens agrees to supply thirty-nine ceiling paintings, to be executed by Van Dyck and 'some others, his assistants', for the new Jesuit Church in Antwerp.

1620

17 July, Francesco Vercellini, visiting Antwerp with the Countess of Arundel, informs the Earl that Van Dyck is still working with Rubens in Antwerp, that his work is almost as highly esteemed and that 'it will be difficult for him to leave these parts'. In this or the following year Van Dyck employs two assistants, Herman Servaes and Justus van Egmont, to make copies of his thirteen panels depicting the *Apostles*, now dispersed among many collections.

London (1620–21)

1620

20 October, Thomas Locke writes from London to William Trumbull, 'Van Dyke is newly come to towne ... I am tould my Lo[rd]: of Purbeck sent for him hither'. (This must refer, but perhaps in error, to John Villiers, elder brother of the Duke of Buckingham.) 25 November, Van Dyck is living with Gortzius Geldorp and has been awarded an annual stipend of £100 by James I.

1621

16 February, receives £100 for 'speciall service' performed for King James. 28 February, receives a passport for eight months travel, signed by Arundel; leaves for Antwerp. 3 October, leaves Antwerp for Italy.

Italian Journey (1621–7)

1621

In Genoa, staying with Cornelis de Wael, probably by 20 November.

1622

February–August, in Rome. August–October, in Venice. October–January 1623, perhaps travelling with the Countess of Arundel between October 1622 and the beginning of 1623, whose itinerary takes in Mantua, Milan and Turin; probably again in Genoa, as well as Bologna and Florence. 1 December, death of Van Dyck's father in Antwerp.

1623

March, in Rome again until October/November. There he meets Sir Kenelm Digby, English Resident and his later patron. In the autumn, probably returns to Genoa.

1624

In Genoa probably until spring, when arrives in Palermo. He paints a portrait of the Viceroy, *Emmanuel Philiberto* (now Dulwich Picture Gallery), who dies on 3 August. On 12 July, visits the painter Sophonisba Anguissola. Leaves Sicily before completing an important altarpiece, the *Madonna of the Rosary* (Oratorio del Rosario, Palermo). Returns probably to Genoa.

1625

Possibly visited Marseille and Aix-en-Provence to meet Nicolas Claude Fabri de Peiresc, whose portrait appears in Van Dyck's *Iconography*, but the visit is not mentioned in Peiresc's correspondence with Rubens.

1626

Lucas and Cornelis de Wael are recorded in Rome around this time.

Antwerp (1627–31) and The Hague (1632)

1627

Probably returns to Antwerp in the autumn.

1628

6 March, makes his will in Brussels. 8 April, paid for the Palermo *Madonna of the Rosary* (see 1624 above) 'novamente fatto nella città di Genova' (recently made in the city of Genoa). December, given a gold chain valued at 750 guilders, by the Infanta Isabella for her portrait. In this year joins the Jesuit Confraternity of Bachelors (*Solidaliteit van de bejaerde Jongmans*) from which he receives significant commissions.

1629

5 July, in a letter to Endymion Porter, acknowledges receipt of £72 for his painting of *Rinaldo and Armida*, painted for Charles I (now Baltimore Museum of Art).

1630

27 May, describes himself in a document as Painter to the Infanta Isabella. Lives in Antwerp, but receives 250 guilders per annum as painter to the Brussels court. December, a restorer, J.-B. Bruno, refers to Van Dyck's collection.

1631

10 May, stands godfather to Antonia, daughter of the engraver Lucas Vorsterman. September–October, paints portraits of Maria de' Medici, then in Antwerp, and her son Gaston d'Orleans. Her secretary, De La Serre, records her visit to Van Dyck's 'Cabinet de Titien; Je veux dire tous les chefs d'Oeuvre de ce grand maistre'. 16 December, a *Virgin and Child with St Catherine* by Van Dyck is despatched to London by Balthasar Gerbier as a

New Year's gift to Charles I. Gerbier states that Van Dyck is planning to travel to England. Writing to Geldorp in London, the artist describes the picture as a copy. 26 December, De La Serre admires the 'new portrait' of Maria de' Medici. Travels to the Dutch Republic.

1632

In The Hague, works for the Prince and Princess of Orange and for the exiled King and Queen of Bohemia (she is Elizabeth, Charles I's elder sister). 28 January, the Prince's secretary Constantijn Huygens in his diary records sitting to Van Dyck.

London (1632–3)

1632

1 April, after a brief visit to Antwerp Van Dyck is in London, and begins paying Edward Norgate, Nicholas Lanier's brother-in-law, 15s per day for lodging and provisions for himself and his servants. After 21 May the artist moves to Blackfriars, outside the jurisdiction of the Painter-Stainers' Company. He also stays at the royal summer residence at Eltham, Kent. 5 July, knighted by Charles I and appointed 'principalle Paynter in ordinary to their Majesties'. 8 August, paid £280 for ten royal commissions, including the portrait of the royal family known as the 'Greate Peece'.

1633

20 April, receives a gold chain and a medal valued at £110. 7 May, paid £444 for nine portraits of the King and Queen. 27 August, date of the *View of Rye* (cat. 13). 1 December, death of the Infanta Isabella; Prince Thomas-Francis of Savoy-Carignan is appointed temporary governor of the Netherlands until the arrival of Cardinal-Infante Ferdinand on 4 November 1634.

Antwerp and Brussels (1634–5)

1634

In Antwerp by 28 March when acquires an interest in the estate of Steen at Elewijt, the property acquired by Rubens in May 1635. 14 April, in Brussels. In October elected honorary Dean by the Antwerp Guild of St Luke, and his name inscribed in capital letters in the list of members, an honour only Rubens had previously received. 4 November, Ferdinand's formal entry into Brussels as governor-general. 16 December, in Brussels. A portrait of Ferdinand by Van Dyck described as 'recently painted'.

London (1635–40)

1635

In London in the spring. A road is constructed between his house and the Thames to facilitate Charles I's visits to the studio in June and July.

1636

14 August, requests inscription from Franciscus Junius, Arundel's librarian, for the portrait of Digby in the *Iconography*, and praises Junius' *De Pictura Veterum* (Painting of the Ancients).

1637

23 February, receives payment of £1,200 from Charles I for some unspecified paintings.

1638

Late in the year, Van Dyck composes a memorandum to the King, listing twenty-five paintings for which he has not been paid and stating that his pension is five years in arrears. The King's annotation reduces the prices of fourteen paintings, and on 14 December Van Dyck is paid £1,603. Another payment of £305 follows on 25 February 1639.

1639

Marries Mary Ruthven, a lady-in-waiting to the Queen. 26 June, the Queen writes to Bernini, asking him to sculpt her portrait like the bust he had made of her husband, promising to send likenesses of herself by Van Dyck for Bernini's use.

1640

Early this year, the Countess of Sussex writes in a letter to Ralph Verney that Van Dyck wants to leave London. 30 May, death of Rubens in Antwerp. Presumably Van Dyck hopes to fill his shoes.

Antwerp, Paris and London (1640–41)

1640

23 September, Cardinal-Infante Ferdinand, writing to Philip IV from Ghent, states that Van Dyck is expected in Antwerp for the celebrations by the painters' guild of the Feast of St Luke (18 October). 10 November, Ferdinand informs Philip IV that Van Dyck does not wish to complete unfinished works by Rubens destined for the Torre de la Parada but is willing to undertake a new commission for the king. Van Dyck is in London supervising the removal of his possessions. December (?), Van Dyck is in Paris, hoping to secure the commission to decorate the Grande Galerie of the Louvre that finally went to Poussin and Simon Vouet.

1641

Van Dyck paints the wedding portrait for the marriage of Princess Mary and William II of Orange on 12 May (now Rijksmuseum, Amsterdam). 13 August, the Countess of Roxburghe refers in a letter to Count Johan Wolfert van Brederode in The Hague to Van Dyck's poor health, but says he has recovered and will in ten or twelve days' time travel with a painting he had promised. October, Van Dyck in Antwerp. 16 November, Van Dyck is in Paris, but too ill to paint the Cardinal's portrait (presumably Richelieu) and requests a passport to travel to England. 1 December, birth of his daughter, Justinia. 4 December, makes his will, while 'weake of body yet injoyinge my sences memorie'. 9 December, dies aged forty-two at Blackfriars. He is buried in the choir of St Paul's Cathedral two days later, where the king erects a monument to him (the tomb was destroyed in the great fire in 1666).

This chronology is largely based on that produced by Brown for Exh. New York–Fort Worth, 1991, pp.13–15 (with previous literature).

INTRODUCTION

It is no accident that when Van Dyck portrayed *Charles I on horse-back*, in the celebrated portrait in the National Gallery in London, he depicted him in armour, riding through the lush green landscape of his realm (fig. 1). Presumably no accident, too, that the season is full summer, or that the artist contrasts two richly foliated trees, one old and venerable on the right, the other more recently sprung from the soil towards the left – and based on a sketch that he had made from nature (see cat. 20). Van Dyck could have commandeered no more potent symbol than the land itself to suggest the King's status, and the trees could almost allegorize the still confident monarch and his ancient lineage.[1]

Landscape backgrounds had formed a highly significant ingredient in the symbolic content of European art since the era of the Van Eycks (see fig. 27), and nowhere more so than in Flanders. A *locus* for history, allegory, portraits and scenes of everyday life, skill in the depiction of landscape was indispensable to all painters of ambition. Van Dyck's abilities as a landscapist have long been acknowledged and are attested to by the backgrounds of many of his portraits and history pieces. However, not one of the five independent landscape oil paintings by him that are recorded in seventeenth-century Antwerp collections is thought to have survived:[2] *A rough landscape* ('Een rouw Landtschap' possibly meaning one showing inclement weather rather than a roughly sketched piece) and a *Landscape with a rainbow* belonged to Jeremias Wildens, the son of the landscape painter Jan Wildens, at his death in 1653. Another Van Dyck *Landscape* is listed without further elaboration in the posthumous inventory of Suzanna Willemsens, drawn up in 1657. Two inventories of Alexander Voet, of 1678 and 1685, describe paintings of a *Fire at night* 'said to be by Van Dyck', as well as eight autograph sketches of trees, perhaps in oil, and a *Small upright landscape*, probably the work that is again mentioned in the later of the two inventories as having *three trees in it*. All these are lost, as are the *Landscape on canvas* that was priced at 100 guilders by the Antwerp art dealer Forchoudt, and the two landscape oils by him owned by David Teniers the Younger in 1686.[3] Still more unexpected are the records of a *Sea peece of Vandyke*, purchased in 1662 for Charles II and said in the Whitehall inventory to include *a great Rocke & some fisher men upon the Shoare*,[4] and of a similar work in the 1678 inventory of the artist Erasmus Quellinus.[5]

For an idea of their appearance we must turn to Van Dyck's landscape backgrounds, such as those in two of his best-known portraits of *Charles I* (figs 1–2), or to his history paintings, like the *Amaryllis and Mirtillo* from Pommersfelden, the *Rinaldo and Armida* now in Baltimore or the *Cupid and Psyche* in the British Royal Collection (fig. 14). In colour and style they reflect the influence of the great Venetian, Titian, the painter most esteemed by Van Dyck, not least in their luxuriant foliage, while the Baltimore painting evokes the blue hills of Titian's birthplace, Cadore. The extraordinarily high quality of these passages of landscape suggests that the loss of Van Dyck's independent landscape paintings, like that of four of the history paintings he executed for the King and Queen of England, is a severe one.[6]

The documentary record and the surviving works imply that Van Dyck concerned himself with landscape as much as did his master, Peter Paul Rubens (1577–1640), whose landscapes have always stood in high regard.[7] Above all, the twenty-nine surviving landscape drawings by Van Dyck, twenty-five of which form the core of this catalogue (nos 1–25), reveal a mastery of the sketch from nature that has few parallels in the work of any artist who was not primarily concerned with the genre. Although the accidents of survival must distort the true picture – and as we shall see, this applies to the drawings as much or more than to the oil paintings – these notations are set down with a skill and sensitivity to atmosphere that even the most distinguished landscape specialists active in Europe in his day found hard to equal.

This Introduction will firstly examine Van Dyck's approach to the study of nature, his stylistic development as a landscape draughtsman (including a few additions to the corpus of his drawings that have far-reaching consequences for understanding his rôle in Rubens' workshop), and the use to which he put these drawings in his paintings. In part two, a briefer section, his drawings from nature – as almost all his surviving landscape drawings seem to be – will be compared with those made by his contemporaries. To assess his contribution alongside artists active at the same period in various parts of Europe is particularly logical in the case of Van Dyck, who spent so much of his career in Italy and England as well as in Flanders, with visits to Holland and France. Finally in the third and longest section, the drawings will be placed in the context of

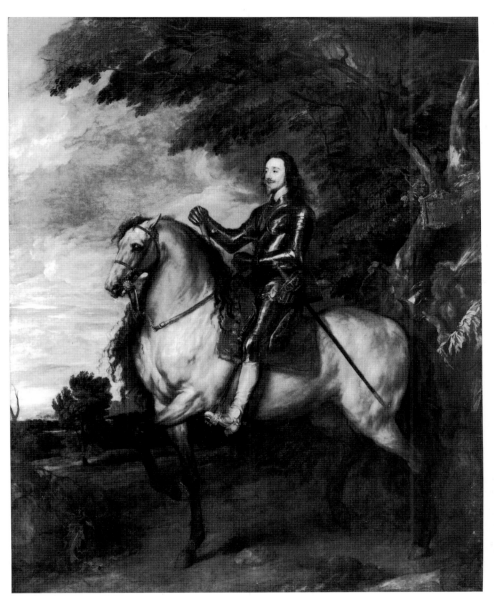

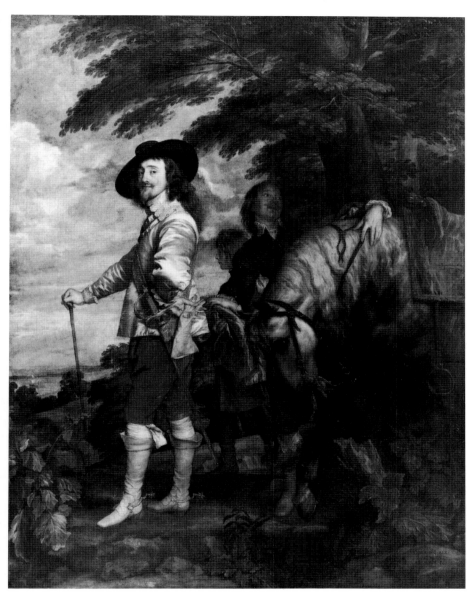

Fig. 1 Van Dyck, *Charles I on horseback*, canvas, 367 × 292.1 cm.
London, National Gallery.

Fig. 2 Van Dyck, *Charles I hunting ('Le roi à la chasse')*, canvas, 272 × 212 cm.
Paris, Musée du Louvre (photo: RMN).

the history of drawing out of doors, a subject that has hitherto received only limited attention in relation to the sixteenth and early seventeenth centuries.

We should stress at the outset that we are discussing drawings of nature and made out of doors, and that we specifically exclude topographical views, whether of cities, monuments or architectural motifs, as well as compositions that were developed in the studio from *plein air* sketches. The distinction between 'natural' and 'artificial' landscape was already made in the late sixteenth century for example by the anonymous author of *A Short Treatise of Perspective*, a manuscript in the British Library: 'The thinges described in Lanskip ar for the most parte naturall, as woodes, hills, dales rivers seas and land: thinges artificiall, as citties, castels, &c ar incident but not necessarie unto Lanskipp'.[8] As we shall see, the drawing from nature occupies a special position as part of the raw material out of which an artist creates his final products, whether painted, drawn or etched. In defining them we have also attempted to restrict the category to works that give every appearance of having been made out of doors, recording a motif that stood before the draughtsman's eyes. At times the artist may deceive us, or he may elaborate a sketch as he worked or once he has returned to the studio, as we suggest may have been the case with some of the drawings in this catalogue (e.g. cats 34, 50 and 57). A degree of 'artist's licence' occurs regularly, as Rubens admitted when he described a landscape painting of *Dawn* ('*Aurora*') to Edward Norgate, as having been *un poco aiutato*, 'a little helped'.[9] The purpose of art, after all, was to improve on nature, not merely to copy her. But in the majority of cases there can be little doubt which drawings belong to our category. It is a category the ramifications of which for the early history of landscape art have not been discussed in isolation before, and a category that has not survived in large numbers – which makes the existence of such a substantial and alluring group by Van Dyck particularly intriguing.

I Van Dyck draws from nature

Outside specialist circles, Van Dyck's landscape drawings remain little known. Few of them have been connected with his finished paintings (this catalogue reveals a few more such connections), and our image of this extraordinary and inventive artist is dominated, not unreasonably, by the large corpus of his portraits, many representing sitters who remain household names to this day, together with his most important biblical and historical compositions.

The only landscape drawings that have hitherto attracted any attention are all late works, made in the last ten years of Van Dyck's life. Best known are the watercolours, probably drawn in England and acknowledged as heralds of the august tradition of the medium in the British Isles. Yet in only five landscape drawings, all present here, did Van Dyck use watercolour extensively (cats 10, 20 and 22–4). The breadth and confidence with which it is deployed has few precursors – the works of Dürer over a century before provide the nearest analogies – or even contemporary echoes, and few challenges to Van Dyck's mastery of watercolour were issued until the early maturity of Thomas Girtin and J. M. W. Turner at the close of the eighteenth century.[10]

None of these watercolours is dated, yet they are placeable in the 1630s because of the connection, already noted, between the tree near the centre of the *Study of trees* (cat. 20) and that towards the left of the portrait of *Charles I on horseback* (fig. 1), a painting generally assigned on grounds of style to the middle of the decade. The sketch, an informal vignette, uses watercolour over an elaborate underdrawing in pen and brown ink, so complete in itself that it may be compared satisfactorily with other drawings made from nature in the same years executed in pen alone, such as the *Wooded slope with farm buildings* (cat. 18). The possibility therefore arises that the colour was applied by the artist away from the motif, after his return to the studio. Yet this conjecture is undermined by the stylistic proximity of the coloured drawing to three of the other watercolours, in which the brush creates tone in a comparable fashion despite the lack of a detailed preparatory underdrawing (cats 22–4). While the style may stay the same, the resulting effect is different where watercolour alone describes the vegetation and shadows. The

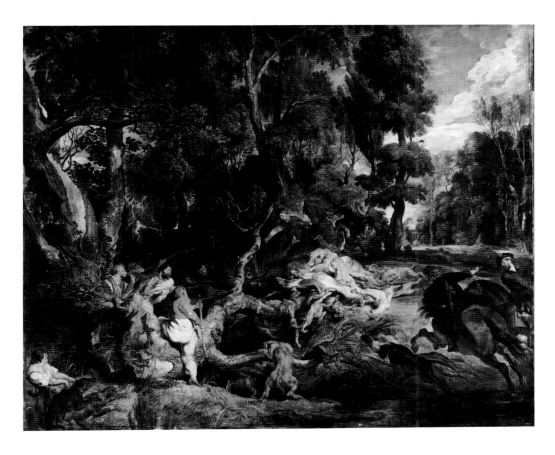

Fig. 3
Rubens assisted
by Van Dyck,
*Landscape with
a boar hunt*,
panel,
137 × 168.5 cm.
Dresden, Staatliche
Kunstsammlungen,
Gemäldegalerie.

although undated is likely to belong with the other drawings of the seaport in the years 1633–4, we encounter once more a descriptive restraint that seems to anticipate Van Dyck's last landscapes. As with most artists who have reached maturity, several styles may have been practised simultaneously. This makes it difficult to date the drawings precisely, even where a related, datable painting exists: although providing a *terminus*, the finished works may depend on drawings that were made considerably earlier.

Nevertheless, stylistic considerations do suggest that Van Dyck's landscape drawings of the 1630s, in general, gradually abandon the precise line and descriptive detail of, say, the *View of Rye from the north east* of 1633 (cat. 12) and move towards an increasingly broad use of wash at the expense of detail, as in the watercolours. Simultaneously, the pen-lines retreat to the most indispensable indications of form (cats 21–5). These more lubricious and evanescent results remind us of Van Dyck's own notion, scribbled on a figure-sketch at Chatsworth (Vey 103): 'It's about an airy style' – *tis om een loechte maniere.*

This assessment of his development in the 1630s provides the only framework for approaching the *terra incognita* of Van Dyck as a landscape draughtsman in his early years. While working on the present exhibition it became increasingly clear that three drawings, hitherto generally ascribed to Rubens – and for good reasons – are in fact by his distinguished pupil (cats 1–3).

The *Fallen tree*, now in the Louvre (cat. 2), is related to Rubens' painting, the *Landscape with a boar hunt*, now in Dresden (fig. 3). Observed from much the same angle, the tree-trunk is there recast so that it writhes like some flailing sea-monster, but the connection between the two is clear. Viewed from the side, the same tree was studied again in black chalk in a drawing at Chatsworth (cat. 3) that is also usually ascribed to Rubens. Furthermore, on grounds of style, the Louvre drawing is rightly associated with another, the Chatsworth *Dead tree overgrown with brambles* (cat. 1). This includes, just below the centre, a particularly thick bramble-stem, which loops back on itself and forks towards the lower right; and this motif also appears in the Dresden painting, towards the lower left of the composition (see p. 65, fig. 1a).

The key reason for assigning these drawings to Van Dyck, in spite of the connection with a painting by Rubens, is that the hand-

variations in style are born of different technical procedures rather than disparities in date or intention.

Further stylistic deviations from any supposed 'norm' belong to these same years of Van Dyck's activity. The spartan, dry line of the *Landscape with two tall trees* (cat. 21), a drawing perhaps intended for further elaboration with the brush, exhibits a reticence encountered again in the *Landscape with a gnarled tree and a farm* (cat. 25), which is drawn on paper with a similar watermark. Both these drawings are usually placed late, in the mid-to-later 1630s, although secure evidence for this is lacking. They contrast again with the more detailed drawings of Rye in Sussex and of trees on hillsides made in 1633–4 (cats 12–15 and 17–18) which provide some of the few fixed points in the chronology of the landscapes. In one of these drawings, the *Ypres Tower at Rye* (cat. 15), which

writing on the Chatsworth *Dead tree overgrown with brambles* is that of the younger artist. Clearly written by the draughtsman, the inscription reads 'fallen leaves and in some places fresh green grass peeps through' (*afgevallen bladeren ende op sommighe plattsen schoon gruen gras doorkycken*). The forms of every letter may be paralleled in Van Dyck's own handwriting, whether in the Italian Sketchbook in the British Museum (see fig. 1b) or in other annotations by him. That the handwriting is not Rubens' has long been recognized, if sometimes half-heartedly,[11] but the logic of the attribution to Rubens in view of the relationship between the Louvre drawing and the Dresden painting has until now inhibited any reassessment.[12] For if Van Dyck made the drawing, then Rubens must have given his young assistant considerable free rein in designing as well as executing the Dresden painting, and by analogy perhaps other works that were commissioned from his master. Such an image of the Rubens workshop runs counter to the generally accepted view that, master of all he surveyed, Rubens closely controlled all the products of his studio.[13]

That this was not the case is argued again and with equal eloquence by a drawing in the Uffizi that, to my knowledge, has yet to enter the Van Dyck literature (fig. 4).[14] The *Study of a youth with a horse* could by no stretch of the imagination be mistaken as a work by Rubens. In style the figure is especially characteristic of Van Dyck. The horse is penned in some detail, with deviations from the underdrawing in black chalk that reveal it to be an original study rather than a copy. This much could also be deduced from its stylistic character. Yet this drawing was undoubtedly the basis for the horse that appears on the left of Rubens' painting of the *Prodigal Son* in the Museum of Fine Arts in Antwerp (fig. 5).[15] The right foreleg is adjusted and the figure is removed to the left, but in other respects the posture of the animal remains almost unchanged, although lit from the right rather than the left.

The painting may have been the *enfant prodigue dans une estable* listed in the inventory of Rubens' estate in 1640, and has always been regarded as entirely his own work. The emergence of the drawing however raises questions as to the degree to which Van Dyck may have been involved in its execution, even if working from Rubens' own general instructions. For Rubens, the configuration of the tree to the right is unusually precise, and the steely execution is

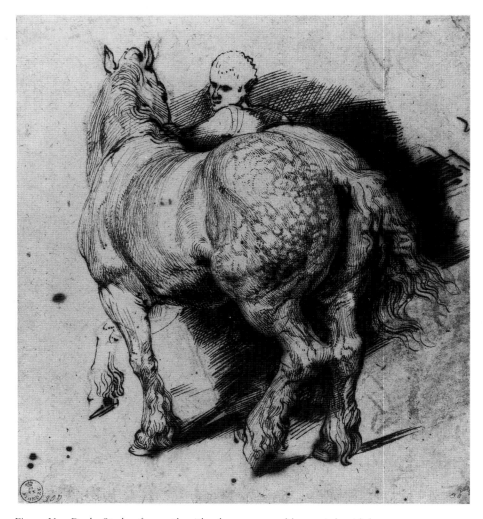

Fig. 4 Van Dyck, *Study of a youth with a horse*, pen and brown ink with brown wash over black chalk, 267 × 238 cm. Florence, Uffizi (inv. 793 O).

Fig. 5 Rubens, *The Prodigal Son*, oil on panel,
145 × 225 cm. Antwerp, Koninklijk Museum voor
Schone Kunsten.

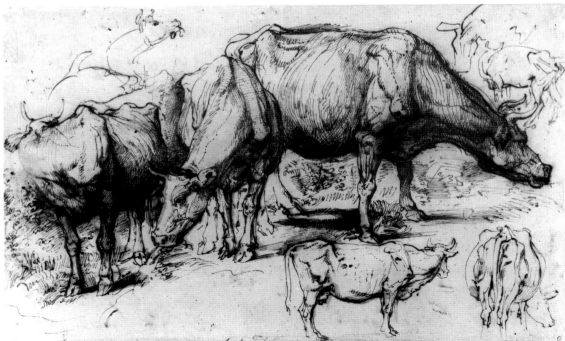

Fig. 6 Van Dyck, *Study of cows*,
pen and brown ink, touched with brown wash,
318 × 515 mm. Chatsworth, Devonshire
Collection (inv. 964; photo: Courtauld Institute
of Art).

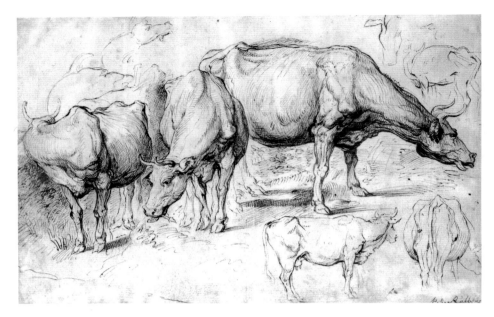

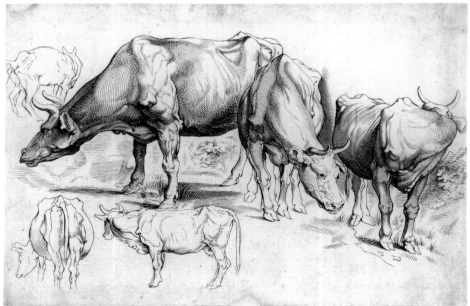

Fig. 9 Rubens, *Study of a wild cherry tree with brambles and weeds*, black, red, white and yellow chalks, 545 × 495 mm. London, Courtauld Institute (Count Antoine Seilern Collection; photo © Samuel Courtauld Trust, Courtauld Gallery).

Fig. 7 Rubens? after Van Dyck, *Study of cows*, pen and brown ink, with some grey wash, 340 × 522 mm. London, British Museum (Hind 118).

Fig. 8 Paulus Pontius after Rubens, *Study of cows*, engraving, 327 × 220 mm. London, British Museum.

Fig. 10 Rubens,
Trees reflected in water at sunset, black, red and white chalk, 276 × 454 mm. London, British Museum (Cracherode Gg. 2-229).

at odds with the older artist's style. These factors, like the Uffizi drawing, argue for Van Dyck's participation in the painting.

Two further drawings cannot be excluded from the present discussion, the first being the *Study of cows* now at Chatsworth (fig. 6), usually although not universally ascribed to Van Dyck.[16] In style it is inseparable from the Uffizi sheet (fig. 4), with the same long skeins of lines describing the flanks of the animals. It can therefore only be by Van Dyck, whose name it bears, possibly in the artist's own hand.[17] Once again the drawing was used by Rubens, in around 1618–20, for three of the cows in his *Landscape with cattle* in Munich.[18] It was also possibly copied by him, as is suggested by the Rubensian style of a version in the British Museum (fig. 7), and by the existence of a print after it by Paulus Pontius that formed part of Rubens' so-called *Livre à dessiner* (fig. 8).[19]

These drawings are indispensable to the present discussion

because the hand responsible for the vegetation around the cows in the Chatsworth drawing (fig. 6), with its *staccato* parallel dashes and spirals of energized foliage, must also have created the study of a *Fallen tree* in the Louvre (cat. 2), where the style is entirely replicated, especially in the central foreground and in the middle-distance. To turn from these two drawings to any study of nature by Rubens is to enter a more mellifluous realm, a world described *a tempo* rather than with an urgent *accelerando* of line. The additional evidence of Van Dyck's handwriting on the other Chatsworth drawing, of the *Dead tree overgrown with brambles* (cat. 1) lends crucial support to this contention. Rubens' own drawings from nature, including his *Study of a wild cherry tree with brambles and weeds* in the Courtauld Institute (fig. 9) and the *Trees reflected in water at sunset* in the British Museum (fig. 10), both of them inscribed by him, display comparable interests in studying the land-

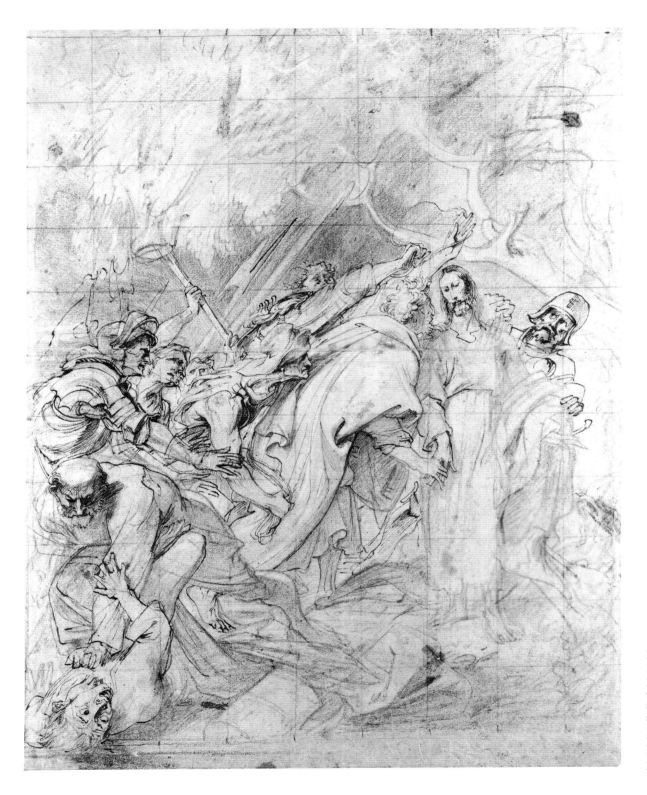

Fig. 11 Van Dyck,
The taking of Christ,
pen and brown ink
over black chalk and
some red chalk,
squared in red chalk,
533 × 403 mm.
Hamburg, Kunsthalle
(inv. 21882; photo:
Elke Walford).

scape.[20] The motifs are related to Van Dyck's, and the inscriptions suggest that they served similar functions. On the other hand the disparity of style is self-evident, even when confining one's judgement to the handling of the chalk alone, where Van Dyck contrasts with the considered and decorative use of line employed by Rubens. Chronology should also inform this assessment: Rubens' style was fully matured by the end of the 1610s, and though the Rubens drawings are datable to the 1630s, his work at that period had not undergone a radical stylistic change. As a landscapist, his work came to a climax in the later decade, but one that remained largely faithful to ideals that he had created long before. Van Dyck's landscapes are markedly different, especially after he had experienced the latest styles in Rome and studied alternative vistas, whether in Italy or England.

That these accretions to Van Dyck's early corpus differ from his later landscapes is to be expected. The same development occurred with his figure drawings, and as Edward Norgate, who knew Van Dyck in Italy and was his host in London for a month,[21] reported, Van Dyck's drawings in Italy were 'neat, exact and curious ..., but since his coming here, in all his later drawings, was ever iuditious, never exact'.[22] Nevertheless, stylistic links between the newly attributed studies of trees and the later works are not wholly absent. The details of leaves and the cross-hatching in pen in the Chatsworth *Dead tree* (cat. 1) find echoes in the *Study of plants* in the Lugt Collection (cat. 4); the foliage in the centre of the Louvre *Fallen tree* (cat. 2), with its diagonal momentum, looks forward to the *Landscape near Genoa* and the *Slope with trees and farm-buildings* (cats 6 and 18). To the clearer evidence of stylistic congruity with the Chatsworth *Study of cows* (fig. 6), which seems incontrovertible, can be added the relationship with some of Van Dyck's composition drawings of the same period, not least the *Taking of Christ* now in Hamburg (fig. 11), the *modello* for his painting of this object in Minneapolis.

The Hamburg drawing exhibits four characteristic traits of Van Dyck (ones that are uncharacteristic of Rubens) that reappear in the early studies of fallen trees (cats 2–3). The first is the solid 'blocking out' in black chalk of the more significant areas of shadow, both above the central group of figures and in some parts of the drapery. This bold manner of expressing tone is replicated beneath much of

the darker penwork in the Louvre *Fallen tree* (cat. 2) as well as in other areas of the sheet where the chalk remains exposed (below the left-hand tree, for example). The second is the use, in the *Taking of Christ*, of a highly sharpened pen, which outlines the essential forms with near-surgical precision. Such refinements are also applied with the pen over the black chalk underdrawing in the Louvre sheet, most clearly in the fallen trunk. In both, the outlines grip the forms closely, a feature, too, of the hatching, whether on the tree trunk in the Louvre drawing or in the armour of the figure on the left, for example, of the Hamburg *modello*. The skeins of lines in the tree-trunk are consonant with those encountered in the Uffizi *Study of a youth with a horse* and the Chatsworth *Study of cows* (figs 4 and 6). By contrast, Rubens' style always tends to the painterly, his lines being more lyrical and his hatching more abstract, conceived in terms of tone rather than form. Finally, the Hamburg drawing includes, at the top right, the outlines of some branches in black chalk, and although certainly drawn from the imagination rather than from nature, the touch here strongly suggests the same hand as that responsible for the trees on the far right of the Louvre drawing, as well as near the edges of the Chatsworth view of the fallen trunk (cat. 3).[23]

For those students of Van Dyck and Rubens who are persuaded by these arguments the repercussions are far-reaching. If Van Dyck made *preliminary* sketches for Rubens' paintings, we have to adjust our image of his role in his master's Antwerp workshop in the years before his departure for England in 1620. The paintings of the *Boar hunt* in Dresden and the *Prodigal Son* in Antwerp (figs 3 and 5) were almost certainly marketed as, or considered to be, by Rubens, perhaps with the assistance of his workshop, and it has hitherto been taken for granted that Rubens was largely responsible for them. The drawings suggest that Rubens must effectively have delegated responsibility for such paintings to Van Dyck, his own participation being restricted, perhaps, to some cursory initial indications and, presumably, to retouching the finished paintings. That Van Dyck was capable of playing the chameleon to his master has long been recognized, for example in the cartoons for the *Decius Mus* series that he made in 1618, the same period; the designs were, apparently, Rubens' own, but Van Dyck's involvement was extensive.[24]

In the case of the Dresden painting (fig. 3), a related sketch in

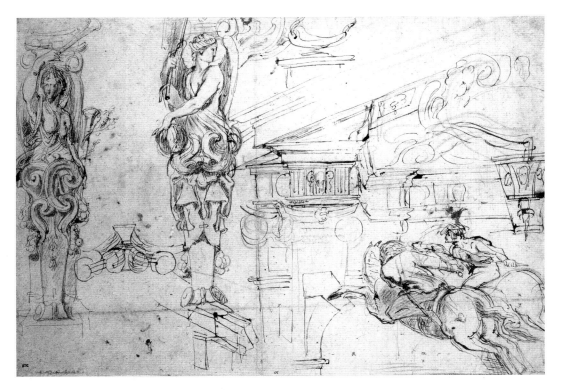

Fig. 12 Van Dyck, *Studies for the Dresden Boar Hunt* and *architectural sketches*, pen and grey-black ink over black and red chalk, 338 × 492 mm. Staatliche Museen zu Berlin – Preussischer Kulturbesitz, Kupferstichkabinett S.M.P.K. (KdZ. 593; photo: Jörg P. Anders).

Fig. 13 *Verso* of fig. 12.

Berlin supplies evidence of the extent of Rubens' contribution (figs 12–13).[25] The drawing, which in the style of the caryatids on the *recto* strongly suggests that it is by Van Dyck when compared with the Hamburg *Taking of Christ* (fig. 11), includes on the *verso* a first idea for the horsemen in the centre of the Dresden painting, made originally in chalk. The figures were subsequently worked up in pen and ink, accompanied by the inscription: 'this is Rubens' idea' (*dit gedaght heft rubens*). The handwriting again compares closely with Van Dyck's most cursory notations,[26] while the spindly lines of the rest of the sheet, in which other details of the Dresden picture are worked out, marry well with Van Dyck's early study of the *Taking of Samson*, formerly at Bremen.[27]

It may be that the chalk indications for the horsemen are indeed by Rubens, as the inscription nearby suggests. In this context it should be remembered that during this period, Rubens wrote a letter, on 18 January 1618, to a certain 'Mr Felix', who had clearly asked for a design: 'You must make the best of these drawings, poor and bad as they are, for it is impossible for me, because of other duties, to do any more to them now. So you will have to make use of them. They could be made wider or narrower, according to the proportions of your work'.[28] This statement leaves us in no doubt that Rubens, in these years, might produce only a slight sketch.

Another document that raises interesting issues in the present context, but which has yet to be considered seriously with regard to Rubens, is the accusation that he was not, at least in 1620, a hard-working individual. This surprising news is conveyed by the record, made in the diary of Aernt van Buchell (Arnoldus Buchelius), of a conversation that occurred in Utrecht on 26 July of that year. Several artists, including Abraham Bloemaert, Paulus Moreelse, Crispijn van de Passe and Adam van Vianen, had gathered to celebrate the return to Utrecht from Rome of Gerard van Honthorst and his companion, the sculptor Jacob Willemsz. Colijn de Nole. Among the guests were the latter's brothers, Jan and Robrecht Colijn de Nole, who had travelled back from Antwerp specially for the occasion. In their discussion, the artists claimed that Rubens' fame was largely due to the engravings after his work by Lucas Vorsterman, and to Rubens' own good fortune more than to his industry.[29] While this statement is not straightforward to interpret, there can be little doubt that Rubens' commitments at this period may have stretched his capacities, forcing him to delegate the productions of his workshop more than ever before, and that he might 'farm out' commissions, towards some of which he may have devoted little time himself.[30] In the following year, a Danish physician, Otto Sperling, described how Rubens only provided drawings for assistants, who 'had to work these up fully in paint, until finally Mr Rubens would add the last touches with the brush and colours. All this is considered as Rubens' work; thus he has gained a large fortune, and kings and princes have heaped gifts and jewels upon him'.[31] Other early writers, including Bellori (1672), Sandrart (1675) and De Piles (1699), state that Rubens allowed his pupils to elaborate his compositional ideas; Houbraken writes that Rubens went further than this and used pupils 'to paint clothes, the grounds, the distances, buildings and other decorative elements, as well as the disposition of the nudes.'[32] To some extent these statements can be related to the picture 'factories' that were a well-established feature of Flemish and Italian practice by the end of the sixteenth century.[33] While it would be wrong to suggest that Rubens' workshop operated in the same way, the surmise that he might sometimes, when pressed, allow his 'best pupil' something close to free rein, especially when producing works of secondary importance (and in the hierarchy of painting, hunting scenes *were* considered secondary), becomes acceptable, even if it was somewhat unusual.[34] This practice was far from new: a comparable relationship is said by early writers to have existed between Verrocchio and Leonardo, and Raphael and Giulio Romano, more than a century before.[35]

If Van Dyck, then, created drawings from nature that were applied to compositions by his master – a rôle also played by the chalk drawing at Chatsworth of the same *Fallen tree* (cat. 3), which later turns up in Rubens' *Ulysses and Nausicaa* – the question arises as to whether the landscape drawings were made specifically for particular commissions that he had in hand, or whether Van Dyck simply made a stock of studies to which he could subsequently refer. To answer this, the whole of Van Dyck's landscape *oeuvre* should be considered together.[36] The story they relate suggests that, as a general rule, he made the landscape drawings from nature to build up a stock of potentially useful motifs; and that he would not have drawn views that lacked this potential, or which he did not consider beautiful.

Apart from the early drawings (cats 1–3), which were referred to for paintings that emanated from Rubens' studio, five further landscape drawings by Van Dyck were clearly consulted by him for the backgrounds of his own portraits in the 1630s (two connections are here made for the first time – see cats 9 and 17). In three cases Van Dyck excerpted just a section of a drawing: only the Ypres Tower from the *View of the coast at Rye* (cat. 14) appears in the portraits of Jabach and Rogiers; the central section of the *Trees on a hillside* (cat. 17) provided the complete view behind the *Portrait of Prince Rupert*; and just one tree was isolated from the *Study of trees* (cat. 20) and placed in the landscape behind *Charles I on horseback*. The other sheets that he used for paintings, the *Two entwined trees* (cat. 9) and the *View of Antwerp* (cat. 11), were also altered in the final compositions; in the former, the sketch formed only the starting-point for trees of a wholly different scale and grandeur.

These transformations strongly imply that the drawings, rather than a mere relaxation or 'leisure activity' as they have at times been interpreted (although they may have served this function too), formed part of a stock of motifs on which Van Dyck could base his landscape backgrounds.[37] The dates of 1633 and 1634 on some of the drawings could be significant, as Van Dyck may have needed to compile a stock of English motifs, having decided to remain at the Caroline court.[38] The changes also communicate the purpose of these settings: to provide a symbolic stage, evoking nature in an idealized, neo-platonic garb in order to set the mood for his portraits, histories and allegories. Nowhere is this symbolic intention clearer than in his painting of *Cupid and Psyche* in the Royal Collection (fig. 14).[39] Psyche slumbers beneath a broadly spreading, idealized tree, with a bare, dead trunk adjacent to it. The branches of the latter are raised and forked like the arms of some anguished giant, perhaps intended to evoke recollections of the opening of Pandora's box which led to Psyche's being stricken to sleep like a corpse. The 'pathetic fallacy' of landscape, the expression of emotion through nature,[40] which is generally perceived only in later works of art, clearly exists here alongside emblematic imagery in the form of the clinging plant that encircles the trunk, standing as an emblem of love.[41] Of interest here is the attention-seeking artificiality of this allegorical motif.

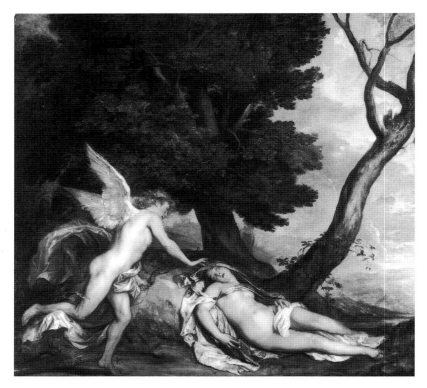

Fig. 14 Van Dyck, *Cupid and Psyche*, oil on canvas, 199.4 × 191.8 cm. London, Buckingham Palace, The Royal Collection © 1999 Her Majesty The Queen.

These considerations lead us to affirm that Van Dyck, when making his landscape drawings, however informal his choices of motif may appear to be, and although his sketches are altered and idealized in his finished compositions, must always have had their potential use in his paintings at the back of his mind.

To complete our survey of Van Dyck's landscape drawings, a few autograph works, along with some copies and stylistically related works, need to be included in the discussion. The Art Gallery of South Australia in Adelaide acquired at auction in 1989 a previously unrecorded drawing of a *Wooded ridge* (fig. 15).[42] Although greatly faded, the drawing is significant for its stylistic proximity to the right background of the Windsor drawing (cat. 6), suggesting that it was made in Italy. Comparable motifs were drawn there by Cornelis van Poelenburch and Bartholomeus Breenbergh, artists represented in the exhibition and to whom we will return.[43] A still slighter *Landscape sketch* in the Courtauld Institute (fig. 16) displays affinities with the *Landscape with farm building* (cat. 7), the tree on the extreme right of the latter being formulated in a similar pattern

Fig. 15 Van Dyck,
A wooded ridge,
pen and brown ink
with brown wash,
206 × 298 mm.
Art Gallery of South
Australia, Adelaide,
V. B. F. Young
Bequest Fund (893D3).

Fig. 16 Van Dyck,
Landscape sketch,
pen and brown ink,
271 × 189 mm.
London, Courtauld
Institute (Count Antoine
Seilern Collection;
photo © Samuel
Courtauld Trust,
Courtauld Gallery, 329).

of spiralling lines. Drawn on the *verso* of a scribbled study of *Christ on the cross with St Mary Magdalene*, the Courtauld drawing probably dates either from Van Dyck's second Antwerp period or perhaps from slightly earlier, as the building in the background appears Italianate.[44] Such a sheet could well be a rare survival of a whole class of minor Van Dyck drawings that has not come down to us.

Vying with the Courtauld sketch in slightness are three leaves from Van Dyck's Italian Sketchbook in the British Museum of 1621–7. They are all coastal views, a motif that often occupied him (see cats 11–16 and 24). The most intriguing, perhaps, and in the best condition, is the first folio, which depicts a *Storm cloud above a mountain* (fig. 17). Although unique in its abstract calligraphy, the style harks back to the energetic touch of the pen drawings of the first Antwerp period (cats 1–2).[45] It shows a coastal view observed from an elevation, although the details of the landscape outlined below are imprecise. The other two drawings from nature in the sketchbook were also taken near the shoreline, a *Coast scene with a lighthouse* (fig. 18) and a *Ship on a calm sea* (fig. 19). Unlike the first folio, these views were set down in graphite, but were later crudely reworked in pen and brown ink, perhaps partly because they were beginning to fade into illegibility.

Another slight sketch of the coast, in pen and brown ink, survives in the Victoria and Albert Museum (see cat. 28, fig. 28a). Like the Courtauld drawing (fig. 16), such informal sketchbook notations must have been common. Had they survived, our image of the breadth of interests taken by Van Dyck, would doubtless have been expanded. The style of these somewhat unprepossessing drawings, made without a thought as to their future preservation or exhibition, departs from the norms of Van Dyck's draughtsmanship as it is otherwise known to us. In the face of such anomalies, it is with trepidation that the art historian rejects either works that have hitherto been accepted,[46] or others, such as the previously unillustrated sketch of *Trees near a coastline with a sailing-boat* now in the British Museum (fig. 20). The description of the foliage in the latter marries entirely with the *Landscape near Genoa* (cat. 6), and the drawing does not have the characteristics of a copy. The penwork is generally lively and in the ground and water resembles that of the drawing in the Victoria and Albert Museum. The outlined animal in

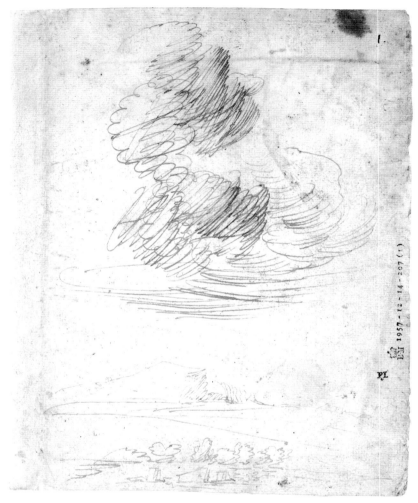

Fig. 17 Van Dyck, *Storm cloud above a mountain*
(*folio 1 from the Italian Sketchbook*), pen and brown ink, 195 × 143 mm.
London, British Museum.

Fig. 18 Van Dyck, *Coast scene with a lighthouse*
(folio 94 from the Italian Sketchbook),
pen and brown ink over graphite, 157 × 203 mm.
London, British Museum.

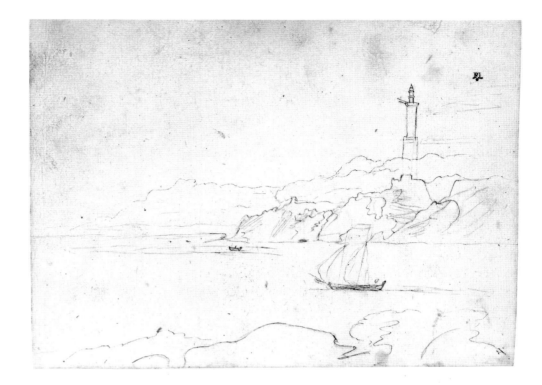

Fig. 19 Van Dyck, *Ship on a calm sea*
(folio 95 from the Italian Sketchbook),
pen and brown ink over graphite, 157 × 203 mm.
London, British Museum.

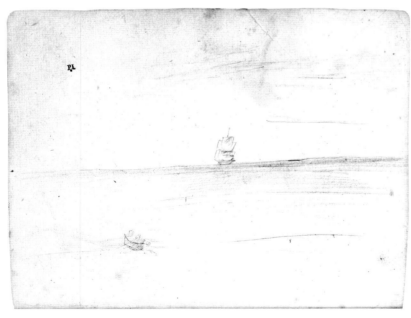

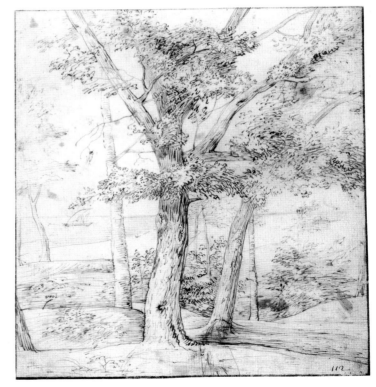

Fig. 20 After Van Dyck?, *Trees near a coastline with a sailing-boat*,
pen and brown ink, touched with black chalk, 229 × 211 mm.
London, British Museum (1946–7–13–997).

the lower foreground may be compared with the sheep in the *Ypres Tower at Rye* (cat. 15). But elsewhere, especially in the tree-trunks, the calligraphy departs radically from anything we can associate with confidence with Van Dyck. Recently catalogued as by Lievens,[47] it could well be the work of an artist who, like Lievens, worked in Van Dyck's circle in England, and who may have based the drawing on a lost sketch by the master.

Also to be rejected is the watercolour at Chatsworth of a *Landscape with a small wood* (fig. 21).[48] This was probably copied from an authentic prototype, reflecting the original closely in detail, including the outlined rams towards the left. Against the drawing's autograph status speak the slackly drawn outlines and the colour of the ink as well as of the green wash in the trees, which are both out of key with the palette of Van Dyck's own materials.

Another drawing in the British Museum has made the journey between Van Dyck and Rubens more than once, the *Study of a pollard willow* (fig. 22). An inscription that could date from the first

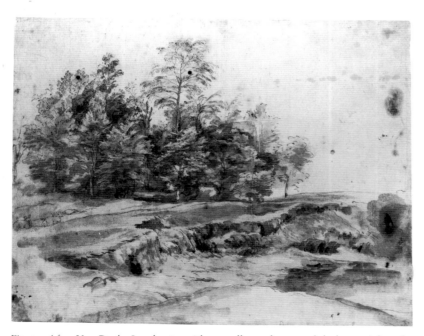

Fig. 21 After Van Dyck, *Landscape with a small wood*, pen and dark grey ink and watercolour, 274 × 346 mm. Chatsworth, Devonshire Collection (inv. 1004; photo: Courtauld Institute of Art).

half of the seventeenth century attributes it to Van Dyck, but has been crossed out and substituted with Rubens' name. Recent cataloguers have also disagreed, although the present consensus favours Rubens. The scale of the motif for a drawing in black chalk, as well as considerations of style, point in Rubens' direction.[49]

Once translated into his paintings, as we have seen, the landscape sketches are idealized and transformed, and at their best these backgrounds are as fluently painted as any descriptions of nature of their time.[50] Yet there are exceptions, especially among Van Dyck's later paintings, such as the alluring portrait of the children *Philadelphia and Elizabeth Wharton* in the Hermitage (fig. 23), of which Oliver Millar has written that 'the landscape in particular is so cold, and so poorly drawn, that it must have been the work of an assistant'.[51] This example is not unusual, and elsewhere Van Dyck merely repeats or varies a landscape background from an earlier portrait.[52] Such practices confirm that the wheel of fortune had turned full circle: that just as Rubens, when under pressure, had made use of his assistants, including Van Dyck, to complete the commissions that came his way, so Van Dyck's popularity led to such a flood of work that he resorted to similar practices. Everhard Jabach described Van Dyck's studio as a virtual factory of portraits.[53]

II A European context: landscape drawings by Van Dyck's contemporaries

To turn from a characteristic landscape drawing by Van Dyck, such as the *Slope with trees and farm-buildings* (cat. 18) to a drawing by Domenichino (cat. 26) is not to enter a different world. In this instance, it is Van Dyck who portrays the forms of the trees in greater detail and who leaves more of his page blank. In other respects the two drawings are surprisingly alike. The compositions are equally informal, and in style their penwork exhibits considerable congruity: thin, broken outlines for the foliage, snaking lines suggesting the lie of the land in the middle-ground, curls and zig-zags describing tufts of greenery near the foreground or changes in the terrain where a ditch or some other depression occurs, parallel shading, often slanting diagonally, and the near-horizontal strokes, at the far right in the Domenichino, the far left in the Van Dyck. To

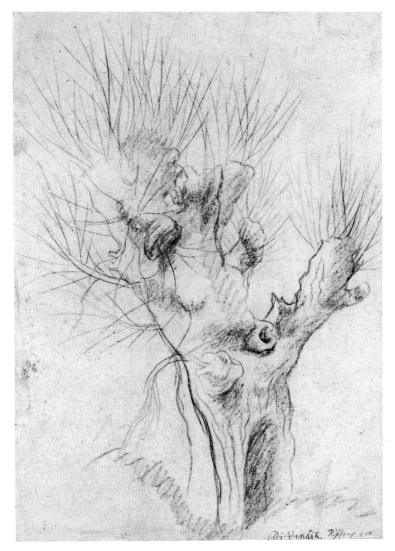

Fig. 22 Rubens, *Study of a pollard willow*, black chalk, 392 × 264 mm. London, British Museum (Fawkener 5213-2).

Fig. 23 Van Dyck and studio, *Philadelphia and Elizabeth Wharton*, oil on canvas, 162 × 130 cm. St Petersburg, the Hermitage Museum.

observe Van Dyck's delineation of the single tree impinging on the hut at the foot of the hill, and move the eye to the trees below Domenichino's cliff, is to drink the same vintage from neighbouring properties.

Both drawings give the impression of having been made out of doors. Their direct engagement with the forms delineated, the palpable immediacy of the description of light, and their uneven finish, with areas of the paper left blank, all speak for this, quite apart from the credibility of the views depicted, which can only be judged on the basis of our personal experience.

Domenichino's drawing inspired the landscape background in one of his paintings (see cat. 26, fig. 26b), just as Van Dyck, as we have seen, sometimes referred to his drawings when he painted his finished compositions. The approach of the two artists is the same, excerpting or rearranging the sketch to suit their requirement of creating an idealized backdrop, an improvement on nature, as a foil to their idealized subject-matter.

Such analogies between works of different pedigree, which can extend to choices of motif, as in the detail studies from nature by three artists represented here (cats 4, 19, 39 and 49) are worth stressing, because the general approach of art historians (apart from some art theorists and iconographers), since the foundation of the subject as an academic discipline in the nineteenth century, has been guided chiefly by the desire to describe difference, whether between artists of different date or nationality, or between artists of the same school. While lip-service is regularly paid to common precedents – in the case of Van Dyck to Rubens and Titian, of Domenichino to Raphael and Annibale Carracci – it is only a minor exaggeration to say that the similarities between a whole range of work being produced in Europe are neglected as the defining monographs are produced on individual schools, themes, or artists, emphasizing their uniqueness (which sometimes amounts to little more than differences of 'handwriting').

Yet the resemblance between the drawing by Domenichino, made by around 1620, and that by Van Dyck of around 1634, would not have surprised these artists. Nor would they have been surprised to discover that most of the landscape drawings by their Italian or Italian-inspired contemporaries in this exhibition also exhibit a comparable approach. Whether by Guercino, Van Poelenburch,

Poussin, Van Swanevelt, Claude, Mola or Della Bella, with all of whom Van Dyck shared the experience of Italy in general, and of Rome in particular, their landscape drawings form a common link, whether in style, their approach to subject-matter, or their subsequent rôle in their paintings.

Of interest in this context are some of the textual sources on which we rely for information about these artists. For example, Joachim von Sandrart, who accompanied Rubens on his journey to Utrecht in 1627, where they visited Abraham Bloemaert and Cornelis van Poelenburch, was in Italy a few years later, in the 1630s. He described how he, Pieter van Laer, Poussin and Claude rode together to Tivoli to paint or draw landscapes from nature.[54] Small wonder, then, that their drawings resemble one another's in style and function. The argument can be pursued further through the writings of Roger de Piles. First, because he mentions Van Dyck in the context of a competition or series of bacchanals, perhaps ordered by one of Van Dyck's sitters, Lucas van Uffel, in which Rubens, Domenichino, Guido Reni, Guercino, Albani, Poussin, Rembrandt and other painters of the time were involved.[55] Whether or not this reference is apocryphal, it reminds us that such international collaborations existed on many levels, from joint involvement in commissions and master-pupil relationships to those between engravers and designers, and that these were nothing new, not least in the painting of landscapes.[56] But De Piles' importance for us lies chiefly in his attempt to measure, using identical yardsticks, the talents of Rubens, Michelangelo, Raphael, Poussin, Rembrandt and others.[57] Nationhood was not a primary concern of writers on art until Jacob Burckhardt began to codify its history, using Giorgio Vasari, a propagator of locally based hyperbole, as his guide. His approach became influential in the nineteenth century, as nationalistic concepts gathered strength in European modes of thought.

This digression, briefly touching on a subject that remains to be fully investigated,[58] is necessary to comprehend the similarities that we have encountered. The 'Roman' style of landscape pursued and developed by these artists was part of a unitary tradition that affected the whole of Europe. Local inflections aside (and they could be strong), we can observe their works through a constant, one that they would have recognized. It might be objected that a comparable consistency exists in other facets of their work, whether in drawings

of the figure or in finished paintings, but the landscape drawings provide a strong indicator of these unifying factors for several reasons.

First, there is the very informality of the sketch from nature. Unselfconscious records that were rarely intended for general display, they are unlike most other artistic productions in having been created outside the walls of the professional kitchen of the studio. To be retained or discarded at will – and we shall see that many, indeed most, must have been discarded – and often, as already noted, considered as something of a leisure occupation,[59] they were not intended for wide public consumption. Thus they were less constrained by externally imposed requirements. In them, 'a rose is a rose is a rose', the forms are as described, and not (yet) transformed by contextualization into carriers of meaning. It follows that they encapsulate with particular purity the essential principles of the art of two-dimensional representation on paper. The drawings themselves assume the rôle of models, to be kneaded, plundered and distorted to suit more elaborate needs.

This leads us to our second reason for putting some faith in these sketches as sensitive indicators of artistic intent within a European context: because they stand at the periphery of a form of art, landscape, that was itself consistently viewed, until well into the seventeenth century, as a peripheral occupation. We shall have more to write on this topic in the third part of the Introduction, but for the present it is sufficient to be reminded that the art of landscape, far from being considered, like history painting, as central to an artist's career, was regarded as 'by-work'.[60] Whether in Italy, Flanders or Holland, the status of landscape, even if idealized, remained secondary to history painting, elevated products of the imagination. Nowhere could the artist stand more distant from history than in recording a landscape directly from nature. In summary, in the hierarchy these drawings are the raw material of art, objects for consultation, adaptation and improvement. Only after their transformation (e.g. through idealization) and contextualization (e.g. in a portrait, history or allegory) do they enter the realms that primarily concern the student of iconography and of cultural history. For this reason they have remained somewhat neglected and, as we hope to show, undervalued – as they always have been.

Combining, as this catalogue does, works produced as far apart as Rome and Amsterdam, but by artists born within about two decades of each other, permits an overview of the degree to which the 'Roman' tendency in landscape drawing held sway, from around 1620–40, in European art. Landscape at this period flourished in Rome with a vitality almost as well-nourished as in Holland. Dutch artists, including several represented in this catalogue (Breenbergh, Van Poelenburch, Van Swanevelt), were central to developments in Italy, and their art evolved from that of Paul Bril (1554–1626), who worked chiefly in Rome where his art was enthusiastically received.[61] Their influence assisted in the growth of an interest in landscape both among northern visitors to the Eternal City as well as among Italian painters, with some of whom Bril, at least, collaborated. Among those he influenced, Agostino Tassi (c.1580–1644), who was also inspired by the Rome-based German painter Adam Elsheimer, played an important part in moulding the style of landscape in Italy in the early seventeenth century, and it was to him that Claude Lorrain was apprenticed in around 1620.[62]

Degrees of influence are difficult to measure, complicated as they are by general, inherited traditions in landscape at this period, a theme discussed further in the third part of this essay. Nonetheless, it may be affirmed that the waves from the Roman tide are still felt with considerable force in the work of the Fleming, Van Dyck, and the Frenchman, Poussin, and other visitors to the city; that they also dominate the work of all Italianate artists, including some not known to have visited the peninsular; that they remain detectable, through the lens of Rubens, in the work of other Flemish artists (Jacques Foucquier, Lucas van Uden, Lodewijck de Vadder); but that the waves lap more feebly at the shores of the Dutch Republic after the beginning of the seventeenth century.

In the landscape drawings made by numerous Dutchmen who lacked direct experience of Italy – Hendrick Avercamp, Claes Jansz. Visscher, Esaias van de Velde, Willem Buytewech, Pieter Molijn, Jan van Goyen, Pieter Saenredam and Claude de Jongh are represented here (cats 29–39 and 52) – we encounter alternative modes of representation. The Bohemian artist Hollar (cat. 55) and Rembrandt (cat. 53) both belong in this camp, in Rembrandt's case despite having a profound interest in Italian art. Hollar's artistic personality, as George Vertue noted, was incapable of adjusting to Van

Dyck's manner.[63] Although not wholly divorced from the 'Romans', the drawings made by all these artists speak in a less delicate, more direct vernacular. Still more significantly, their landscape drawings relate closely to their finished products, whether painted or etched. Willem Buytewech may be singled out as a key example of the Dutch approach, his drawings and etchings being created in the same spirit and without stylistic distinctions in their degree of finish or pictorial effect.[64] In this respect he and the other artists mentioned resemble an *avant-garde* of their period: while the distinction in style between their landscape drawings and those by Van Dyck, for example, may appear marginal to the untutored eye, it is important; but yet more distinctive of the Dutchmen is the narrowing of the gap between their preliminary sketches from nature and their final compositions, which became almost equally direct transcriptions of an at least believable actuality,[65] so that the drawings could assume an almost equivalent iconographic significance. As a result, we respond to their works with different preconceptions. (It was a development which in the nineteenth century was mirrored in the rise of Impressionist art, in which the finished work again embraced the qualities of the spontaneous sketch.)

The individuality of this Dutch development is usually explained in terms of the increased political independence of the Dutch Republic, in combination with other factors: the immigration of large numbers of artists from the southern Netherlands for whom the northern landscape was a fresh discovery and a refuge, a 'New Israel';[66] a reaction against Mannerist styles; the influence of Calvinism, so that more factual depictions of nature, 'God's other Book', as Constantijn Huygens expressed it,[67] became a fit subject for art (raising the prospects of an iconography that lacked the contentious imagery of religious painting, a point to which we will return), and the rise of empirical experimentation and more precise classifications in the natural sciences.[68] Parallel artistic developments also occurred in the literature of the Republic during the same period, as Dutch poets struggled to employ their native language, turning for inspiration to the spoken vernacular. In their different ways both Gerbrand Adriaensz. Bredero and Samuel Ampzing stand as examples of this practice, and the ambitions of Dutch writers were later described by Joost van den Vondel in his *Introduction to Dutch Poetry*:[69] the Dutch language could either be used in a form that resembled everyday speech, or adapted to more elevated styles derived from literary conventions rooted in the Antique.

The Dutch artists' approach to nature can be viewed as near-equivalents of the vernacular approach in literature. They reach out, even in their finished compositions, for the informal and the quotidian. We respond to their landscape drawings differently as a result. For example, the areas of the paper left white, which we observed in the drawings by Domenichino and Van Dyck, appear in the Dutch drawings to result not so much from a casual omission, made for the sake of brevity, but to be germane to the drawings' compositional and descriptive powers, helping to suggest wide spaces and open skies that flood their landscapes with light. This characteristic is more prevalent, among Van Dyck's contemporaries, in the work of Dutch artists outside the 'Roman' group. Rembrandt is no exception, although in the *Sailing-boat on a wide expanse of water* (cat. 53) he pares his composition to its bare essentials. In such drawings his work not only feeds off local Dutch styles, but also grows directly out of a knowledge of the broader, international traditions that informed Van Dyck as well. In the latter's anniversary year we may point out that his landscape drawings, which anticipate many of the qualities admired in the work of Rembrandt and other Dutch artists, were probably all made many years before Rembrandt found his stride as a landscape artist in the 1640s.

These developments, and how the traditions of landscape were refreshed and its status altered in the early seventeenth century, are discussed in part three below. But before embarking on the next sections, a few other characteristics of the drawings in this catalogue require investigation.

To begin with, the limitations of any attempt to view these drawings from a purely Flanders-based viewpoint need to be highlighted. The landscapes of Rubens, who provides the most obvious model for what may be regarded as distinctively Flemish, are equally indebted to Italian art. Unsurprisingly, therefore, his landscape drawings, like his figure drawings, belong in the same camp as Van Dyck's, and they differ quite as much as his from those by the Dutch contingent. Yet Rubens remains a vital and inescapable ingredient in the work of his countrymen. Jacques Foucquier, Lucas van Uden and Lodewijk de Vadder (cats 40–43) are unified by Rubensian qualities as much as by the localities that their drawings describe.

Of the three, it is Van Uden who succeeds in developing the most singular vision, resulting from a direct observation of natural effects that renders comprehensible the traditional attribution of his *Landscape with a village* (cat. 41) to Van Dyck (who portrayed him in the *Iconography*, his compendium of engraved portraits of distinguished contemporaries). The later Flemings, such as David Teniers and Jacques d'Arthois (cats 56–7), despite strongly individual artistic personalities, also remain wedded to their local stylistic inheritance.

Turning to Italy, whether in the work of native artists – Domenichino, Filippo Napoletano, Guercino, Della Bella and Mola – or of visitors like Van Poelenburch, Breenbergh, Van Swanevelt or the permanent resident Claude Lorrain, any Rubensian sense evaporates. No clearer demonstration could be given of the degree to which Van Dyck, whose landscapes reveal such rich stylistic links with these artists, broke free of his master's influence.

Against these trends, Jan Lievens, whose art was almost inseparable from Rembrandt's at the beginning of the 1630s, attempted to reinvent himself on the basis of Van Dyck's example (and in whose *Iconography* he, too, is included). The result, in his landscape drawings (cat. 54), is the creation of a manner that is primarily Flemish in feeling. Not even Peter Lely, a devoted emulator of Van Dyck, or Jacob Esselens, whose drawing of Rye (cat. 60) depends closely on Van Dyck's example, abandoned the traditions of their native Holland to this degree. It was of course chiefly in England that these artists came into contact with each others' works, a country the significance of which in our context lies in its having attracted a range of talent in the field of landscape to its shores.[70]

The Dutch characteristics we have described were perhaps partly the result, as has been suggested in the past, of the colonization of the northern Netherlands by artists from the south. In exploring the terrain of Holland they particularized it. In Italy, which had long been the intellectual, spiritual and artistic centre of Europe, the landscape was explored more overtly in a spirit of nostalgia and longing for a supposed Arcadian past. Almost only in the drawings – and it was perhaps no accident that so many of them were by outsiders – were its own qualities unearthed and explored.

III The tradition of sketching from nature:

(a) The surviving works

It would be tempting to attribute the comparabilty of the styles of Van Dyck's landscape drawings and those by many of his contemporaries to the strength of his own influence. To the stylistic evidence could be added Van Dyck's fame and his contacts throughout Europe, from the Netherlands to Italy. Our knowledge that his dates in Rome coincided with time spent there by Domenichino and Guercino, as well as by Breenbergh and Van Poelenburch, or that his visit to Constantijn Huygens in The Hague occurred soon after the latter had written in praise of Rembrandt, Lievens and other artists, could be harnessed to explain such wide-ranging analogies.

By turning to a rather improbable source, Fra Bartolommeo (1487–1517), such a theory can be persuasively invalidated. His drawings of landscapes, made in around 1500,[71] thus more than one hundred years earlier, exhibit extraordinary parallels with Van Dyck's work (see fig. 24). Most were apparently made from nature. Although the motifs tend to include man-made structures and there are some topographical views, Fra Bartolommeo's landscapes are often informal compositions drawn with a freedom that speaks of an 'unofficial'[72] aspect of his art. Also like Van Dyck, this informal character embraces stylistic traits, with comparable penwork, from the solidly outlined profiles of hills and trees to the skeins of parallel hatching. The blank page is used in the same way, and Fra Bartolommeo's approach is identical when adapting his drawings for use in the landscape backgrounds of his finished paintings, which exhibit naturalistic effects that clearly depend on his direct study of nature (see fig. 25).

More than fifty such drawings by Fra Bartolommeo survive, although yet more (106 *foglie di paesi*) are mentioned in the painter's posthumous inventory.[73] It also lists 'four coloured canvas scrolls of coloured landscapes' and landscape drawings by Lorenzo di Credi, none of which are known today. Forty-one of Fra Bartolommeo's landscape drawings resurfaced in an album in 1957. Three have been connected with his paintings, in which particular views or sections are introduced with a certain amount of freedom. These rare survivals of Italian Renaissance landscape draughtsman-

ship beg the question as to how common the practice of drawing from nature was at that time, one hundred years before it flourished in the early seventeenth century.

The received wisdom is that the practice of drawing directly from nature, like naturalistic landscape painting, was rare before 1600, apart from studies of plants, or else topographical views and drawings of monuments which are excluded from this discussion as belonging to another catagory of work.[74] Also, that a succession of artists, from Pieter Bruegel the Elder to Jan van Goyen, with rôles assigned to Gillis van Coninxloo, Jan Brueghel the Elder, David Vinckboons, Claes Jansz. Visscher and Pieter Molijn, acted as the midwives to the birth of the naturalistic, and very largely Dutch, landscape in the first quarter of the seventeenth century. Certain,

often-cited exceptions exist, including Leonardo da Vinci, Dürer and the so-called Master of the Small Landscapes. But apart from these, was Fra Bartolommeo's interest in drawing the landscape unusual? And would his landscape backgrounds have appeared different without the experience of drawing from nature?

For the answer we have to undertake three types of enquiry, and in the context of this catalogue they can only be undertaken in brief: to compare the landscape backgrounds of Fra Bartolommeo's paintings with those by his contemporaries and predecessors (for if they look similar, they may also have made drawings from nature); to search for other, comparable drawings of the period; and to study the written sources for evidence. In the case of the second and third avenues, the evidence is spartan. But if sufficient

Fig. 24 Fra Bartolommeo,
*Landscape with a house at
the foot of a hill,*
pen and brown ink.
285 × 213 mm.
London, British Museum
(1957-11-29-67 *verso*).

material suggests that the practice was indeed already common, this will alter our perception of the place occupied by the drawings by Van Dyck and others in this catalogue in the development of landscape art.

The paintings of the period reveal that Fra Bartolommeo's contemporaries, including such figures as Francesco Granacci (1477–1543), Francesco Franciabigio (1482–1525), Raphael (1483–1520) and Lorenzo Lotto (c.1480–1556) produced landscape backgrounds which are entirely comparable in the degree of their naturalism and atmospheric effects.[75] A few drawn scraps by Raphael, whose paintings reveal extraordinary gifts as a landscapist, show that he also made landscape sketches,[76] and it seems highly probable that Granacci and Lotto also made them, and that drawings from nature provided the raw material for their paintings in precisely the same way as they did for Fra Bartolommeo. All these artists produced realistic landscape backgrounds that went

far beyond the achievement of painters who worked in the spirit advocated by Cennino Cennini (c.1370–c.1440), who near the end of the fourteenth century wrote that 'If you want to acquire a good style for mountains, and to have them look natural, get some large stones, rugged, and not cleaned up; and copy them from nature, applying the lights and the dark as your system requires'.[77] As late as the 1460s Filippo Lippi (c.1406–69), in his celebrated *Virgin and Child with two angels* in the Uffizi, appears to have followed this advice, just as some Italian artists were beginning to develop a greater realism in their landscapes.

For as has been stated in the past, the tradition for naturalistic landscape in Italy can be traced back to the 1460s, in paintings by Alesso Baldovinetti (c.1426–99) and the brothers Antonio (c.1432–98) and Piero del Pollaiuolo (c.1441–96 or before).[78] To step from the landscape behind the celebrated *Battle scenes* by Paolo Uccello in the Uffizi, Louvre and National Gallery in London of the

1450s, into that behind Antonio's *Hercules and the Hydra* (fig. 26)[79] of the early 1460s, is to cross the threshold of the symbolic, medieval world into a Renaissance and humanist one, predicated upon empirical observation. Pietro Perugino (*c.*1445–1510) stands as a significant landscapist between the generations of Baldovinetti and the Pollaiuoli on the one hand and Fra Bartolommeo on the other, and his work again suggests a basis in drawing from nature.[80] Other artists, including Filippino Lippi (*c.*1457–1504) and Piero di Cosimo (1462–1521?), should be mentioned in this context. The problem for our theory is that the drawings simply do not survive.

The interest in landscape exhibited by some Italian artists from the 1460s suggests the influence of Flemish art, and in 1450 a direct contact apparently took place between the two traditions (and there were surely many other such contacts), when Rogier van der Weyden (*c.*1399–1464) visited Rome.[81] His *Lamentation* in the Uffizi, probably executed with studio assistance, is generally assigned to this period. For Northern artists the tradition for naturalism in landscape backgrounds already had a long pedigree, stretching back through the Ghent altarpiece of the Van Eycks, completed in 1432 (fig. 27), to the work of the Limbourg brothers, who hailed from the northern Netherlands, in the *Très riches heures du Duc de Berry* of around 1411–16.[82]

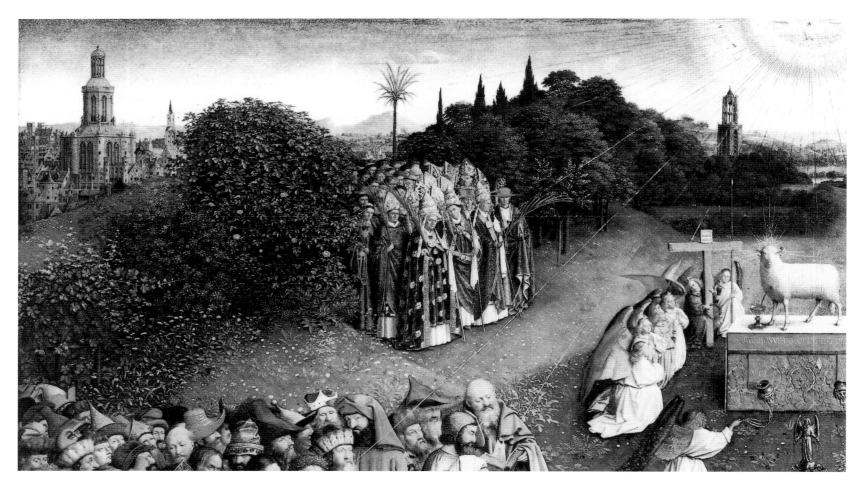

Fig. 27
Hubert and Jan
Van Eyck,
*The adoration of
the lamb (central
panel of the Ghent
Altarpiece, detail)*,
oil on panel,
134.3 × 237.5 cm.
Ghent, St Bavo.

Fig. 28 Leonardo,
View from S. Maria della Neve,
pen and brown ink,
195 × 285 mm.
Florence, Uffizi (8P).

Kenneth Clark, in *Landscape into Art*, his investigation of the development of landscape styles, suggested that the landscapes painted by Hubert van Eyck (*c*.1385–1426) in his miniatures were 'so sure in their sense of colour-values that they must be based on studies made direct from nature, probably in watercolours'.[83] This assessment seems inescapable not only to the observer of the Ghent altarpiece (fig. 27), with its extraordinarily acute representation both of the details and atmosphere of the landscape, but of large numbers of works by Netherlandish painters of the first half of the fifteenth century. Despite the unsophisticated atmospheric perspective, equal sharpness being accorded to every detail regardless of its distance from the viewer,[84] the idea that such landscapes could have been made without recourse to drawing from nature is wholly improbable.

That stylistic links exist between these early representations of nature and much later landscapes has occasionally been noted. For example, comparisons have been made by Otto Pächt between the background of Jan van Eyck's unfinished *St Barbara* in Antwerp and the well-known drawing of a *Dune landscape near Haarlem* by Hendrick Goltzius of around 1603 (cat. 32, fig. 32a).[85] The analogies are closer with Pieter Bruegel the Elder,[86] but nonetheless, from the time of Van Eyck to that of Van Dyck, an almost uninterrupted tradition exists for the convincing portrayal of landscape in western painting: in Flanders through such figures as Rogier, Geertgen tot Sint Jans, Gerard David, Dirck Bouts, Quentin Massys, Bruegel, his son Jan Brueghel the Elder (whose portrait was engraved in Van Dyck's *Iconography*), Abraham Bloemaert, Joos de Momper and Rubens (the last two also portrayed in the *Iconography*); in Italy, from the 1460s, through such artists as Giovanni Bellini, Giorgione, Raphael, Polidoro da Caravaggio, Titian (as we have seen, a primary inspiration for Van Dyck, of whose works he formed an important collection)[87] together with his fellow Venetian Domenico Campagnola, Girolamo Muziano, Paolo Fiammingo and other painters of his circle, through to the Carracci and Paul Bril, who as we have already noted had a profound influence on the landscape styles being practised in Italy at the time of Van Dyck's arrival in Rome, where they could even have met.

For all their symbolic and stylistic wanderings, the paintings, whether by Fra Bartolommeo, by whom drawings from nature survive, or by all the other artists we have mentioned, by most of whom no such works are known, all idealize and codify nature in the spirit of Neo-Platonic, humanist thought. These, their finished products, develop uniformly enough to suggest that the Frate was not exceptional in the knowledge of nature that he had gained through sketching out of doors. But it is with some frustration that we turn our attention to the drawings themselves, for apart from Fra Bartolommeo's, the material is exceedingly scarce.

An obvious candidate for study is Leonardo da Vinci (1452–1519), whose earliest dated drawing is inscribed in his right-to-left script: *di di Sta Maria della Neve, addì 5 d'Aghosto 1473* (fig. 28).[88] In style the drawing is far removed from Fra Bartolommeo and yet the inscription implies that it was made from nature, or based on a particular view. This has been questioned, and the handling resembles the fantasy background in a drawing of *St Jerome in a landscape* by Leonardo's contemporary Piero di Cosimo (1462–1521?).[89] In so far as it is possible to reconstruct the appearance of

the fifteenth-century Florentine landscape drawing, Leonardo's drawing may stand as a 'characteristic' glimpse of its style.[90] And the fact that these landscapes of reality and fantasy appear so linked is explicable through the tyranny of the 'schema' in artistic production: faced largely by precedents of fantasy in landscape drawing, Leonardo's first attempt at realistic representation could not escape their influence.[91] While its status as a drawing made directly from nature has been questioned, it has been pointed out that despite Leonardo's primary interest in scientific observation, the graphic language of the drawing expresses a sense of his spontaneous reaction to an empirically observed visual experience.[92]

That Leonardo finally succeeded in throwing off this inheritance – a remarkable achievement – is demonstrated by a few other drawings. It is worth stressing their *rarity*, as Leonardo above all, with his acknowledged interest in natural effects, quite apart from the convincing illusionism of his painted landscape backgrounds, might have been expected to make many more. A study of his writings, of which more will be said in due course, suggests the same. But apart from his celebrated studies of individual plants, which are also not numerous, there are only some five landscape drawings by him that appear, like the sketch of the *Edge of a copse of birches* at Windsor, to have been made directly from nature.[93] Another is the *Study of rocks*, also at Windsor, in which we detect such analogies with a drawing by Van Dyck that we reproduce it here (see cat. 13, fig. 13b).[94] A drawing that should also be included in this discussion is the astonishing *Study of a tree* (fig. 29), also from Leonardo's albums at Windsor, but now universally attributed to his pupil Cesare da Sesto.[95]

As a group these drawings seem to stand as prophets in the long tradition of sketching from nature. They foretell in their style and compositional focus not only the coming of Fra Bartolommeo's contribution to that tradition; but in combination with the latter's drawings, much of the spectrum of the practice until the mid-nineteenth century. From detail studies to broad sweeps of terrain, whether in chalk or ink with wash, whether as records of place or stylized derivations inspired by the landscape, many of the approaches tested in drawings from nature are attempted by these artists. If we include one more painter of this period, Albrecht Dürer (1471–1528), then the entire spectrum is almost fully anticipated.

Fig. 29 Cesare da Sesto, *Study of a tree*, pen and brown ink over black chalk on blue-grey paper, 392 × 265 mm. Windsor, The Royal Collection (12417) © Her Majesty The Queen.

Fig. 30
Albrecht Dürer,
*Landscape near
Segonzano*,
watercolour,
210 × 312 mm.
Oxford, Ashmolean
Museum.

In Dürer's work, which at times resembles the precise *Study of a tree* by Cesare da Sesto (fig. 29), we also encounter a sophisticated, liquid use of watercolour for the first time. His *Landscape near Segonzano* of around 1505–7 (fig. 30) is a characteristic example of his work in the medium, in which passages of great precision, like the more distant mountain, contrast with the broad washes of colour on the right that suggest the forms of the landscape with an elastic tension. To study the technique of this section of the drawing beside Van Dyck's watercolours of the 1630s reveals that their intentions, as well as the results, were similar (cats 22–5). The links are of course paralleled by the plant studies made by these two artists.[96]

From these key examples, together with the evidence provided by their paintings and, in Dürer's case, engravings, it can be deduced that by around 1500 the more interesting figures in the history of art were drawing from nature. Given the lack of drawings to support this statement, it would be foolhardy to be dogmatic: *some* painters may, exceptionally, have always relied for their landscape backgrounds on secondary sources rather than on a direct study of nature (as even Fra Bartolommeo occasionally did).[96A] But the case of one recently identified draughtsman, Antonio di Donnino del Mazziere (1497–1547), a Florentine pupil of Franciabigio, suggests that the practice of venturing out of doors was not restricted to exceptionally gifted or determined artists. Many of Antonio's land-

Fig. 31 Antonio di Donnino del Mazziere, *View of a fortified town on a hill*, red chalk (with a border by Giorgio Vasari in pen and brown ink with brown wash), 270 × 394 mm. London, British Museum (1946–7–13–34).

scape drawings are copies or derivations from Dürer's engravings. But others, like his *View of a fortified town on a hill* (fig. 31), now in the British Museum, were probably drawn on the spot, providing a glimpse of the interest taken, even by a minor figure, in landscape drawing.[97] The composition, with its open foreground and the detail of the hill and architecture, resembles Fra Bartolommeo's landscapes (fig. 24), and may again be compared with Van Dyck, whose *View of Rye from the north east* (cat. 12) retains some of these qualities.[98]

It would be inappropriate in the context of this publication to study the development of *plein air* landscape sketching from its

beginnings until the time of Van Dyck in detail. However, because no history of this specific type of work has been written, a brief summary is necessary in order to attach Van Dyck's generation to this tradition. Again we must stress that our concern is with drawings that are not primarily of topographical or antiquarian interest. Although Van Dyck's views of Rye and Antwerp have a place in the history of topography, most of his landscape drawings do not, and our focus is on the sketch made directly from nature: the study of trees, valleys, plains, hills, rivers and the shoreline.[99]

In Italy, the most significant style of landscape drawing was developed in Venice by Domenico Campagnola and Titian. But in

almost every case, their surviving works on paper are compositions rather than sketches from nature, like the *Landscape with a castle* in the British Museum (see cat. 28, fig. 28b) and the *Landscape with a fortified castle* in the Musée Bonnat in Bayonne (fig. 32).[100] The latter remains pertinent as a precursor of Van Dyck for two reasons. First, it typifies the kind of penwork employed regularly by the two Venetian draughtsmen which, with its parallel striations of shading, was taken over by many artists, including Van Dyck himself (*cf.* cats 13–14, 17–18), as well as his Italian contemporaries, Domenichino and Guercino among them (cats 26 and 28). Second, there is the compositional comparison with the work of the Fleming, with the now familiar open foreground, and in addition

the diagonal slant (*cf.* cats 17–18), and, in this instance, the closely comparable architectural motif in Van Dyck's *Landscape sketch* in the Courtauld Institute (fig. 16).

Despite these links, Van Dyck's style as a landscape draughtsman remains distinctive, as becomes yet more apparent in the comparison with a drawing of *Trees and shrubs by water* by Titian, a rarity for him in that it may well have been made directly from nature (fig. 33). The purer colourist, Titian combines the delineation of form with a strong tonal sense, producing a coral texture; and for all the informality of the motif, which may have inspired a passage in a woodcut of *St Jerome*,[101] such density of foliage is encountered in Van Dyck only in his paintings rather than his drawings (see fig. 14).

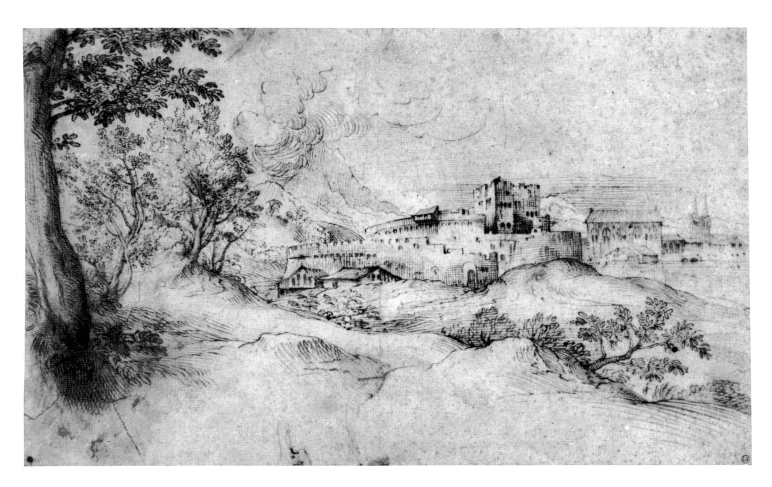

Fig. 32 Attributed to Titian, *Landscape with a fortified castle*, pen and brown ink, 216 × 347 mm. Bayonne, Musée Bonnat (1323; photo: RMN).

As a landscape draughtsman, Van Dyck found inspiration in other models as well.

Other Italian precursors are few. It would be tempting to suppose, from the paucity of surviving drawings, that the practice of drawing from nature fell into neglect, were it not for the existence of a few notable exceptions. That most 'mannered' artist and prolific draughtsman, Parmigianino (1503–40), produced a flawless performance as a landscapist, a *Study of tree-trunks and shrubs* now in the Uffizi, which suggests that there must have been others, not least because Vasari, in the opening paragraph of his life of the artist, singled out his manner as a landscapist for praise.[102] The detail of

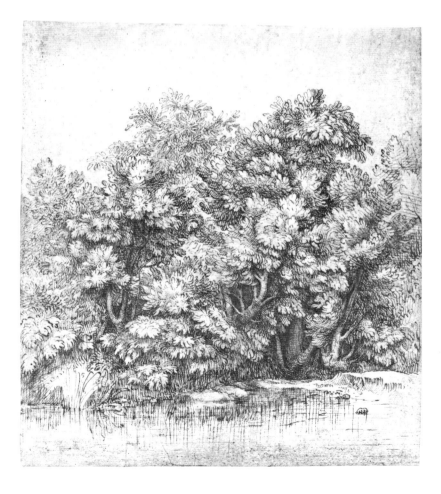

(*Left*) Fig. 33 Titian, *Trees and shrubs by water*, pen and brown ink over traces of black chalk, 243 × 207 mm. New York, Steiner Collection.

(*Above*) Fig. 34 Federico Barocci, *Landscape study with bank and shrubs*, watercolour with bodycolour over black chalk, 393 × 249 mm. London, British Museum (Pp. 3-202).

shrubbery resembles the choices of motif made by Federico Barocci (1526–1612), whose liquid landscape studies prefigure both Rubens and Van Dyck (fig. 34). No earlier painter is known to have employed watercolour with quite such freedom in a sketch from nature. Only six drawings of this kind by Barocci survive, yet the inventory of his possessions at his death suggests that his studio then contained at least 170, another indication of the losses that have been sustained by this kind of work.[103] Ironically, but perhaps understandably, the works of an amateur, Gherardo Cibo (1512–1600), have been preserved in larger numbers than for any other Italian landscapist.[104] More typical is the fate of drawings by Girolamo Muziano (1532–92), an artist mentioned before, who was renowned

for his landscapes. Yet all of his surviving drawings appear to be compositions, his penwork influenced by Titian but his designs at times tending to a purer naturalism.[105] His style was often dictated by the printmaker's burin, the drawings being produced for the engraver Cornelis Cort to whom a comparable landscape drawing in Besançon is attributed (fig. 35). Whether by Cort or Muziano, as seems perhaps more likely, and despite the fact that it is composed, the draughtsmanship is remarkable for its anticipation of Van Dyck's – whose motifs drawn by the coast are comparable (e.g. cats. 14 and 16) – and partly bridges the gap between him and Fra Bartolommeo.[106]

That Italian artists with no particular reputation in the field of

Fig. 35
Girolamo Muziano
or Cornelis Cort,
*Landscape with a
beached ship*,
pen and brown ink,
200 × 313 mm.
Besançon, Musée
des Beaux-Arts et
d'Archéologie
(D. 2753; photo:
Charles Choffet).

landscape nonetheless drew from nature is also argued by an informal sketch, a very rare survival among this painter's drawings, of a *Pine forest near Vallombrosa* (fig. 36), by Federico Zuccaro (1541/2–1609), dated *1576 adì agosto*. An artist, perhaps Federico himself, is depicted on the right, drawing into a sketchbook, a motif that gains momentum in the second half of the sixteenth century (becoming widespread in the seventeenth), one that supports the contention that this kind of work was common.[107] That Zuccaro should be the draughtsman has a particularly strong resonance for our thesis. For in him, as we know from his theoretical writings, we have an artist who was especially concerned with promoting the status of art – *la dignità dell'arte* – and thus he was the kind of painter for whom sketching from nature was least likely to appeal as an activity because of the low regard in which theorists held the practice of recording the landscape.[108]

Accidents of survival make it impossible to judge how often Federico may have sketched from nature. Yet this difficulty must certainly distort our view of an artist such as Paul Bril, the landscape specialist whose importance we have already noted. His drawings survive in considerable quantities, but only one *plein air* landscape sketch is known, the *Italian farmhouse by a stream* in the Rijksmuseum.[109] His other landscape drawings bear every sign of being dependent on a close scrutiny of natural forms, including trees, rocks and woodland, often combined with views of the Italian coastline and the monuments of Rome and Tivoli. The same problem bedevils the landscape sketches made by his approximate contemporaries, the Carracci. Hundreds of their drawings are known, and their contribution to the rise in the status of landscape as an art form in Italy is not in doubt. But although their painted landscapes were among the most naturalistic and influential of their era south of the Alps, evidence of their sketches from nature is hard to find, their known landscape drawings almost all being compositions. And this despite the fact that an eye-witness records that 'In the country they drew hills, landscapes, lakes, rivers and everything

Fig. 36 Federico Zuccaro, *Pine forest near Vallombrosa*, black and red chalk, 217 × 396 mm. Vienna, Graphische Sammlung Albertina (13329).

Fig. 37 Annibale Carracci? *Landscape with a pool*, pen and brown ink, 172 × 260 mm. Formerly Ellesmere (Duke of Sutherland) Collection (T. 62). (Photo: courtesy of Sotheby's.)

Fig. 38 Master of the
Errera Sketchbook,
*Folio 49: Coastal landscape
with a windmill,*
pen and dark brown ink
and wash, 135 × 210 mm.
Brussels, Koninklijke musea
voor schone kunsten van
België (4630).

of beauty that presented itself to their gaze'.[110] This practice is confirmed only by rare exceptions among their works, perhaps the most elaborate being Annibale Carracci's *Landscape with a pool,* formerly in the Ellesmere collection (fig. 37),[111] which in style is almost as reminiscent of Fra Bartolommeo (see fig. 24) as of the artists the Carracci inspired, including two Italian artists in this catalogue, Domenichino and Guercino (cats 26 and 28), and Van Dyck. The debt of Rubens to the Carracci is more generally acknowledged, and that Van Dyck himself studied their work when in Italy is documented by two copies after their designs in his Italian Sketchbook[112] as well as by affinities of style.

Of equal importance for Van Dyck's art was his Flemish inheritance. But if, as we have seen, Netherlandish sketches from nature of the fifteenth century have entirely disappeared as a class of object,

the situation for the earlier sixteenth century is only marginally better.[113] None survive by most of the artists whose contribution to that tradition was seminal, including Joachim Patinir (d. 1524 or earlier), Jan Wellens de Cock (c. 1480–before 1527), Lucas Gassel (c. 1500/10–after 1568) and Cornelis Massys (1505/8–after 1557), not to mention those involved in the continuing tradition of miniature painting that culminated in the work of Simon Bening (1483/4–1561). An assemblage of drawings known as the Errera Sketchbook, stylistically close to Cornelis Massys and Matthys Cock (c. 1509–before 1548), includes primarily topographical views and compositions, but some sketches devote as much attention to the surrounding landscape and give the impression of having been made out of doors, although perhaps with some elaborations made on the spot or in the studio (fig. 38).[114] One even anticipates the drawing of

plants by Claude Lorrain in this exhibition (cat. 49),[115] and the Errera drawings must stand as representatives of a type of material that was already commonly seen in Flemish workshops as landscape gained in popularity as an independent art form during the sixteenth century.

Among the most crucial drawings in the history of naturalistic landscape are those attributed to the Master of the Small Landscapes, an anonymous artist (thought by some to be more than one artist) from the circle of Bruegel (fig. 39). The drawings formed the basis for two contiguous sets of prints, published as 'done from life' (*gheconterfeyt naer dleven*) in Antwerp by Hieronymus Cock in 1559 and 1561.[116] The growing consensus is that the draughtsman, possibly the obscure Joos van Liere (d.1583), may have been copying prototypes, mostly now lost, made by several artists (probably including Van Liere himself and Matthys

Cock) in preparation for the engraver. Nonetheless, the series retains its place in the history of landscape art because this was the first time that everyday, unidealized views of no special topographical import were deemed suitable for presentation as finished works of art in their own right. It was a challenge to normative values in landscape that remained isolated until the seventeenth century, when, as we shall see, Dutch artists reprinted them and emulated their informal compositional style (especially Claes Jansz. Visscher, on whom see also cat.30).

Nothing of this kind was produced by Pieter Bruegel the Elder (*c.*1525/30–69), for all the importance he retains in the history of landscape art. His finished compositions, whether painted or printed, are artificial, if at times almost plausible constructs.[117] But certainly his landscapes must often have been based on sketches made from nature (although in one case he borrowed a composition

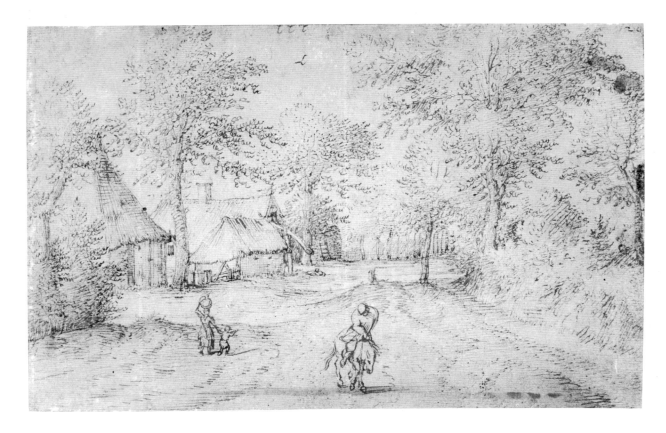

Fig. 39 Master of the Small Landscapes, *A road through a village*, pen and brown ink, 130 × 200 mm. Chatsworth, Devonshire Collection (844A; photo: Courtauld Institute of Art).

Fig. 40 Roelant Savery,
Water-mill on the Moldau,
watercolour, 230 × 357 mm.
Paris, École Nationale
Supérieure des Beaux-Arts
(M. 582).

from Domenico Campagnola), now almost all lost.[118] In a celebrated passage, his biographer Karel van Mander states as much: 'On his travels he portrayed many views from life, so that it is said that when he was in the Alps he had swallowed all those mountains and rocks, and on returning home, spewed them out on canvases and panels, so realistically was he able to follow nature in these and other respects'.[119] A similar dearth of studies from nature occurs in the oeuvre of Hans Bol (1534–93), one of the most productive landscapists of this period. Although considerable numbers of his landscape drawings survive, almost all are compositions, the few made from life being topographical.[120]

From Bol it is a short journey to the era of Rubens, and Van Dyck, through figures such as Hendrick Goltzius (1558–1617), already mentioned above for his rare drawings from nature, Abraham Bloemaert (1564–1651), whose surviving *plein air* drawings usually include tumbledown farm buildings or concentrate on individual plants,[121] and through two artists by whom larger groups of drawings from nature survive, Paulus van Vianen (1569/70–1613)[122] and

Frederik van Valckenborch, although in the latter case the impetus for his 'Travelling Sketchbook' was primarily topographical.[123]

As we approach the end of the sixteenth century, the number of surviving landscape studies made from nature continues to increase, with a significant number of drawings by Jacob de Gheyn (1565–1625). Details of tree-trunks, plants or pieces of turf, and small groups of trees predominate among the approximately eighteen drawings by De Gheyn of this class that are known, often greatly stylized. His careful renderings of tree-trunks, for example, despite their 'scientific' veneer of style, depart so radically from their prototypes that the species is usually in doubt.[124] The rapid black chalk sketches from nature by Roelant Savery (1576–1639) underpin the convincing naturalism of his elaborate landscape compositions that evoke the Tyrol. In the present context, his much rarer watercolour drawings, such as the *Water-mill on the Moldau* (fig. 40) and the *Wooden bridge over a river with a water-mill behind*,[125] are closer in spirit to the works in this catalogue, expressing an interest in tonality and atmosphere that goes beyond topographical record.

They stand at the pinnacle of the achievement of several late Mannerist landscapists who worked in the same vein – often in Prague – including Van Valckenborch, Van Vianen (both already mentioned) and Pieter Stevens (1567–after 1624).

The survival of *plein air* drawings by these artists, working in the years of Van Dyck's childhood and early maturity, together with the survival of some landscape drawings from nature by Rubens (figs 9–10, although these, as we have seen, probably do not anticipate Van Dyck's), has perhaps obscured the extent of the losses that have been sustained, and of the *lacunae* in our knowledge of the development of this type of work. For example, the known landscape drawings by Jan Brueghel the Elder (1568–1625) are almost all compositions,[126] a situation that resembles the problem already

encountered with Paul Bril. Yet Brueghel's impact on the development of landscape painting was enormous and he was admired by both Rubens and Van Dyck, whose *Iconography*, as we have seen, includes his portrait. Three further artists represented in this catalogue make an appearance there, Jan Lievens, Cornelis van Poelenburch and Lucas van Uden, alongside another landscape specialist known to Van Dyck through his collaborations with Rubens, Jan Wildens (1586–1653). But once again, our interest in his stylistic links with Van Dyck's sketches from nature are impossible to document, as none by Wildens survives.[127] Nor are there any by Joos de Momper (1564–1635) or Maerten Rijckaert (1587–1631), landscape specialists who, like Wildens, are present in the *Iconography*.

Fig. 41 Gillis Claes d'Hondecoeter ('The Master of the Farm Landscapes'), *The 'Gastes Hoef' near Deurne*, Pen and brown ink with watercolour, 229 × 374 mm. London, British Museum (1895-9-15-1040).

Thus the gaps in our knowledge remain as we enter Van Dyck's own time. For instance, few drawings survive by Adam Elsheimer (1574–1610), whose landscapes stimulated interest not only in Italy (where he worked) but also in Flanders and the Netherlands. But his sketches from nature are unknown with just one possible exception.[128] Perhaps only one landscape each drawn out of doors by his emulators, Jan Pynas (c.1581/2–1631) and his brother Jacob Pynas (c.1592/3–after 1650), survives, although both were highly regarded for their landscapes.[129] More comparable to the works in this catalogue are a few sheets by Gillis Claes d'Hondecoeter (c.1570–1638)[130] and the dozen by the anonymous 'Master of the Farm Landscapes' – who in my opinion was the same artist (fig. 41).[131] The style of his drawings seems to straddle the River Scheldt, combining concerns for compositional effect, informed by figures such as Hondecoeter's teacher, Gillis van Coninxloo (1544–1607) – yet another landscape specialist by whom no drawings from nature are known – with an interest in informal motifs that connects them with the work of Dutch artists.

Although the evidence is fragmentary (and the present text cannot aim at completeness), enough sketches from nature survive from before the time of Van Dyck to demonstrate that the activity was hardly new. Rather, his generation was the first by whom such drawings survive in considerable numbers, and this has led to the false impression that artists had previously only very rarely worked out of doors, directly from the landscape. Some reasons for the increased survival rate are suggested below, but it is as well to point out that the gaps in this type of work continue into the seventeenth century. It is difficult to find drawings from nature by many of the artists represented in this catalogue, including Guercino, Pieter Molijn, Jacques Foucquier, Nicolas Poussin and Peter Lely. The same obstacles stand in the way of assessing the art of numerous other landscapists of significance, such as Agostino Tassi (c.1580–1644) and Giovanni Francesco Grimaldi (1606–80) in Rome, Guido Reni (1575–1642) in Bologna,[132] or Jan van de Velde (1593–1641), Salomon van Ruysdael (1600/2–70) and Jan Both (1618–52) to name but a few of the Dutch. The albums of the Ter Borch family preserve only a limited number of drawings from nature, and must represent but a fraction of the work they produced.[133] And there is no other logic to explain the presence of landscape drawings by both

Rubens and Van Dyck, and their complete absence by their most important fellow-artist in Flanders, born in the years that separate them, Jacob Jordaens (1593–1678).[134]

One result of our survey is that the stylistic connections between Van Dyck and many of his contemporaries and the whole tradition of sketching from nature emerge. The styles evolved by the early sixteenth century, communicated to us through the surviving parcel of landscape drawings by Fra Bartolommeo (fig. 24) are echoed time and again – by Titian, Muziano and Annibale Carracci (figs 32, 33, 35 and 37) – before being taken up by Van Dyck in the seventeenth century. Van Dyck fuses certain distinctively northern characteristics onto this inheritance, but it is the Italianate style that dominates and which makes his landscape drawings, as we have seen, differ from those by his master, Rubens. Or at least, from those that survive. The extended record of loss we have charted necessitates this qualification. The number of landscape drawings by Rubens is small, probably only a fragment of the nature studies he made,[135] and in all likelihood the twenty-nine by Van Dyck also represents only a fraction of what he made.

III The tradition of sketching from nature:

(b) sources, prints and status

Our final search – again far from complete – for evidence about sketching from nature has been among the standard written sources, from the time of Alberti until Van Mander, a search that provides two kinds of information. The first concerns the existence of the practice, and is only specifically mentioned occasionally. But the reasons for this are bound up with the attempt that all the early writers undertake to elevate the status of artistic practice. Landscape was not a highly esteemed branch of art, but the sources also inform us of a gradual increase in its stature, a change that was to have repercussions for the survival of this kind of art.

For the first writers on art, 'nature', and the study of nature, referred not to the landscape but to the human figure. Nevertheless, as is well known, Vasari states that Alberti had some form of *camera obscura*, a device that was already recorded in antiquity and was doubtless in Alberti's time employed to delineate

various objects. Leonardo describes a related device, suggesting in his *Paragone*, in a note entitled *Of a mode of drawing a place correctly*, that the artist should:

'Have a piece of glass as large as a half-sheet of royal folio paper and set this firmly in front of your eyes, that is, between your eye and the thing you want to draw; then place yourself at a distance of 2/3 of a *braccio* from the glass, fixing your head with a machine in such a way that you cannot move it at all. Then shut or cover one eye and with a brush or drawing-chalk draw upon the glass that which you see beyond it; then trace it on paper from the glass, afterwards transfer it onto good paper, and paint it if you like, carefully attending to the aerial perspective'.[136]

While Leonardo's text depends on one in Alberti's *Della Pittura*, book I, it should also be understood in the context of his quest for a more scientific approach to the study of all aspects of the universe. The device was not to be regarded as a way for producing works of art, although as a 'way to depict natural prospects and to diminish the figures it was useful for art' (*utili all'arte e bello affatto*). Indeed, he is somewhat critical of those

'who look at the objects of nature through glass or transparent paper or veils and make tracings on the transparent surface; and they then adjust their outlines, adding on here and there to make them conform to the laws of proportion ... These practices may be praiseworthy in whoever knows how to represent the effects of nature by his imagination ... but they are reprehensible in whoever cannot portray without them nor use his own mind in analyses, because through such laziness he destroys his own intelligence, and he will never be able to produce anything good without such a contrivance. Men like this will always be poor and weak in imaginative work or historical composition, which is the aim of this science ...'.[137]

These passages reveal a great deal about attitudes to landscape that were to remain common currency for a considerable period. The aim of art is imaginative, not purely imitative, although the one feeds on the other. The business of simply copying what is before you is of little consequence unless tempered (i.e. improved) by the artist's intelligence. In this we obtain our first glimpse of the reasons why drawings from nature have survived so rarely, because they were not valued as works of art that were themselves worthy of imitation. But these passages are also of consequence because Leonardo seems almost to take it for granted that the artist was interested in depicting nature faithfully, even if only to transform

it through the imagination. Direct observation is the raw material of art, as becomes clear in several passages where Leonardo describes in detail effects that he had observed in nature.[138] At one point he specifically states what in general is only implied: that the artist should sketch from nature out of doors, an activity that appears in other parts of his text to be taken for granted: 'To represent a landscape choose that the sun shall be at noon and look towards the west or east and then draw'.[139] The artist must do this as part of his training to master all aspects of his art, 'For', as Leonardo states elsewhere,

'do you not perceive how many and various actions are performed by men only; how many different animals there are, as well as trees, plants, flowers, with various mountainous regions and plains, springs and rivers, cities with public and private buildings, machines, fit for the purposes of men, divers costumes, decorations, and the arts? And all these things ought to be regarded as of equal importance and value by the man who can be termed a good painter'.[140]

Leonardo detains us to this degree because his writings set the tone for those that follow in the next century or more. He is also more explicit about drawing from nature, the activity of merely recording the landscape clearly being held so low in esteem that it was not considered conducive to the improvement of the status of the artist, which was invariably of concern to those who wrote about their craft. His universality of interest was echoed by Ludovico Dolce, writing in the *Dialogo della Pittura* of 1557. Despite seeing landscape as an inferior form of art, he states that 'the painter must know how to represent the sheen of arms, the darkness of night, the light of day, lightning, fire, lights, waters, earths, stones, grass, trees, foliage, flowers, fruit, buildings, houses, animals and similar things so perfectly that they all form part of a living reality'.[141] Giorgio Vasari, although he frequently praises paintings and even relief sculptures for their *paesi bellissimi*, is not specific about artists drawing out of doors, directly from the landscape, although he sometimes states that works depict particular cities and landscapes *di naturale*, a term that is loosely applied throughout the literature – and in all languages, including the Dutch phrase '*naer het leven*' – to any scene that is lifelike because based on nature.[142] But in one instance, at least, Vasari comes close, when relating how Alesso Baldovinetti, an artist we have already

encountered, 'took much delight in making landscapes, copying them from life and from nature, precisely as they are'.[143] Sadly, little of Baldovinetti's work survives and (of course) none of his landscape drawings.

Vasari's *Lives* were to inspire Karel van Mander (1548–1606) to write his *Schilder-Boeck*, first published in 1604, with detailed lives of northern artists as well as a theoretical section, on 'The foundations of the noble and free art of painting' (*Den grondt der edel vry schilderconst*). His text has been studied before, not least the passage quoted above concerning Bruegel's drawings of the Alps, with a view to establishing that sketching from nature had been current by the time Dutch artists put theory into practice in the early seventeenth century. But as has occasionally been suggested, theory rarely precedes practice, and a thorough reading of his lives of northern artists appears to confirm our thesis that drawing from nature was far from unusual in the sixteenth century.[144]

The passages that have already been focused on reveal that Van Mander (and in one case, his fellow-artist P. C. Ketel) believed that artists should sketch nature. In a marginal note at the beginning of Van Mander's chapter on landscape, he encourages painters to 'go early out of town to see nature, and to amuse themselves with some drawing'.[145] In the same chapter he states, in the context of perfecting an art that comes from the spirit (*geest*): 'Also one should try, continually, whether from nature or from pleasant works of art, to draw in ink and wash on coloured paper, leaves in swaying movements'.[146] In Ketel's text, part of a laudatory introductory poem entitled the 'Landscape Painter Song' (*Landtschap-Schilder-Liedt*), that introduces Van Mander's book, the function of such drawings is finally spelt out. The youthful painter should take 'charcoal and chalk, pen, ink and paper, to draw what you see', and at the end of the poem 'return to the town', and at home look at 'all you saw here outdoors, which you have recorded in your book, adhere to such landscapes with the colours you grind, bring it to life'.[147] Thus the sketches from nature were merely the raw material for proper works of art, precisely as we have noticed is the case for other artists, from Fra Bartolommeo to Van Dyck.

Van Mander makes no claim that there was anything novel about this practice, and in the 'Lives' he names several painters who had studied the landscape and drawn directly from nature. Lucas van Leyden is praised as a prodigy, who 'never stopped drawing everything from life: faces, hands, feet, houses, landscapes'.[148] In a more unorthodox passage in the life of Jan den Hollander (probably Jan van Amstel) he writes: 'I am very well informed and convinced that he was a very distinguished master in landscape… He painted in oils and watercolour. He spent a lot of time leaning out of the window and looking at the sky, so as to make everything after life'.[149] But other artists ventured further, including Jan van Scorel, celebrated for drawing views in the Holy Land. Already as a youth, 'During the afternoons of Sundays and days off Schoorel usually went out of Haarlem to where there used to be a pleasant wood and he copied the trees in colours, very subtly and vividly, differently from the usual way of other painters'.[150]

Similar tales are told by Van Mander of other painters, including both Lucas and Maerten van Valckenborch, who after the first part of the Dutch Revolt in 1566, 'moved, with Hans van Vries among others, to Aachen and Liège where they did much from life, since along the Maas and around Liège there are many attractive stretches of countryside'.[151] Further artists specifically stated to have drawn from life include Hendrick van Cleef, Lucas de Heere, Jacob Grimmer, Pieter Balten, Joris Hoefnagel and Abraham Bloemaert, whose abilities as a landscapist are praised by Van Mander 'for he does a great deal after life, having a very clever manner of drawing and penmanship to which he then adds some watercolours so that it looks particularly good'.[152]

With such an abundance of information from Van Mander, combined with the significant increase in the number of drawings from nature that survive from the first half of the seventeenth century, including those by Van Dyck, there is little need to dwell at length on the many later references by other writers to such drawings. Suffice to say that they include Samuel Ampzing (1628), who like his contemporary Constantijn Huygens can be seen as something of a promoter of the new Dutch styles of landscape being practised in Holland, based on the local terrain of Haarlem, for Ampzing the birthplace of landscape painting.[153] Giovanni Baglione (1642, quoted in cat. 27 below), Edward Norgate (1649), whom we have already had cause to quote above, Samuel van Hoogstraten (1678) and Arnold Houbraken (1719–21, quoted in cat. 41 below) also refer to the practice. Of perhaps especial interest is Willem Goeree

(1697), firstly because he repeats Leonardo's description of the contraption that assisted in the exact copying of nature onto a piece of glass, as if little had changed; and also because he recommends that the artist spend two to three days each year making landscape drawings from nature.[154] Houbraken was later to record that Adriaen van de Velde (1636–72) drew in the countryside once every week,[155] and doubtless the practice saw a gradual increase in popularity, one that might be traced, were more data available, from the fifteenth century until the nineteenth.

The sources also reveal that the status of landscape painting underwent a substantial improvement during the sixteenth and early seventeenth centuries, a progression that has been investigated elsewhere.[156] From being viewed only as diversion or an accessory of art, it began to be recognized, by the time it was mentioned by Marc Antonio Michiel in his notes on the Grimani collection made in 1521, as an independent genre. In Michiel's *Notizia d'opere di disegno*, he lavishes praise on landscapes and passages of landscape that he had seen in the work of northern, north Italian and Venetian painters.[157] By the mid-sixteenth century, this had become a commonplace, although landscape was never to enjoy the status of history painting. For example, Vasari was content to describe the honour brought to his craft by paintings that included landscape. Perugino, for example, created a painting with 'a landscape then held to be most beautiful'; Correggio's painting of *Venus* showed her 'in an admirable landscape. No Lombard ever made these things better than he'; Raphael painted a *Madonna and Child* in 'a landscape, which is singular in every perfection, and very beautiful' – the examples are numerous.[158]

Nevertheless, despite the praise that Vasari and others might accord to landscape specialists such as Hans Bol and Jacob Grimmer, the most fulsome encomiums are reserved only for landscape as 'background', or for finished landscape compositions that include historical subject-matter. Certainly this was the case for writers such as Cristoforo Sorte, who in 1580, in his *Osservazione nella pittura* published in Venice, was the first to discuss landscape systemati-cally,[159] as well as for Lomazzo and for Van Mander, who devotes a substantial chapter to landscape.[160] It was also the view of the anonymous compiler of the *Short Treatise on Perspective* written in England at the end of the sixteenth century (already

mentioned on p. 12), for whom landscape was only relevant as an accessory.[161] It was again true for Giovanni Battista Agucchi, who in around 1602 wrote a detailed programme for a *Landscape with Erminia and the shepherds*.[162] In 1678 Samuel van Hoogstraten, in the chapter on landscape in his *Inleyding tot de hooge schoole der schilderkunst*, acknowledged that artists such as Herri met de Bles and Patinir had brought landscape 'to a high level', but retains the old hierarchy, which finally collapsed only in the nineteenth century.[163]

The exceptions to this general rule among the written sources are almost non-existent, and generally reserved for discussions of just one artist, Pieter Bruegel the Elder. For instance, Karel van Mander records that Dominicus Lampsonius, who held the landscapes of Jan van Amstel in high regard,[164] believed Bruegel (who, among others, bore 'the palm of landscape')[165] merited praise no less than any other artist.[166] Abraham Ortelius secured Bruegel's reputation by comparing him, in an *album amicorum* of 1574, to Eupompas, the Greek painter of the fifth century BC mentioned in Pliny's *Historia Naturalis*.[167] Another antique landscapist mentioned by Pliny was Studius, or Ludius, a Roman fresco painter of the first century AD. These figures served as precedents in creating a 'niche' for landscape artists from the sixteenth and seventeenth centuries.[168] But generally landscape continued to be regarded as one of art's accessories or *parerga* (the term used by Pliny);[169] it was necessary for the painter to master it and, if he succeeded, he could receive due praise for it; but it should not form the central plank of his art. It is also taken for granted by these writers that in their finished works, artists should choose only what is beautiful, enhancing the beauty of nature through their imaginative powers.[170] Only a sculptor – most famously Michelangelo – could scorn the genre altogether, but the remarks attributed to him by Francisco de Hollanda were made in the context of the lively debate concerning the superiority of either painting or sculpture, landscape being of only marginal interest to the latter art (and for his negligence of landscape Michelangelo was gently criticised by Vasari).[171] If Michelangelo's imaginative powers were incapable of inventing a landscape, it must surely be because he, unusually, did not make drawings from nature.[172]

The overriding consideration in the context of drawings from nature is that the art of landscape was only worthy of consideration

if its ambition, far from slavishly copying nature, was to improve on nature.[173] A mere 'copy' or description of an existing view of trees or fields enjoyed no status at all in the hierarchy of art. They were not made from *ingenio*, as conceptions from the artist's own imagination, or what Federico Zuccaro termed the *disegno interno*.[174] It is therefore all the more surprising – and supportive of our thesis – that Federico should have made such drawings at all (see fig. 36). This failure to register in the hierarchy of art is of course precisely why sketches from nature are rarely mentioned in the sources, and why, more than most types of drawing, they have disappeared: they were of no value, either to other artists or to the few 'amateur' drawings collectors of the time. Attitudes to drawings in general made their survival hazardous, if we are to believe Edward Norgate's report of Van Dyck: 'the long time spent in curiouse designe he reserved to better purpose, to be spent in curious painting. For when all is done, it is but a drawing, which conduces to make profitable things, but is none it selfe'.[175] An apprentice, if he were to copy landscapes at all, might have been put to copy prints of landscape, or landscape compositions in other media; but he would not be encouraged to copy a *plein air* sketch. This was a type of drawing he could do for himself, from nature. So when the time came to sort out the mass of material left behind in a deceased artist's studio, the sketches from nature, doubtless often slight (like the Van Dyck drawing, here fig. 16), would have naturally become a casualty in the harvest, or subsequently. The group of drawings by Fra Bartolommeo forms one of the rare exceptions to this general rule; in the case of Federico Barocci, as we have been able to document, his inheritors must have been considerably more ruthless. Yet for many artists they must all have been destroyed.

As so often, it is the prints of the period that reveal most, in this case about the status of the naturalistic landscape. The low esteem accorded such works is mirrored by the fact that it was not until 1559, when Hieronymus Cock published the first part of the series of views after the so-called Master of the Small Landscapes (see fig. 39), that anything became available in print to show how an 'ordinary' landscape might be approached. After the completion of the set in 1561, no more compositions of this type were engraved until the next century. Presumably there was insufficient demand to commission further plates of this type. What subsequently happened is of interest: in 1601 the same set of plates was reprinted, presumably because the publisher, Theodoor Galle, believed there was now a market for them.[176] He described them as based on drawings by Cornelis Cort, which as we have seen is almost certainly wrong. This suggests, perhaps, that in the intervening years they had suffered enough neglect to lose their author's identity; and Galle presumably did not feel that new plates or designs were necessary. Eleven years later, another interesting development occurs: Claes Jansz. Visscher published copies after the set; and doubtless wishing to promote their marketability, he claimed that they were designed by Pieter Bruegel the Elder. He also wrote that they were published 'for the benefit of painters' (*in pictorum gratiam*), an indication that artists, at least, might now value them. Presumably these sold well, for within one year, in *c*.1612–13, Visscher published fresh designs in the form of his now celebrated set of twelve prints depicting landscapes near Haarlem, the *Plaisante plaetsen*.[177]

The publication of Visscher's copies after the Master of the Small Landscapes in 1612 precisely coincides with that of another work that has repercussions for our topic: the second edition of Henry Peacham's *The Art of Drawing with the Pen and Limning in Water Colours*, first published in 1606. As has been well documented, the two editions differ in one important respect: Peacham adjusts his view of the genre from having only a subsidiary rôle as background to acknowledge it as a separate mode of art. Whereas in the first edition he had written of landscape, 'Seldome it is drawne by it selfe, but in respect & for the sake of some thing els, wherfore it falleth out among those thing[s] that we call *Parerga*', in 1612 he wrote, 'If it be not drawne by it selfe or for the owne sake, but in respect, and for the sake of some thing else, it falleth out among those things which we call *Parerga*'.[178] The alteration suggests that landscape was gaining independent recognition, even if other writers still retained the old hierarchies until the nineteenth century.[179]

Later developments need not be examined in detail, because a veritable deluge of independent landscape paintings, prints and even drawings survives from the second decade of the seventeenth century, revealing that this type of work had been accepted into the canon of high art, albeit at a lower level than history painting.[180] Whether in Rome, among the classicising followers of the Carracci, or among the foreign painters active there in a more naturalistic

vein, or in Flanders and Holland, where many concentrated on the 'vernacular' style, landscape became a major preoccupation for many studios in Europe. Landscape paintings (always of course finished compositions) hang side by side with biblical and other history paintings in the many ideal galleries depicted by Flemish artists from the first quarter of the century[181] (in Teniers' painting in Brussels of 1651, the Archduke Leopold Wilhelm is actually shown studying the drawings rather than the paintings on the walls, another interesting development),[182] and landscape painters are accorded full acknowledgement, whether by a connoisseur such as Huygens, by biographers like Cornelis de Bie or, as we have seen, in the pages of Van Dyck's *Iconography*.[183] Norgate wrote that landscape was 'an Invention of these later times, and though a Noveltie, yet a good one, that to the Inventors and Professors hath brought both honour and profitt'.[184] Even the French Academy, founded in 1648, finally admitted Étienne Allegrain in 1677 as a member who specialized in landscape.[185] All this ground has been covered before. What has hitherto escaped attention is the fact that in the realm of the drawing, the sketch from nature was nothing new, and had informed the appearance of painted landscapes since the fifteenth century. By the time of Van Dyck it had gained a respectability that it had previously been denied; he and others might sign them (perhaps they could be given to friends or even sold),[186] and a wide range of styles of landscape sketching was being practised. But many of these styles, though from different parts of Europe, grew from similar roots, as I hope that this catalogue reveals.[187]

Other pressures were exerted in the same decades that led to greater respect being accorded to sketches from nature, and in turn to improved chances of their survival. One we have already mentioned: that the aesthetic distinction between the preliminary sketch and the finished painting narrowed, especially in the northern Netherlands, with the advent of the naturalistic, locally based landscape painting, although as the drawings and the paintings based on them by Domenichino and others in this catalogue reveal, this narrowing was not unique to Dutch art. The gap between the preliminary sketch from nature and the finished work, being less wide than before, allowed the drawings to assume greater significance than had previously been the case.[188]

Coincidentally, there was a gradual increase in the number of drawings collectors. Apart from a few isolated examples, the vast majority were artists, until well into the seventeenth century, although a few amateurs are recorded in the sixteenth;[189] and in landscape both categories of collector would primarily have sought out finished compositions. In the seventeenth century the numbers of both collecting types grew (for prints and drawings), increasing demand not only for topographical work done as if 'from life' but also for drawings generally, allowing their status to develop along with a market for them, creating tastes that would embrace some of the categories of work that had previously been overlooked.

The improvement in the status of landscape art in general should perhaps also be related, more forcefully than usual, to the religious controversies of the time, and not merely to the the (not uniquely) Calvinist wisdom that every detail of God's earth exhibits His hand (the reasons usually stressed are given above, on p. 30).[190] Calvin would hardly have inspired artists in Roman Catholic states, where landscape was also being re-evaluated. But the doctrinal debates on both sides of the Catholic-Protestant divide, whether at the Council of Trent or in the Remonstrant versus Counter-Remonstrant controversies within the Calvinist community in the north, overshadowed too by the iconoclasm of the later sixteenth century, undoubtedly forced painters and their audience onto their back feet, helping to explain the insipid, 'politically correct' academicism of much that was produced from Rome to Amsterdam at the turn of the seventeenth century. Artistic freedom had come under pressure, from the inquisitional trial of Paolo Veronese in Venice in 1573 to the secular prosecution of Torrentius in Amsterdam in 1627. The case for 'falling back', as it were, on landscape, both for the artist and the consumer, was a strong one, landscape being the art form, as Norgate famously stated, 'of all kinds of painting the most innocent, and which the Divill him selfe could never accuse of or infect with idolatry'.[191] This passage raises wider questions than can be answered fully here, and was written at the time of renewed Puritan iconoclastic attacks in England. But the idea that landscape could be a refuge, for both painters and collectors, from doctrinally contentious iconographies seems persuasive.[192]

Another insufficiently acknowledged spur to the appreciation of landscape art must surely have been the marked growth in the urbanization of Europe in the early seventeenth century.

Fig. 42 Thomas Gainsborough, *Landscape with a waggon in a glade*, watercolour and gouache over black chalk, 237 × 317 mm. London, British Museum (1899–5–16–10).

Immigration ensured that nowhere did the towns grow faster than in Holland, and nowhere else did landscape painting see a more rapid increase in popularity, along with Dutch literary paeans to the countryside, the *Hofdichten* or 'country-house poems' among them. The expansion of the towns, by no means restricted to the Netherlands, combined with the greater exploitation of the surrounding terrain for the peat and other industries, led inexorably to a longing for and greater appreciation of the countryside, a development that continues to this day as manifested by our national parks and protected areas.[193]

In summary, we can state that for their landscapes, no less than for their study of the human figure, artists relied from as early as the fifteenth century on the direct study of nature, and that sketching out of doors would have been regarded as a necessary exercise to this end, one that had become unexceptional in Italy as well as the north of Europe by the period of Fra Bartolommeo.[194] The sketches themselves only occasionally survive before the seventeenth century, as they lacked any pedagogical or commercial value.[195] By the time Van Dyck made them, such drawings had begun to develop a degree of respectability, partly as a result of the improved status of landscape painting, which can be charted through the written sources and through published engravings and etchings, and partly because finished paintings were beginning to resemble the sketches more closely. This meant that Van Dyck and his contemporaries, as well as making landscape paintings and compositions in other media, might even sign informal drawings from nature, as are at least nine of his own works in this catalogue.[196] Although Dutch artists may have been the most dedicated landscapists in the first part of the seventeenth century, and before, they were not alone in their commitment to drawing from nature, and since the 1460s, when the practice probably began to take root in Italy, had never been so. For Van Dyck's contemporary, Henry Peacham, who as a member of Arundel's circle must have known the artist, it was possible not only to promote landscape but even to recommend sketching as a worthy pastime for the nobility in his *The Compleate Gentleman* of 1622 (long before the practice is noted by John Evelyn in his diaries), which in the later editions of 1634 and 1661 has his *Graphice* bound in with it.[197]

This is not to suggest that there was no development of style within the genre of the landscape sketch from nature in the early seventeenth century; nor an increase in the importance attached to the practice. The particular concentration on the study of atmospheric effects, and on subtleties of tone, rather than on topographical exactness, can be observed in the works included in this catalogue. But Van Dyck's *plein air* sketches can now be understood in the context of a long and distinguished tradition in which his drawings stand comparison with the finest achievements of a class of work that stretches back into the fifteenth century. Only in Van Dyck's own time, however, did these fragile and ephemeral records of natural form come to be admired for their intrinsic beauty, a development that relates them not only to the development of landscape painting, but also to that of man's intellectual advance from traditional patterns of emulation and copying towards a more empirical analysis of the physical world.

The encapsulation, in Van Dyck's drawings, of atmospheric mood, was equalled by few of his contemporaries; but the style, especially of his watercolours, was reconstituted towards the end of the eighteenth century by Thomas Gainsborough, John Constable, Thomas Girtin and J. M. W. Turner, and was ultimately destined to act as a foundation-stone, along with elements derived from other sources, including Rubens, of the Romantic and even post-Romantic vision of landscape. The sketch from nature was to beget the *plein air* study in oils, probably born in the first half of the seventeenth century, although examples from before the eighteenth century are hard to find.[198] And from these beginnings finally emerged the Impressionist art of the later nineteenth century. But in the intervening years, Van Dyck was always held in high regard by his fellow artists. None more so than Thomas Gainsborough, whose landscape watercolours (see fig. 42), as well as his commissioned portraits, stand in Van Dyck's debt. Gainsborough's drawings, with their direct and vivid handling and colour, assist in defining the qualities that separate Van Dyck from many of his contemporaries, and from Rubens. Perhaps Gainsborough's supposed dying words, uttered to Joshua Reynolds, form the most fitting tribute with which to close a text devoted to the Fleming in his 400th anniversary year: 'We are all going to Heaven, and Vandyck is of the company'.[199]

1 Ulrike Hemschke, *Die flämische Waldlandschaft. Anfänge und Entwicklungen im 16. und 17. Jahrhundert*, Worms, 1988, pp. 167–70, points out that Alciati calls the oak tree 'Jupiter's Tree', and includes one among various emblems of 'Concordia', with a wind storm that cannot destroy it, and that the tree is also found as a symbol of virtue.

2 A landscape painting in the Dulwich Picture Gallery, based on a composition by Titian, was published as by Van Dyck by Jaffé, 1966a, together with a related drawing at Chatsworth. The latter has been rejected by A. C. Sewter and D. Maxwell White, 'Variations on a theme of Titian', *Apollo*, XCV, 1972, pp. 88–95. They however draw attention to Van Dyck's study of the foreground figure from Titian's composition on folio 36 of his Antwerp Sketchbook. Recent cleaning (1998) has revealed the painting to be of indifferent quality, probably the work of another pupil of Rubens, whose style it approaches more closely than Van Dyck's.

3 F. J. van den Branden, 'Verzamelingen van schilderijen te Antwerpen', *Antwerpsch Archievenblad*, vols XXI and XXII. The details are repeated by Vey, p. 52, based also on J. Denucé, *De Antwerpsche 'Konstkamers'. Inventarissen van kunstverzamelingen te Antwerpen in de 16e en 17e eeuwen (Bronnen voor de Geschiedenis van Vlaamse Kunst, II)*, Antwerp, 1932, with additions from the same author's *Kunstuitvoer in de 17e eeuw te Antwerpen. De Firma Forchoudt (Bronnen voor de Geschiedenis van Vlaamse Kunst, IV)*, Antwerp, 1931, p. 151 and N. de Pauw, 'Les trois peintres David Teniers', *Annales de l'Académie Royale d'Archéologie de Belgique*, 1897, p. 352.

4 B. Reade, 'William Frizell and the Royal Collection', *Burlington Magazine*, LXXXIX, 1947, p. 73. The Whitehall inventory gives the measurements as 46 × 36 in (see O. Millar, *The Tudor, Stuart and early Georgian pictures in the collection of Her Majesty the Queen*, London, 1963, I, p. 92).

5 Van den Branden, *op. cit.* (n.3 above), vol. XXII, p. 23.

6 Bellori, 1672, p. 263, lists their subjects as *The dance of the muses with Apollo on Parnassus, Apollo flaying Marsyas, The Bacchanals* and *Venus and Adonis with dancing cupids*. Only the *Cupid and Psyche* survives (here fig. 14).

7 For an introduction to Rubens' landscape paintings and drawings, see Brown in Exh. London, 1996–7.

8 British Library Sloane MS 536, this extract published by Ogden and Ogden, 1955, p. 2. J. Müller Hofstede, 'Zur Interpretation von Pieter Bruegels Landschaft: Aesthetischer Landschaftsbegriff und Stoischer Weltbetrachtung', in *Pieter Bruegel und seine Welt*, Berlin, 1979, pp. 73–142, describes how ancient writers (Livy, Cicero and Pliny) informed sixteenth-century descriptions of landscape, with a distinction between ordinary vistas and topography. Peacham, 1606, p. 28, in defining landscape, lumps all these features together. (See also p. 48 below and Gombrich 1971, as well as A. Boström, 'The acquisition of Flemish landscapes for Italy or the Antwerp art market', *Nederlands kunsthistorisch jaarboek*, XLVIII, 1997, pp. 9–21).

9 *Miniatura*, 1649, 1997 edn, p. 84 (with an extensive footnote on pp. 162–4).

10 See Martin Hardie, *Water-colour painting in Britain*, I, London, 1966, p. 57 on Van Dyck's contribution.

11 See Held, 1959, under no. 131, in which he states that 'a disturbing feature is the fact – in my opinion undeniable – that the writing in pen and ink is not in Rubens' own hand'. In the second edition of the book (1986, no. 116) Held is less dogmatic but remains convinced of Rubens' authorship of the drawing.

12 Arnout Balis, currently working on Rubens' so-called Pocket-Book, knows that artist's handwriting well and is convinced that the Chatsworth drawing is not annotated by him. He agrees that the drawing, and thus the handwriting, is by Van Dyck (as he kindly informed me by telephone early in 1998). He rightly points in particular to the writing on a drawing in Chatsworth, Vey 103, in which much of the character of the handwriting reappears, as also to Vey no. 93 in the Rijksmuseum, although the hand is there somewhat more florid. Some of the characters in the inscription on another drawing at Chatsworth (inv. 986; Vey 98 *verso*, with *Studies for Peter and Malchus*) are also close to those here. For the opinion of Dr Katlijne van der Stighelen, who agrees with this assessment, see cat. 1, n. 4.

13 Arnout Balis, in two ground-breaking texts, has begun to challenge this view of Rubens (see Balis 1986 and 1993), noting that Rooses believed that in all the hunting-scenes Rubens was assisted by pupils (1986, p. 36).

14 Listed as 'Circle of Van Dyck' by Kloek, 1975, no. 433. The drawing featured in the Uffizi inventory of 1793 as *Vandic*. To my knowledge it has not otherwise been discussed. I am grateful to Giovanni Agosti for his help in Florence.

15 Adler, 1982, no. 26, fig. 75, generally dated between 1612 and 1619. The involvement of Van Dyck would suggest a date towards the end of this range.

16 Recent opinions are summarized in Adler, 1982, pp. 104–6 (his no. 27a, fig. 81) and Held, 1986 edn, pp. 14–15 and n.6. K. Renger, *Kunstchronik*, XXXI, 1978, p. 135, is now alone in attributing this drawing to Rubens. Adler, *loc. cit.*, describes it as a copy after a lost original by Rubens.

17 The signature is accepted by Held, 1986, p. 14. On a recent inspection at Chatsworth I was not convinced of its genuineness.

18 Adler, 1982, no. 27, fig. 77; the date is suggested by Held, 1986, p. 14.

19 The more painterly line of the British Museum copy (fig. 7) appears more 'Rubensian' than the Chatsworth sheet, although its quality speaks for a studio hand. The idea that it depends on a now lost copy by Rubens cannot, however, be discounted. Another drawn copy is also in the same collection (pen and brown ink, 315 × 517 mm; Hind 122, Adler, 1982, no. 27b(3), fig. 83). It omits the two beasts sketched in outline to the upper left of the other versions, as well as the indication of a cow at the top right, above the micturating one. By a more mechanical hand, this is the closest in detail to the engraving by Pontius (fig. 8; C. G. Voorhelm Schneevoogt, *Catalogue des estampes gravées d'après Rubens*, Haarlem, 1873, p. 238, no. 65). Made in 1649, the print belongs to the set, said in the title-page to be after Rubens, that make up the *Livre à dessiner*, but it cannot have formed the basis for the drawings already mentioned (nor for the drawing formerly in the Northwick collection, Adler, 1982, no. 27b/4) as it shows the composition in reverse. It, too, omits three of the peripheral animals seen in the Chatsworth drawing and in the better of the two versions of the British Museum (fig. 7).

20 Held, 1959, under no. 131, dates the Courtauld drawing by association to *c*.1617–19, and is followed by Adler, 1982, no. 71, although as he points out, other writers had thought the drawing later. Held, 1986, no. 226, dates the British Museum drawing *c*.1635.

21 As pointed out again recently by Muller and Murrell in Norgate, 1649, 1997 edn, n. 304.

22 Held, 1959, I, p. 15, Vey pp. 19–20, White in Exh. London, 1987, p. 23 and Muller, 1990–91, p. 36, n. 49. See Norgate, 1649, 1997 edn, with this passage on p. 108.

23 Some further comparisons with Van Dyck are made in the relevant catalogue entries. For the handwriting, compare also the sheet of *Costume studies* on folio 8 *recto* and 120 *recto* of the Italian Sketchbook (on which see Adriani, 1940); on the latter folio compare individual characters such as the 'm' of 'dalmatia' and the 'k' of 'koetcino', with those on the Chatsworth drawing (here cat. 1). Analogies are also found in the short inscription on no. 6 of the present catalogue.

24 For the series, in which Van Dyck's participation is recorded by Bellori as well as a document of 1661, see recently Susan J. Barnes, 'The Young Van Dyck and Rubens', in Exh. Washington, 1990–91, pp. 17–26, especially p. 20, and (particularly for the iconography) E. McGrath, *Rubens. Subjects from History. Corpus Rubenianum Ludwig Burchard*, XIII (I), I, London, 1997, pp. 74–81.

25 The Berlin drawing has been generally dismissed as a copy after Rubens, on the mistaken understanding that the architectural motifs on the *recto* are in some way related to his later work in the Jesuit Church in Antwerp (H. G. Evers, 'Zu einem Blatt mit Zeichnungen von Rubens im Berliner Kupferstichkabinett', *Pantheon*, XIX, 1961, pp. 93–7 and 136–40). In fact the comparison is only generic and far from convincing, and the drawing style suggests anything but a copy. Another full discussion of the drawing is in Exh. Berlin, 1977, no. 54, where it is described as a copy. Adler, 1982, no. 18c, figs 59–60, captions it 'Rubens?', but in the text states that the parts of the drawing related to the Dresden *Boar hunt* are 'recollections or copies by another hand'.

26 Compare, for example, the central paragraph of folio 7 and of folio 33 of the Antwerp Sketchbook published by Jaffé, 1966.

27 Vey 2. The drawing is also discussed by Brown in Exh. New York–Fort Worth, 1991, under no. 9.

28 Magurn, 1955, p. 57; quoted, among others, by Balis, 1993, p. 105.

29 See M. J. Bok in Exh. San Francisco–Baltimore–London, 1997–8, p. 87 (with further literature). Van Buchell's text reads: 'Ille artem et ingenium Rubenii elevabant, plus illi profuisse fortunam quam industriam sustinebant. Eius plura in aes incisa prodibant a quondam Vorstermanno in aedibus eius operata, sed nimis illa care vendebantur et longe supra communem modum, minima nempe in dimidio folio flor'. See J. W. C. van Campen (ed.), *Aernout van Buchell. Notae Quotidianae. Werken uitgegeven door het Historisch Genootschap*, series 3, vol. 70, 1940, p. 2.

30 Balis, 1993, argues that this was the case (see also n. 13 above).

31 Quoted from Exh. Boston–Toledo, 1993–4, p. 33.

32 Houbraken, 1753 edn, p. 69: ... *dat hy veele Leerlingen in zyn tyd heeft aangekweekt, die hy tot schilderen van kleederen, gronden, verschieten, gebouwen en andere sieraden, ook wel tot het aanleggen der naakten, gebruikte,*

33 Balis, 1993, pp. 98 and 107, referring also to Van Mander, *Grondt*, fol. 250, and Houbraken, II, p. 294. In the *Lives* Van Mander states that Hans Bol emerged from the more than 150 workshops for canvas painting in Malines (fol. 260r). These were already well established, and as early as 1492 a Medici inventory refers to some large Flemish landscapes on canvas (D. Wolfthal, *The beginnings of Netherlandish canvas painting 1400–1530*, Cambridge, 1989, p. 19; P. Nuttall, 'The Medici and Netherlandish Painting', in F. Ames-Lewis (ed.), *The early Medici and their artists*, London, 1995, pp. 135–52).

34 Rubens' correspondence with Carleton suggests that the painter normally divided his work into (a) wholly autograph, (b) collaborative and (c) works only retouched by him. See further Sutton in Exh. Boston–Toledo, 1993–4, pp. 34–5, where he also shows that Snyders was given increasing independence when executing work for Rubens. Van Dyck was not only called by Rubens his 'best disciple', but in the contract for the ceiling of the Jesuit church in Antwerp Van Dyck was the only assistant mentioned by name. That he should be given as much or more freedom than Snyders seems probable (see *op. cit.*, p. 45).

35 Giorgione and Titian also worked together – see, for example, the *Notizia d'opere di disegno*, by Marcantonio Michiel (1486?–1552), Ch. 7, section 60, p. 66, who refers to the Dresden *Venus* as a painting which *fu de mano de Zorzo da Castelfranco; ma lo paese e Cupidine furono finiti da Tiziano.* Giorgione's death led Titian to complete some of his master's work.

36 Of the landscapes in Vey, I cannot accept the following as belonging to the corpus of Van Dyck's drawings: the *Landscape with a road* in the British Museum (Vey 286; possibly by two hands, but neither is convincing as Van Dyck,

and the landscape on the *verso* is wholly removed from him), the *Landscape with a hill near water* in Hamburg (Vey 285, which may be by the same hand as Vey 286; Vey describes it as a copy after Van Dyck), the *Wooded hill* in Oxford (Vey 295, also described as a copy by Vey but perhaps less directly related to Van Dyck), the *Trees and bush by a slope* now in the Metropolitan Museum (Vey 299 as a copy, which I would again see as only indirectly related to Van Dyck), and the watercolour *Landscape with a small wood* at Chatsworth (here fig. 21; Vey 305), which I believe to be a copy after a lost drawing by Van Dyck (see further the main text above). For the *gouache* landscapes traditionally connected with Van Dyck, see cat. 58, and for a reworked but autograph drawing of Rye, see cat. 15, fig. 15b. The damaged drawing of *Trees on an embankment* from the Van Regteren Altena collection, traditionally attributed to Van Dyck, seems closer to the circle of Poussin and Claude (see Exh. Rotterdam–Paris–Brussels, 1976–7, no. 49, pl. 105).

37 L. van Puyvelde, *Van Dyck*, Amsterdam and Paris, 1950, p. 186 states of the landscape drawings 'il les fit pour le plaisir de dessiner'. Buijsen, 1992–3, studying a Van Goyen sketchbook of *c*.1648, noted that one quarter of the 144 sheets it contains can be related to a finished work (which seems to me a high proportion).

38 According to Horace Walpole, *Anecdotes of painting in England*, II, London, 1786, p. 166, Van Dyck spent his summers at Eltham in Kent, where he could have made some of the landscape drawings.

39 Larsen 1043; see also Exh. Washington, 1990–91, no. 85.

40 The phrase 'pathetic fallacy' was coined by John Ruskin (*Modern Painters*, II, 1856, ch. 12).

41 See Exh. Haarlem, 1986, pp. 125–6 (with further literature) for the use of vines and clinging plants as symbols of love and marriage, and the origins of such visual symbolism in Andrea Alciati's emblematic literature. This symbolism has been noticed in the Van Dyck literature by J. Wood, 'Van Dyck's pictures for the Duke of Buckingham', *Apollo*, CXXXVI, 1992, pp. 37–47, especially pp. 43–4. Oppé, 1941, p. 189, noted the emblematic use of a dead tree in the *Cupid and Psyche*.

42 Acquired from the sale at Christie's, London, 6 December 1988, lot 170, repr., where it is stated that the attribution to Van Dyck was confirmed by Michael Jaffé and Horst Vey. I first saw it there, but am grateful to Sarah Thomas of the Art Gallery of South Australia for sending me details about the drawing, and to Julie Robinson for showing it to me there in 1997.

43 Cats 44 and 46. Compare also, for example, the drawing by Poelenburch of a *Rocky cliff with trees* now in Dresden, repr. Chong, 1987, p. 51, fig. 37.

44 Published by A. Seilern, *Flemish Paintings and Drawings at 56 Princes Gate London SW7. Addenda*, London, 1969, pp. 67–8, repr. figs xliv and xlv.

45 There is a striking similarity between the sketch and the background of Van Dyck's *Portrait of Justus van Meerstraten* in Kassel (Larsen 1015, fig. 382). Compare also the drawing, now attributed to Melzi, of a *Storm cloud above a landscape* in the Leonardo albums at Windsor, Clark and Pedretti, no. 12393.

46 See note 36 above.

47 See Schneider-Ekkart, 1973, p. 388, no. 420. The *verso* includes some figure studies that resemble the staffage in the British Museum drawing, Vey 286, which is rejected above (see n. 36).

48 Vey 305.

49 Last catalogued as Van Dyck by Hind, no. 81, and mentioned as his work also by Otto Benesch (*Gazette des Beaux-Arts*, 6th series, 1946, pp. 156–7), but G. Glück (*De Landschappen van Peter Paul Rubens*, Antwerp and Amsterdam, 1940, p. 19, fig. 11), Held (1959, no. 134 and 1986, no. 119), Burchard d'Hulst (1963, no. 73), Rowlands (Exh. London, 1977, no. 197) and Adler (1982, no. 73) all support the Rubens attribution. The lines of interlocking, snaking hatching below resemble those in another drawing with a borderline attribution, the *View of a pond* in Hamburg (Inv. 22445) which has been assigned to Rubens by Winner, 1985, pp. 85–96, repr. fig. 18, with previous literature. Among a group of drawings assigned by O. Benesch to Van Dyck ('Zum zeichnerischen Oeuvre des jungen Van Dyck', *Festschrift für Karl M. Swoboda*, Vienna, 1959, pp. 35–7, reprinted in Benesch's *Collected Writings*, ed. E. Benesch, II, London, 1971, pp. 318–22) is a *Landscape* in the Albertina (his fig. 264 in the later edition), but these attributions have not generally been accepted and the drawings are closer to the work of Franchois.

50 Other particularly fine passages of landscape occur, for instance, in the *Amaryllis and Mirtillo* in Pommersfelden (Larsen 735; Exh. Washington, 1990–91, no. 60) and in the *Allegory of Lady Digby as Prudence* in the National Portrait Gallery, London (Larsen A219/4; Exh. Washington, 1990–91, no. 64).

51 Exh. London, 1982–3, no. 56.

52 Compare, for example, the portrait of *Anne, Countess of Clanbrassil* in the Frick collection (Larsen 814), from which the landscape was reused with differences in the *Duke of Hamilton* still in the ownership of the family (Larsen 856). It was repeated by David Scougall in his portrait of the *3rd Earl of Lothian* (Marquess of Lothian collection), as pointed out by Millar in Exh. London, 1982–3, under no. 60.

53 See Cust, 1900, pp. 138–9.

54 For this oft-quoted passage, see Sandrart, 1925 edn, p. 209: *Ein andermal sind wir* [i.e. Sandrart and van Laer] *Pousin, Claudi Lorenes und ich, Landschaften nach dem Leben zu mahlen oder zu zeichnen auf Tivoli geritten.*

55 Roger de Piles, *Abrégé de la vie des peintres*, Paris, 1677, pp. 142–3. Rubens' picture is thought possibly to have been

the *Drunken Silenus supported by satyrs* in the National Gallery, London (see Gregory Martin, *National Gallery Catalogues. The Flemish School circa 1600 – circa 1700*, London, 1970, pp. 217–25). See also Vaes, 1924, p. 180.

56 Miedema, in his 1973 edn of Van Mander, II, p. 409, notes that Italian artists in the sixteenth century employed landscape specialists from the Low Countries. Van Mander's master Pieter Vlerick (as a figure painter) and other Flemings assisted Muziano, e.g. at the Villa d'Este, Tivoli; Bartholomeus Spranger, the pupil of the landscapist C. van Dalem, executed landscapes for Alessandro Farnese at Caprarola in 1569–70; Jan Soens assisted Lorenzo Sabattini in the Sala Ducale of the Vatican; and both Jacopo Zucchi and Federico Zuccaro had Netherlanders in their workshop teams. Pieter Bruegel collaborated in Rome with Giulio Clovio, who owned a depiction of a tree in *gouache* by the former (see Exh. Berlin, 1975, p. 8). Later, Claude, Poussin, Dughet, Van Swanevelt and Both all contributed to a series of landscape paintings for Buen Retiro for Philip IV of Spain (as noted recently by Orr in Exh. San Francisco–Baltimore–London, 1997–8, p. 110).

57 Roger de Piles, 1708.

58 I touched on this theme, with some further literature noted, in *Simiolus*, XXIV, 1996, pp. 350–57.

59 See above p. 22 and n. 37. Several early writers viewed outdoor sketching expeditions as an enjoyable pastime for hours not otherwise employed. For example, in 1604, as noted below, Karel van Mander (*Den grondt der edel vry schilder-const*, Miedema ed., 1973, I, p. 203, margin), urged painters to 'go out of town early to see nature, and to enjoy themselves by doing some drawing' (*vroech buyten der Stadt te gaen, om te sien de natuere, en met eenē hun te vermaken met wat te teyckenen*). See also the quote from Malvasia concerning the Carracci mentioned below in n. 110.

60 To use the term (*bijwerk*) employed by Miedema, *op. cit.*, 1973, II, p. 536. The term is an old one, and was used in 1656 by Thomas Blount (see n. 179 below).

61 G. J. Hoogewerff, *De Bentveughels*, The Hague, 1952, lists northern artists working in Rome in 1617 and 1639. On Bril, see Baer, 1930 and recently L. Wood Ruby, *The drawings of Paul Bril: a study of their rôle in 17th century European Landscape*, diss. New York, 1997.

62 For a recent study of landscape in Rome in the seventeenth century, and its origins, see Chong, 1995 (with further literature). Fundamental is M. Chiarini, 'Filippo Napoletano, Poelenburgh, Breenbergh e la nascita del paesaggio realistico in Italia', *Paragone*, 269, 1972, pp. 18–34.

63 See further under cat. 55.

64 For a recent discussion, see G. Luijten in Exh. Amsterdam, 1993–4, cat. 342, with further literature.

65 The extent of the 'revolution' in Dutch landscape painting is rightly stressed by Simon Schama, 'Dutch landscapes: culture as foreground', in Exh. Amsterdam–Boston–Philadelphia,

1987–8, pp. 64–83, and in Dutch painting generally by J. L. Price, 'By their fruits shall ye know them: the cultural legacy of the Revolt', *De zeventiende eeuw*, X, 1994, pp. 47–56.

66 As stressed, among others, by J. G. A. Briels, *Vlaamse schilders in de Noordelijke Nederlanden in het begin van de Gouden Eeuw, 1585–1630*, Antwerp, 1987.

67 Quoted from Huygens' *Hofwyck*, line 1524, by Sutton, *op. cit.*, p. 13. See also H. Leeflang, in *Nederland naar 't leven*, Exh. Amsterdam, Rembrandthuis, 1993–4, pp. 24–5. Huygens was not unusual in seeing the Bible and nature as the two sources of divine knowledge; compare also the words of Francis Bacon that inspired the title of the present catalogue: 'The knowledge of man is as the waters, some descending from above, and some springing from beneath; the one informed by the light of nature, the other inspired by divine revelation' (from *Advancement of learning*, II, v, 1). Jacob Cats, in *Sorghvliet*, echoed Huygens' sentiments (as pointed out by Freedberg, 1980, p. 14). They were of course not new: Savonarola believed that beauty in the material world was a reflection of the divine (see Blunt, 1962, pp. 45–6). Clark, 1949, p. 25 quotes the sixteenth-century mystic, Sebastian Franck, who in his *Paradoxa* stated that in nature, like the sun, 'God dwells in everything and everything dwells in him'.

68 This paragraph owes much to Freedberg, 1980, especially pp. 11–15. Much of what he wrote there was revisited by Leeflang, 1997 (with further literature). Also worthy of note is Ake Bengtsson, 'Studies in the rise of realistic landscape painting in Holland 1610–1615', *Figura*, 3, 1952, pp. 16ff., and E. Spickernagel, 'Holländische Dorflandschaften im frühen 17. Jahrhundert', *Städel Jahrbuch*, N.F. VII, 1979, pp. 133–48.

69 For Vondel's *Aenleidinge Ter Nederduitsche Dichtkunste*, see the edition published by the Instituut de Vooys in 1977. His text was anticipated by several writers, including Roemer Visscher and Jacob Cats. See further, for example, L. van den Branden, *Het streven naar verheerlijking, zuivering en opbouw van het Nederlands in de 16e eeuw*, Ghent, 1956, and J. G. C. A. Briels, 'Brabantse blaaskaak en Hollandse botmuil. Cultuurontwikkelingen in Holland in het begin van de Gouden Eeuw', *De zeventiende eeuw*, I, 1985, pp. 12–36. Ampzing's position in this development was outlined by David Freedberg, 1980, p. 40, who describes how in his text of 1628 Ampzing encapsulates the replacement of the Arcady of Theocritus, Horace and Virgil with the local Dutch scene. Freedberg's summary (*op. cit.*, pp. 11ff.) of the cultural changes in Holland has also been plundered by me here. Also relevant is J. G. van Gelder, *Jan van de Velde 1593–1641*, The Hague, 1933.

70 More information on this topic is supplied in the catalogue entries. For a summary, see Ogden and Ogden, 1955, especially pp. 20–21, and G. Rubinstein, 'Artists from the Netherlands in seventeenth-century Britain: an overview of their landscapes', in S. Groenveld and M. Wintle (eds), *Britain*

and the Netherlands XI. The exchange of ideas: religion, scholarship and art in Anglo-Dutch relations in the 17th century, London, 1991, pp. 163ff. Houbraken, 1753 edn, II, p. 225, relates that a painter, Gerard Pietersz van Zyl, so admired Van Dyck that he moved from Amsterdam to live opposite him in Westminster in the 1630s. They became friends, Van Zyl often observed Van Dyck painting, and returned home after the Flemish master's death in 1641. Van Dyck's presence in London must have attracted other artists to England, including ones who sometimes painted landscapes.

71 Dated between *c*.1495 and 1508 by C. Fischer, *Fra Bartolommeo. Master draughtsman of the High Renaissance*, Exh. Rotterdam, 1990–91, p. 375. Westfehling, 1993, pp. 293ff., attempts to put these drawings in the context of studio practice in Renaissance Italy.

72 The adjective employed by Fischer, *loc. cit.*

73 E. Ridolfi, 'Notizie sopra varie opere di Fra Bartolommeo da San Marco', *Giornale Ligustico di Archeologia, Storia e Belle Arti*, V, 1878, p. 125.

74 As stressed above (see p. 12). Typical remarks are those made recently in the impressive book by C. S. Wood on *Albrecht Altdorfer and the origins of landscape*, London, 1993, p. 17, when stating of artists of Altdorfer's generation: 'For most painters of this period, there was really no need to venture out under an open sky'. On p. 151 he again stresses: 'Few painters in the early sixteenth century actually drew trees and flowers and mountains from life'. (He later tempers this, on pp. 204–5, by suggesting that 'they must have done so', although '*Plein-air* drawing was certainly no ordinary exercise'.) F. J. Duparc, in Exh. Cambridge–Montreal, 1988, p. 13, believed that P. C. Ketel's poem, mentioned below, was 'precocious' for suggesting that artists should draw from nature in 1604. W. T. Kloek, in Exh. Amsterdam, 1993–4, p. 102, suggests, perhaps referring only to Dutch artists, that 'It must have been around 1600 that the first artists set out into the surrounding countryside with a sketchbook in hand'. The purpose of part III of this essay is to challenge this (currently, it seems, universal) preconception. An overview of the history of drawing from nature is attempted by K. G. Boon, 1992. Wood, 1997, pp. 33ff., records many of the surviving early examples of landscape art, as does Leeflang, 1997, p. 83. He also discusses the woodcut illustrations in Jacob Bellaert's 1485 Dutch edition of the text of *c*.1260, *De proprietatibus rerum* (*Van de proprieteyten der dinghen*), the first landscape prints without a human presence, also investigated by J. E. Snyder, 'The early Haarlem school of painting', *Art Bulletin*, XLII, 1960, pp. 39–55, and *idem.*, 'The Bellaert Master and *De proprietatis rerum*', in S. Hindman (ed.), *The early illustrated book. Essays in honor of Lessing J. Rosenwald*, 1982, pp. 41–62. For topographical drawings, see for example, H. Egger, *Römische Veduten: Handzeichnungen aus dem XV. bis XVIII. Jahrhundert zur Topographie der Stadt*. 2. vols. Vienna, 1931–2, Exh. Amsterdam–Toronto, 1977, and Schatborn, 1995, all with further literature. T. Vignau-Wilberg, in Exh. Munich–Bonn,

1993, pp. 9–12, unites topographical with cartographical influences (also with further literature; see in particular J. F. Heijbroek and M. Schapelhouman (eds), *Kunst in kaart*, Exh. Amsterdam, 1989, and W. S. Gibson, '*Mirror of the earth*': the world landscape in sixteenth century Flemish painting, Princeton, 1989, chapter IV).

75 Granacci's *Joseph presenting his father and brothers to Pharaoh* of *c.*1515 in the Uffizi, many of Raphael's early, Peruginesque and Florentine-period paintings (let alone the more sophisticated backdrops to the later tapestry cartoons) and Lotto's *Susannah and the Elders*, also in the Uffizi, among many other of his works, should suffice as examples. A. Richard Turner, *The vision of landscape in Renaissance Italy*, Princeton, 1966, gives a general overview of developments in Italy, concentrating on some of the key artists. C. S. Ellis, 'Fra Bartolommeo, a problematic landscape drawing and the repetition of the painted landscape image', *Paragone*, XLVI, 1995, pp. 3–17, summarizes and extends our knowledge of workshop repetitions of successful landscape models.

76 See Paul Joannides, *The Drawings of Raphael*, Oxford, 1983, e.g. nos 33, 73, 260 and 350. The same author also accepts as authentic the outline sketch, clearly made from nature, of the *Sabine Hills* on the *verso* of a drawing recently on the London art market (sale, Phillips, 2 July 1997, lot 120, repr.).

77 From D. V. Thompson's translation of 1933, reprinted by Dover publications, Cennino d'Andrea Cennini, *The Craftsman's Handbook ('Il Libro dell'Arte)*, New York, 1960, p. 57. On p. 15, Ch. XXVIII, Cennini recommends drawing from nature, but it should be assumed that he was referring to the human figure.

78 K. Clark, 1949, remains the best general account, although J. Guthmann, *Die Landschaftsmalerei der Toscanischen und Umbrischen Kunst von Giotto bis Raffael*, Leipzig, 1902, and Buscaroli, 1935, include more detail on Italian landscapes. Clark, *op. cit.*, p. 21, focused on Baldovinetti (noting the *Nativity* in SS. Annunziata; his *Madonna and Child* in the Louvre of *c.*1460–65 might also be mentioned) and on Pollaiuolo. Piero della Francesca's landscape backgrounds can be placed in the same context. Giorgio Vasari, 1568, I, p. 271 gives more credit to Paolo Uccello for innovations in landscape, although also praising Baldovinetti (see Buscaroli, 1935, p. 124 and below, n. 143).

79 Compare also the larger scale background of the *Martyrdom of St Sebastian* in the National Gallery in London, NG 292, a work that was known to Raphael and Andrea del Sarto, who both copied details from it.

80 For a landscape drawing recently attributed to Perugino, see G. Goldner, 'New drawings by Perugino and Pontormo', *Burlington Magazine*, CXXXVI, 1994, pp. 365–7. B. Toscano, 'Una nota su paesaggio dipinto e paesaggio reale', *Paragone*, 501, 1991, pp. 20–34, reveals that particular sites influenced the appearance of Perugino's landscapes.

81 Bartolomeo Fazio in 1456 stated that Van der Weyden was in Rome in 1450. Some doubt has however been thrown on his trustworthiness and on the autograph status of the Uffizi painting. For a summary see Lorne Campbell in *The Dictionary of Art*, J. Turner (ed.), London, 1996, vol. 33, p. 127.

82 It has been argued, perhaps not entirely persuasively, that the Limbourg brothers were inspired by Sienese and Lombard art (see Otto Pächt, 'Early Italian Nature Studies', *Journal of the Warburg and Courtauld Institutes*, XIII, 1950, pp. 13–47). Buscaroli, 1935, p. 59, also argues that Italian sources were a dominant force in early Netherlandish landscape. For the stylistic changes in Netherlandish painting, perhaps the best account remains that by M. J. Friedländer, *From Van Eyck to Bruegel*, London, 1956.

83 Clark, 1949, p. 19.

84 The improvement of aerial perspective was a contribution of Leonardo (see Blunt, 1962, pp. 29–30).

85 Otto Pächt (ed. M. Schmidt-Dengler), *Van Eyck*, Munich, 1989, p. 87.

86 As noted, among others, by Clark, 1949, p. 18.

87 For the strong links between Netherlandish and Italian artists in the fifteenth century, when the latter viewed the landscapes of the former as paradigmatic, see K. Christiansen, 'The View from Italy', in *idem*. and M. W. Ainsworth, *From Van Eyck to Bruegel*, New York, 1998, pp. 48–9. Marco Boschini, in 1660, wrote of Van Dyck's admiration for Titian, as noted recently by Muller in Exh. Washington, 1990–91, p. 27. See also the biography, p. 8, under 1631. Van Dyck's posthumous inventory lists seventeen paintings by Titian, including the *Vendramin Family* (now National Gallery) and the *Perseus and Andromeda* (Wallace Collection).

88 Berenson, 1938, no. 1017; Popham, 1946, no. 253.

89 Berenson, 1938, no. 1859J. Other versions of the subject by Piero are in the Uffizi and discussed, by Gianvittorio Dillon, in Annamaria Petrioli Tofani (ed.), *Il disegno fiorentino del tempo di Lorenzo il Magnifico*, Exh. Florence, Uffizi, 1992, nos 10.2–3 (with further literature).

90 The depth of the problem of making generalizations is made manifest by a browse through Berenson, 1938, in which landscape is extraordinarily rare and the only fifteenth-century studies from nature illustrated are (including that here fig. 28) and an outline of a rose by Benozzo Gozzoli in the Uffizi (inv. 20F; Berenson no. 536). A search of B. Degenhard and A. Schmitt's *Corpus der italienischen Zeichnungen 1300-1450* produces similarly desultory results – a study of an *Iris* on folio 56 of Jacopo Bellini's Paris album (*op. cit.* Teil II. *Venedig. Jacopo Bellini. 6 Band*, Berlin, 1990, p. 387, colour plate IV). This is compared to Dürer's drawing of the same plant by U. Jenni, 'Vorstufen zu Dürers Tier-und Pflanzenstudien', *Jahrbuch der Kunsthistorischen Sammlungen in Wien*, vol. 82/83, N.F. XLVI/XLVII, 1986/87, p. 31.

91 The theory of the influence of received *schemae* was proposed by Ernst Gombrich, *Art and Illusion*, London, 1960, especially chapter II, *Truth and the stereotype*. Gombrich later suggested that Leonardo's drawing was a studio invention (*The Heritage of Apelles*, London, 1976, pp. 33–4), and is followed by A. Perrig, 'Die theoriebedingten Landschafts-formen in der italienischen Malerei des 14. und 15. Jahrhunderts', in W. Prinz and A. Beyer (eds), *Die Kunst und das Studium der Natur vom 14. zum 16. Jahrhundert*, Weinheim, 1987, p. 52. M. Kemp, *Leonardo da Vinci. The marvellous works of nature and man*, 1981, p. 52, stops short of stating that the drawing was done from nature.

92 Gianvittorio Dillon, *op. cit.* (n. 89 above), no. 10.1 (with further literature). Attempts to identify the site precisely have proven difficult.

93 Windsor, Clark and Pedretti, no. 12431. Leonardo's trees can be compared with those by Giorgione, which must also depend on a direct study of nature, in his *Landscape with a pilgrim* in Rotterdam, inv. I, 485 (see H. Tietze and E. Tietze-Conrat, *The drawings of the Venetian painters*, New York, 1944, no. 709). An anthology of sixteenth-century landscape drawings was included in R. Bacou *et al.*, *Il paesaggio nel disegno del cinquecento Europeo*, Exh. Rome, Villa Medici, 1972–3.

94 At n. 45 above we note another analogy between a landscape sketch by Van Dyck and a drawing formerly attributed to Leonardo at Windsor.

95 See Clark and Pedretti, no. 12417.

96 The *Landscape near Segonzano* is Winkler, no. 99. See further cat. 4. I have resisted elaborating on this point as the background is largely covered in Fritz Koreny's study, *Albrecht Dürer und die Tier- und Pflanzenstudien der Renaissance*, Exh. Vienna, Albertina, 1985 (NB also the drawing by Jacopo Bellini mentioned in n. 90 above). Buijsen, 1992–3, p. 47, notes that Van Mander encouraged artists to bedeck their landscape foregrounds with plants (*met eenighe schoon cruyden te bewassen*). This tradition, from Van Eyck to Dürer, is discussed by Jenni, *op. cit.* (n. 90 above), p. 28.

96A As recently noted and discussed by M. Rohlmann, 'Memling's Pagagnotti triptych', *Burlington Magazine*, CXXXVII, 1996, p. 439, and Christiansen, *op. cit.* (n. 87 above), pp. 56–7.

97 For a recent discussion of the attribution, see Maria Sframeli in *L'officina della maniera*, Exh. Florence, Uffizi, 1996–7, pp. 272–5, nos 92–3 and pp. 388–9, no. 146. For the British Museum drawing see N. Turner, *Florentine drawings of the sixteenth century*, London, 1986, no. 69 (as attributed to Michele di Ridolfo, whose name appears on the *verso* along with Antonio di Donnino's). The drawings have in the past also been ascribed to Andrea del Sarto and Bacchiacca. Vasari, 1568, II, p. 222, praises Antonio: *fu fiero disegnatore, & hebbe molta invenzione in far cavalli, e paesi*.

98 Compare also the drawings in the Uffizi sketchbook attributed to Cornelis van Poelenburch, inv. 770P–813P, including the

examples illustrated by Chong, 1987, pp. 38–9, figs. 21, 21a and 22.

99 Topographical and non-topographical traditions of course coincide to some extent. A significant number of artists from the fifteenth century onwards practised both, including Van Eyck, Konrad Witz and other important figures. Dürer's landscapes rarely lack a topographical interest altogether, including the *Landscape near Segonzano* (fig. 30). Many other views survive from his travels, such as those of *Heroldsberg* and *Antwerp Harbour*, the second showing the waterfront in 1520 that was depicted by Van Dyck 112 years later (cat. 11), respectively in Bayonne and Vienna (Winkler, nos 481 and 821). Dürer's style there resembles that of Wolf Huber's *Mondsee and Schafberg in the Salzkammergut* of ten years earlier, now in Nuremberg (inv. 218; P. Halm, 'Die Landschafts-zeichnungen des Wolfgang Huber', *Münchener Jahrbuch für bildende Kunst*, N.F. VII, 1930, no. 32). Dürer's two drawings are conditioned by the discipline of architectural description, but among northern artists active after him, to judge from the few remaining comparable works, his strong outlines were often retained, for example in the work of Augustin Hirschvogel (e.g. in his *View towards Neuburg* in Berlin, KdZ.4717. For further examples, see Jane S. Peters, 'Early drawings by Augustin Hirschvogel', *Master Drawings*, XVII, 1979, pp. 359–91, with further literature). The topographical tradition is also discussed by Wood, 1993, pp. 204ff., who brings together a wealth of material. But as we have stressed, we exclude topography here; by virtue of their antiquarian interest, topographical drawings were more likely to survive.

100 The composition is related to a woodcut *Landscape with a milkmaid*, repr. M. Muraro and D. Rosand, *Tiziano e la silografia veneziana del cinquecento*, Exh. Venice, 1976, no. 28. They point to two other Titian drawings that include the same architectural motif.

101 See K. Oberhuber, *Disegni di Tiziano e della sua cerchia*, Exh. Venice, 1976, no. 36 bis. The woodcut is Muraro and Rosand, *op. cit.*, no. 29.

102 The drawing is inv.753P, in pen and brown ink with brown wash, heightened with white on blue paper. 278 × 176 mm. Repr. A. Repp, *Goffredo Wals: zur Landschaftsmalerei zwischen Adam Elsheimer und Claude Lorrain*, Cologne, 1985, fig. 37. Vasari, 1568, II, p. 230: *una particolar maniera di far in pittura bellissimi paesi, non è da posporre à nessuno*. On p. 234 Vasari praises Parmigianino again for *certi paesi che sono bellissimi, essendo in cio particolarmente Francesco eccellente*.

103 J. A. Gere and P. Pouncey, *Italian Drawings ... in the British Museum. Artists working in Rome c.1550–c.1640*, London, 1983. no. 51, pl. 42. Five comparable landscape sketches are included by A. Emiliani, *Federico Barocci (Urbino 1535–1612)*, Bologna, 1985, figs 206 and 958–61, although the British Museum drawing here reproduced seems to have been omitted. For the landscapes in the artist's inventory, see *Studi e notizie su Federico Barocci (a cura della Brigata*

urbinate degli Amici dei Monumenti), Florence, 1913, pp. 80–82 (I am grateful to Michael Bury for this reference): 'Paesi coloriti a guazzo di colori, acquarelle ritratti dal naturale da vinti in circa; altri paesi dissegnati di chiaro oscuro, di acquarella, di lapis, tutti visti dal vero, circa cento. Altri pezzi di paesi schizzati visti dal naturale, tutti di mano del S.ᵒʳ Barocci circa a cinquanta'.

104 See A. Nesselrath, *et al.*, *Gherardo Cibo alias Ulisse Severino da Cingoli. Disegni e opere da collezioni italiani*, Exh. San Severino, 1989.

105 Such as the drawing in the Uffizi of a *Wooded hillside with a stream* inv.509P (on which see recently B. W. Meijer in *Fiamminghi a Roma 1508–1608*, Exh. Brussels–Rome, 1995, no. 142).

106 I am grateful to the Muziano specialist, Taco Dibbits, who kindly told me that he was also uncertain about the attribution of the Besançon drawing to Cort (conversation of 25 August 1998).

107 For the motif, see Winner, 1985, and B. Weber, 'Die Figur des Zeichners in der Landschaft', *Zeitschrift für schweizerische Archäologie und Kunstgeschichte*, 34, 1977, pp. 44–82, who stresses that the earliest examples stand as witnesses to topographical exactitude.

108 Federico Zuccaro's contribution is described by Mahon, 1947, Part III. More on this on p. 51.

109 Boon, 1978, no. 92, who notes that more drawings of this type must have existed. In reviewing Boon in *Simiolus*, XI, 1980, pp. 39–50, Hans Mielke mentioned two other works by Bril, in Berlin and Florence, as related, but although made out-of-doors they depict Roman ruins and thus fall outside our category of landscape.

110 The passage translated above occurs in C. C. Malvasia, *Felsina Pittrice*, Bologna, 1841 edn by G. Zanotti, p. 308, in the 1603 funeral oration to Agostino by L. Faberi: *alla villa si disegnavano colli, campagne, laghi, fiumi e quanto di bello e di notabili s'appresentava alla lor vista*. I am grateful to Aidan Weston-Lewis for finding the right passage. For an overview of Carracci drawings, see S. M. Bailey, *Carracci Landscape Studies. The drawings related to the 'Recueil de 283 estampes de Jabach'*, diss., California, 3 vols, 1993. A drawing of an *Eroded river bank with trees and root* in the Pierpont Morgan Library may have been begun from nature, although appears to have been extended into a composition (1972.6, formerly Ellesmere collection, see C. Denison and others, *European Drawings 1375–1825*, Exh. New York, Pierpont Morgan Library, 1981, no. 38; I am grateful to William Griswold and Kathleen Stuart for the reference). A comparable drawing, but more overtly composed, in the style of Muziano, is in the Louvre (inv. 7474). The latter collection houses further, generally cursory sketches by Annibale that may have been done from nature (inv. nos 7210, 7392 *verso*, 7416 *verso* [a sketch of the *Isola Tiburtina*, repr. C. Legrand, *Le dessin à Bologne 1580–1620. La réforme des trois Carracci*, Exh. Paris, Louvre, 1994, no. 56], and

7460, as well as a drawing of *Two trees*, possibly from nature, inv. 7484). Minor scraps by Agostino are in the Brera, Milan (inv. 682; Gernsheim photo. 99808) and the British Museum (repr. Turner, 1980, no. 36, and Exh. London, 1996–7a, no. 44; 1895–9–15–696). A school of Carracci landscape drawing is at Christ Church (James Byam Shaw, *Drawings by Old Masters at Christ Church, Oxford*, Oxford, 1976, no. 949). Held, 1963, p. 81, noted that Malvasia complains about the loss of large numbers of Carracci drawings.

111 Sold at Sotheby's, 11 July 1972, lot 43, bt M. N. Owen; the attribution to Annibale is uncertain.

112 Adriani, 1940, folios 5 *verso* and 21 *recto*.

113 Among the earliest must be the sheets in Hamburg and in the Rothschild collection in the Louvre by Gerard David, datable *c.*1505–10 (repr. Ainsworth and Christiansen, *op. cit.* (n. 87 above), p. 280, figs. 92–3).

114 The standard study of northern landscape of this period is Franz, 1969. See Boon, 1992, pp. xvii–xxii, with further literature including O. Benesch, 'The name of the Master of the Half-Lengths', *Gazette des Beaux-Arts*, XXIII, 1943, pp. 269–82 (reprinted in *idem.*, *Collected Writings*, E. Benesch (ed.), II, London, 1971, pp. 50–55); E. de Callatay, 'Cornelis Massys paysagiste, collaborateur de son père et de son frère et auteur de l'album Errera', *Bulletin des Musées Royaux des Beaux-Arts de Belgique*, XIV, 1965, pp. 49–70; Franz, 1969, I, pp. 70–77; B. L. Dunbar, 'Some observations on the 'Errera Sketchbook', *Bulletin des Musées Royaux des Beaux-Arts de Belgique*, XXI, 1972, pp. 53–82; and Mielke in Exh. Berlin, 1975, no. 181; and C. S. Wood, 'The Errera Sketchbook and the landscape drawing on grounded paper', in *Herri met de Bles*, ed. N. E. Miller *et al.*, Turnhout, 1998, pp. 101–13, with further literature.

115 The leaf illustrated by S. J. Gudlaugsson, 'Het Errera-schetsboek en Lucas van Valckenborch', *Oud Holland*, LXXIV, 1959, p. 137, fig. 35. He attributed the sketchbook tentatively to Van Valckenborch.

116 For a recent summary, see Mielke, 1996, pp. 86–8.

117 Such as the *Pagus Nemorosus* print, Hollstein no. 16.

118 The *River valley* in the Louvre is singled out by Mielke, 1996, cat. 1, as a 'Naturaufnahme von höchster Meisterschaft, die ohne Vorbild ist'. The *Monastery in a valley* in Berlin is also a drawing from nature, albeit with some topographical interest (KdZ.5537; Mielke, cat. 2), also the central concern of the Chatsworth *View of the Tiber with the Ripa Grande in Rome* (inv. 841), which was certainly made on the spot, although the foreground, in a different ink, was probably added later (Mielke, cat. 14). The drawing based on Campagnola is in Berlin (KdZ.1202, Mielke, cat. 21).

119 Van Mander, *Schilder-boeck*, 1604, fol. 233. *In zijn reysen heeft hy veel ghesichten nae t'leven gheconterfeyt soo datter gheseyt wort dat hy in d'Alpes wesende al die berghen en rotsen had in gheswolghen en t'huys ghecomen op doecken en*

Penneelen uytghespogen hadde, soo eyghentlijck con hy te desen en ander deelen de Natuere nae volghen. Van Mander's metaphor was presumably not chosen to flatter – compare Cervantes: *Los buenos pintores imitan la naturaleza, pero los malos la vomitan* (from *El Licenciado Vidriera*).

120 Such as the silverpoint *View of Antwerp* in the British Museum, with views of shipping and a *Canal at Delfsgauw* on the *verso* (Popham, 1932, no. 5), recently discussed by A. van Suchtelen, 'Hans Bol. Een van de eerste schilders van het Hollandse stadsgezicht', *Antiek*, XXVIII, 1993, pp. 220–27, figs 5–6; see also H. G. Franz, 'Hans Bol als Landschaftsmaler', *Jahrbuch des kunsthistorischen Instituts der Universität Graz*, I, 1965, pp. 21ff.

121 A sheet bearing, on the *recto* and *verso*, both types is discussed by J. Bolten in Exh. Amsterdam, 1993–4, no. 318.

122 T. Gerszi, *Paulus van Vianen. Handzeichnungen*, Hanau, 1982.

123 Discussed by O. Benesch, *From an art historian's workshop*, E. Benesch (ed.), Lucerne, 1979, pp. 45–76, pls. 40–68. See also T. Gerszi, *Netherlandish drawings in the Budapest Museum*, Amsterdam and New York, 1971, nos 265–70. The same catalogue (nos 5–6, with earlier literature) reproduces two drawings by the 'Anonymous Fabriczy', another landscape artist whose was apparently inspired by Bruegel.

124 For De Gheyn, see I. Q. van Regteren Altena, *Jacques de Gheyn. Three Generations*, 3 vols, The Hague, Boston and London, 1983, and M. Schapelhouman in Exh. Amsterdam, 1993–4, no. 317.

125 J. Spicer-Durham, *The Drawings of Roelandt Savery*, diss., New Haven, 1979, nos 97–8, and discussed by P. Schatborn in Exh. Amsterdam, 1993–4, no. 193. See also *Roelant Savery in seiner Zeit (1576–1639)*, Exh. Cologne-Utrecht, 1985–6, nos 99–101.

126 A possible exception being the *Landscape with a water-mill* in the Victoria and Albert Museum (inv. 528). A few seascapes, including one in the Van Regteren Altena Collection, may at least have been begun out of doors (see Exh. Rotterdam–Paris–Brussels, 1976–7, no. 34, repr.) as also such drawings as the *Falls at Tivoli* (Leiden, inv. 1240).

127 See Adler, 1980. Only the black chalk sketch of a *Road through trees* in Leiden (Adler's cat. 2.26, fig. 197) might possibly be from nature.

128 K. Andrews, *Adam Elsheimer*, Oxford, 1977, no. 42, the *Mountainous landscape* in Berlin, which formed the basis for his painting of *Aurora* now at Braunschweig (*op. cit.*, no. 18).

129 P. Schatborn, 'Tekeningen van de gebroeders Jan en Jacob Pynas', *Bulletin van het Rijksmuseum*, XLIV, 1996, pp. 37–54 (the drawing by Jan being a topographical *View of the Tiber*, recently on the art market, fig. 11) and XLV, 1997, pp. 3–25 (the drawing by Jacob, a *Hilly landscape with cattle by a river*, in the British Museum, fig. 8, inv. 1848-7-8-118,

already attributed to Elsheimer when it was engraved by Hollar, looks possibly to have been drawn from nature although this is far from certain).

130 On Hondecoeter, see the summary, with previous literature, by M. Schapelhouman in *Catalogus van de nederlandse tekeningen in het Rijksprentenkabinet, Rijksmuseum, Amsterdam, deel III: Nederlandse tekeningen omstreeks 1600*, The Hague, 1987, no. 32.

131 Adler, 1982, no. 10. He attributes the drawings (his nos 2–13) to Rubens, a proposal that has not found favour. The old attribution to him was written on the drawings by the same hand as the equally erroneous one to Van Dyck of a series of *gouache* landscapes, on which see cat. 58 below. A comparison between a drawing by Hondecoeter in Berlin (KdZ 11757), for which the Amsterdam drawing mentioned in the previous note is a study, with the Master of the Farm Landscapes' drawings in London (here fig. 41) and the Pierpont Morgan Library (inv. I.231; Adler, *op. cit.*, no. 11) leaves no room for doubt about the single identity of the draughtsman.

132 For a discussion of some of Reni's landscape drawings, although those discussed appear to be compositions, see C. Johnstone, 'Reni's landscape drawings in Mariette's collection', *Burlington Magazine*, CXI, 1969, pp. 377–80.

133 As already noted by E. van de Wetering, *Rembrandt, the painter at work*, Amsterdam, 1997, p. 53. The Ter Borch drawings are catalogued by A. McNeill Kettering, *Drawings from the ter Borch family studio estate*, 2 vols, Amsterdam, 1988.

134 On Jordaens' extensive surviving *oeuvre* as a draughtsman, see R.-A. d'Hulst, *Jordaens Drawings*, 4 vols, Brussels, London and New York, 1974.

135 Rubens refers to a topographical 'drawing of mine, done upon the spot' showing the Escorial in a letter to Balthasar Gerbier of 15 March, 1640 (Magurn, 1955, p. 412, no. 246). Rubens states that it formed the basis for a painting by Pieter Verhulst of *St Lawrence in Escorial* which Edward Norgate had seen in Rubens' house and believed to be by Rubens himself. The original painting, like the drawing, does not survive, but several copies of the oil do (one is illustrated in Exh. London, 1996–7, p. 40, fig. 31).

136 Richter, 1939, p. 317.

137 *Op. cit.*, p. 97. Leonardo's illustration of the device shows the artist drawing an armillary sphere (see Westfehling, 1993, pp. 264–5).

138 For example, 'When the sun is in the east the trees to the south and to the north have almost as much light as shadow, but a greater share of light in proportion as they lie to the west and a greater share of shadow in proportion as they lie to the east' (*Op. cit.*, p. 287, no. 443).

139 *Op. cit.*, p. 289, no. 449.

140 *Op. cit.*, p. 309, no. 500.

141 Dolce, *op. cit.*, p. 83.

142 A particularly clear case occurs in 1604 when Karel Van Mander, in his life of Jan Scorel, states that the view of Jerusalem in Scorel's Lockhorst triptych in Utrecht was portrayed from life (*hier was de Stadt in nae t'leven*) although he in the same breath states that it was executed in Utrecht (see *Lives*, I, 1994 edn, folio 235v). For a succinct discussion of the meaning of the phrase, see Freedberg, 1980, p. 10.

143 *Dilettossi molto di far paesi, ritraendoli dal vivo e naturale come stanno apunto* (Vasari, 1568, I, p. 380). Vasari also states that Masaccio and other artists who followed up the lead of Giotto observed 'the shadow and the lights ... and other difficult things, and the compositions of the stories with more correct similitude, and tried to make the landscapes more similar to the truth, and the trees, the grass, the flowers, the air, the clouds and other things of Nature' (*op. cit.*, I, p. 247, in the *proemio* to part II, quoted by Buscaroli, 1935, p. 121). This would, however, have been before the 1460s, the period to which, as we saw, the most telling advances in the depiction of landscape occurred in Florentine art. Vasari's contemporary Antonio Francesco Doni (*Disegno del Doni*, Venice, 1549, p. 22r) refers to a landscape sketch being turned, with variations, into a painting, but does not specifically state that the sketch was made from nature: *Quando tu ritrai in pittura una macchia d'un paese, non vi vedi tu dentro spesse volte animali, huomini, teste ...'.

144 Schatborn, 1994, p. 50, noted that while Van Mander suggests that Netherlandish painters drew from nature, few such works seem to survive from the sixteenth century.

145 See n. 59 above.

146 Van Mander, *Grondt*, 1973 edn, I, p. 214.

147 *Op. cit.*, I, pp. 64–5: *Neemt kool en krijt, pen inckt, pampiere,/ Om teeck'nen dat ghy siet, oft u de lust ghebiedt* and *Keert weer naer Stadt .../ Stelt t'huys al dat, ghy saeght hier buyten,/ T'geen ghy in't Boeck beschreeft, sulcx lantschaps doen aencleeft,/ Met verwen die ghy wreeft, maeckt dat het leeft*.

148 Van Mander, *Lives*, 1994, folio. 211v.

149 *Op. cit.*, folio 215r.

150 *Op. cit.*, folio 234v.

151 *Op. cit.*, folio 260r.

152 Respectively *op. cit.*, folios 230r+v, 255r+v, 256v, 257r, 262v and 298r. The last passage on Bloemaert was singled out in the underrated book by Grosse, 1925, p. 8. Those on Scorel, Bruegel and de Heere are noticed by Schatborn and Schapelhouman in Exh. Amsterdam, 1987, p. viii.

153 See especially Freedberg, 1980, p. 40, and Leeflang, 1997, pp. 81–2, who traces the history of the notion that Haarlem was the birthplace of landscape; and of the use of the word *landscap* to a contract for an altarpiece for St Bavo in

Haarlem of 1485. Huygens praised numerous Dutch land-scapists of the then younger generation – 'enough to fill a book' – in 1629/30, including Esaias van de Velde, Cornelis van Poelenburch and Jan van Goyen, as well as the Fleming Jan Wildens (*Oud Holland*, IX, 1891, p. 117).

154 Goeree, 1697, pp. 85–7.

155 Houbraken, III, p. 90, as noted in Exh. Amsterdam, 1987, p. ix.

156 Gombrich, 1971 edn, pp. 107–21; Sutton, in Exh. Amsterdam–Boston–Philadelphia, 1987–8, pp. 8–10 summa-rizes the sources as they affect Dutch painting. Walter S. Melion, *Shaping the Netherlandish Canon. Karel van Mander's Schilder-Boeck*, Chicago and London, 1991, p. 98, notes that van Mander was 'keen to certify landscape as an independent genre'. See also Wood, 1997, pp. 54ff.

157 Marcantonio Michiel, D. Iacopo Morelli (ed.), *Notizia d'opere di disegno nella prima metà del secolo XVI*, Bassano, 1800.

158 Vasari, 1568, I, p. 509, II, p. 18 and 74 respectively (*un paese che fu tenuta allora bellissimo; ne mai Lombardo fu, che meglio facesse queste cose di lui; un paese che in tutta perfezzione è singulare e bellissimo*). I have found more than one hundred such examples in Vasari's text.

159 Gombrich, 1971 edn, p. 118.

160 G. P. Lomazzo, *Trattato dell'arte*, 1585, Book 6, ch. 62. On Van Mander see *Grondt*, Miedema ed., 1973, pp. 202ff. (Van Mander's Ch. VIII, folios 34ff.)

161 See Ogden and Ogden, 1955, p. 2.

162 See C. Whitfield, 'A programme for *Arminia and the shepherds* by G. B. Agucchi' *Storia dell'arte*, XIX, 1973, pp. 218–20 (Michael Kitson kindly sent me a translation he had made of Agucchi's text).

163 Hoogstraten, 1678, p. 137 (*tot eenen hoogen trap gebracht*).

164 In the portrait of the artist as plate 11 in the *Pictorum aliquot celebrium Germaniae inferiores effigies*, Antwerp, Hieronymus Cock, 1572 (as pointed out by Miedema, 1973, p. 409).

165 Quoted from the *Grondt*, p. 19, by L. Vergara, 'The printed landscapes of Pieter Bruegel', in Exh. Tokyo-Hiroshima, 1989, p. 83.

166 Van Mander, 1604, folio 234r. This has been noticed by D. Freedberg, in Exh. Tokyo–Hiroshima, 1989, p. 23.

167 Pliny, XXXIV, 61, as noted by H. Mielke in Exh. Berlin, 1975, pp. 6–7.

168 Gombrich, 1971 edn, p. 113. Ludius is mentioned by Van Mander, *Grondt*, 1604, 1973 edn, p. 45, and Van Hoogstraten, 1678, pp. 74, 87 and 136–7.

169 Paolo Giovio revived Pliny's term *parerga* in the late 1520s to describe Dosso Dossi's landscape backgrounds (Gombrich, 1971 edn, p. 111).

170 The continuing importance of imagination is underlined by the story, related by Van Hoogstraten, 1678, p. 238, of a painting competition between Frans van Knibbergen, Jan van Goyen and Jan Porcellis, which was won by the latter, because he conceived the result more throughly in his mind before taking up the brush, and because of his selective naturalism (*keurlijke natuerlijkheyt*). The story was repeated by Houbraken (1753 edn, pp. 166–8). The importance of choice in nature is stressed by Freedberg, 1980, p. 10 (quoting Hoogstraten) and by Leeflang, 1997, p. 87, who points out that Jan van de Velde's etching of a lime-kiln, an industrial site, is a rarity.

171 Michelangelo's statement to Francisco de Hollanda (published by J. de Vasconcellos, *Quellenschriften für Kunstgeschichte und Kunsttechnik des Mittelalters und der Renaissance*, IX, 1899, pp. 28–9): 'In Flanders they paint only things to deceive the external eye, things that gladden you and of which you cannot speak ill. They paint stuffs and masonry, the green grass of the fields, the shadows of trees, and rivers and bridges, and what they call landscapes, with many figures on this side and many figures on that. And all this, though it pleases some persons, is done without reason or art, without symmetry or proportion, without skilful choice or boldness, without substance or vigour'. Paul Joannides pointed out to me (in conversation) that Michelangelo's generation may also have been responding negatively to the 'manufacture' of landscapes in watercolour on canvas in Flanders, which were widely exported at the time (in 1535 a merchant in Mantua had 300 landscapes from Flanders, thirty of which depicted scenes of fire, as reported by Buscaroli, 1935, p. 56 quoting A. Luzio, *La galleria del Gonzaga venduta all'Inghilterra nel 1627–1628*, Milan, 1913, p. 30; the Gonzaga acquired 120 of these paintings). Gombrich, 1971 edn, p. 116 suggests that what was a 'fictional' landscape to a Flemish artist might appear like northern reality to an Italian connoisseur (citing Paolo Pino, 1548). The passage from Vasari occurs in *Le vite*, 1568, II, p. 749. Describing the late frescoes in the Cappella Paolina, he wrote: 'Ha Michelagnolo atteso solo, come s'è detto altrove, alla perfettione dell'arte, perche ne paesi vi sono, ne alberi, ne casamenti, ne anche certe varietà, & vaghezze dell'arte vi si veggono, perche non vi attese mai: come quegli, che forse non voleva abassare quel suo grande ingegno in simil cose' (Michelangelo only paid attention, as has been said elsewhere, to the perfection of his art, as there are no landscapes to be seen there, nor trees, nor buildings nor also certain variations and embellishments of art, because he never paid attention to them; as if he perhaps did not wish to lower his great genius to such things).

172 Michael Hirst, *Michelangelo and his drawings*, New Haven and London, 1988, pp. 9–10, notes the lack of landscape drawings by the artist and its repercussions for his art.

173 Miedema, 1973, p. 436.

174 In Zuccaro's *Idea de' pittori, scultori e architetti*, printed in 1607 but probably written around the time of his becoming a founder member of the Accademia di S. Luca in Rome in 1593. He was influential also through membership of the academies in Perugia and Parma (discussed by Mahon, 1947 and Blunt, 1962, pp. 141–2).

175 Norgate, 1649, 1997 edn, p. 108. See also n. 22 above, from the same paragraph.

176 As noted by P. Schatborn, 'The importance of drawing from life. Some preliminary notes', in W. W. Robinson (ed.), *Seventeenth-century Dutch drawings. A selection from the Maida and George Abrams collection*, Exh. Amsterdam–Vienna–New York–Cambridge, 1991–2, p. 8.

177 See cat. 30 below, which includes one of Visscher's preparatory drawings for this set. Amusingly, he described these prints, based on local topography, as a replacement for actual travel, in the same terms as Braun and Hogenberg described their wide-ranging topographical atlas, the *Civitates orbis terrarum* of 1572–1617 (see further Schatborn, 1994, p. 55; the concept has been studied by Catherine Levesque, *Journey through landscape in seventeenth-century Holland. The Haarlem print series and Dutch identity*, Pennsylvania, 1994; on p. 41 she I think overstates the differences between Cock's and Visscher's series). Houbraken (1753 edn, pp. 341–2) quotes Vondel's poem in which the poet studies landscape prints by Herman Saftleven as a journey. The *Plaisante plaetsen*, on which see further cat. 30 below, were reissued in 1728.

178 Ogden and Ogden, 1955, pp. 5–6.

179 Wood, 1993, p. 57, discovered the passage by the lexi-cographer Thomas Blount, who in 1656 wrote 'All that which in a Picture is not of the body or argument thereof is *Landskip, Parergon* or by-work. As in the Table [i.e. panel painting] of our Saviour's passion, the Picture of Christ upon the *Road* …, the two theeves, the blessed Virgin *Mary*, and St. *John*, are the Argument. But the City *Jerusalem*, the Country about, the clouds, and the like, are *Landskip*' (from Blount's *Glossographia*, London, 1656). Earlier, Buchell referred to Esaias van de Velde's art as 'elegant but slight' (as noted by Freedberg, 1980, p. 20), and most writers continued to view landscape as an inferior genre. The *Oxford English Dictionary* entry for 'Landscape' cites two sources of the first decade of the seventeenth century that exemplify different attitudes to the *genre*: first, I. Sylvester's translation of Guillaume de Saluste de Bartas: 'The cunning painter … Limning a Landscape, various, rich and rare', and secondly, Thomas Dekker, *The Seven Deadly Sinnes of London*, 1606: 'A Drollerie (or Dutch peece of Lantskap)'.

180 Although landscapes are classed under 'historie' in the stock-list of the print publisher Cornelis Claes in Amsterdam in 1609 (as noted by Schatborn, 1994, p. 56), but this is exceptional.

181 Gombrich, 1971 edn, p. 108. Of interest here is the inclusion of drawings and sketchbooks in these paintings, the drawings always being figurative or finished compositions that show the artist's powers of invention. In the gallery painting by Frans Francken in the Borghese Gallery, the painter points to his forehead to draw attention to his *ingenio* (as noticed by

Z. Z. Filipczak, *Picturing art in Antwerp*, Princeton, 1987, pp. 68–9).

182 *Op. cit.*, fig. 66, now in the Musée Royal des Beaux-Arts, Brussels.

183 See recently E.-J. Sluijter, 'Jan van Goyen als marktleider, irtuoos en vernieuwer' in Exh. Leiden, 1996, pp. 38–59, who notes that Huygens and Orlers appreciated landscape without a hint of denigration, the latter, in 1641, choosing to represent the greatness of Leiden through seven painters without hierarchical differentiations, including two landscape specialists (Van Goyen and Pieter de Neyn).

184 Norgate, 1649, 1997 edn, p. 83.

185 Restated in Exh. Paris, 1990, p. 7.

186 I would not go so far as to suggest, as does Bruyn, 1994, p. 82, that any landscape sketch intended for sale would necessarily have had an iconographic programme, even in the seventeenth century, although agree that this would usually have been the case, and certainly so in the sixteenth century. Schulz, in Exh. Berlin, 1974, p.ii, noted that studies from nature were generally intended for the studio, and only compositions for the market

187 Chong, 1994, p. 100, notes of landscape drawings in Rome that 'In the 1630s, no artist had the monopoly of novelty'.

188 See p. 30.

189 A history of this topic has yet to be written, although much of the raw material has been assembled. For a sixteenth century collector, see Matteo Lafranconi, 'Antonio Tronsarelli: A Roman collector of the late sixteenth-century', *Burlington Magazine*, CXL, 1998, pp. 537–50, with further literature on Vasari and others. See also Held, 1963, pp. 72–95 (also with previous literature) and Carlo James, *et al.*, *Old master prints and drawings. A guide to preservation and conservation*, Amsterdam, 1997, pp. 138ff. The fundamental work remains that by Lugt, 1921 and 1956.

190 The case for the Calvinist influence is most cogently argued by De Klijn, 1982. See also Bakker, 1993. For the wider impregnation of religious allegory in Dutch landscape painting, see especially J. Bruyn, 1987–8, pp. 84–103. Sutton himself and Simon Schama also discuss the religious dimension of landscape iconography in their contributions to the same catalogue (pp. 12–13 and pp. 64–5 respectively). On sixteenth-century landscapes see also R. L. Falkenberg, *Joachim Patinir. Landscape as an image of the pilgrimage of life*, Philadelphia, 1988, and W. S. Gibson, 'Mirror of the earth'. *The world landscape in sixteenth-century Flemish painting*, Princeton, 1989.

191 Norgate, 1649, 1997 edn, p. 83. The passage echoes Michelangelo's comment reported by De Hollanda (see n. 171) that 'In Flanders they paint only … things that gladden you and of which you cannot speak ill'.

192 This might also explain why the clergyman Samuel Ampzing was such a supporter of landscape art, and generally avoided references to religious paintings in Haarlem, laying emphasis on the town's claim to be the original home of landscape painting (see Leeflang, *op. cit.* n. 67 above, p. 25, and *idem.* 1997, pp. 81–4). This is not to deny (following Bruyn, 1987–8) that landscapes were allegorical, containing religious and *vanitas* symbolism. After all, Visscher's title-page to his 1612 set of Haarlem landscapes is adorned with the name of God (as noted by Schatborn, 1994, p. 55). But in a discussion of the *plein air* sketch the iconographic agenda of the finished landscape is tangential. See also Wood, 1993, p. 31, who interprets Altdorfer's images of the forest 'simultaneously as a potential refuge from orthodox but idolatrous cult practices, and as the mythical setting of heathen idolatry', expanding on this theme in Chapter III of his book. For more on the meaning of landscape, see D. Cosgrove and S. Daniels (eds), *The iconography of landscape*, Cambridge, 1988.

193 See K. Thomas, *Man and the natural world*, London, 1984 edn, Harmondsworth, p. 301. The theme is touched on by Leeflang, e.g. in 1997, pp. 87–8. For population changes see recently, for example, the essays by E. Sonnino and H. Nusteling in P. van Kessel and E. Schulte (eds), *Rome–Amsterdam*, Amsterdam, 1997, pp. 50–69 and 71–84.

194 Clark, 1949, pp. 7 and 21 quotes passages from the writings of Petrarch, Alberti and Pope Pius II that reveal their enjoyment of the sight of the countryside, an attitude that prepared the way for the exploration of nature by artists.

195 Although focusing on the sketch from nature, and charting losses into the seventeenth century, this part of my argument partly echoes what has been written before of earlier periods, especially the fifteenth century. For example, F. Ames-Lewis and Joanne Wright, *Drawing in the Italian Renaissance workshop*, Exh. Nottingham–London, 1983, p. 15, wrote: 'Many, many more [drawings than those that survive] must have been destroyed'. Buscaroli, 1935, p. 163, believed that some fifteenth-century Tuscan artists must have made landscape drawings *con sapore veristico*. Van de Wetering, *op. cit.* (n. 133 above), pp. 6ff., argues that prepared papers used by artists for silverpoint drawings were recoated and reused, destroying countless drawings in the process (I believe that this can only have been a rare occurrence). Ad van der Woude has argued that only a around one per cent of Dutch seventeenth-century aintings survive ('The volume and value of paintings in Holland at the time of the Dutch Republic', in D. Freedberg and J. de Vries (eds), *Art in history. History in art*, Santa Monica, 1991, pp. 285–329).

196 Cats 7–8, 11–14, 16–18 and perhaps others (though none of the watercolours is signed). Claude also signed some of his sketches from nature, yet their importance was not recognized by the early sources: Baldinucci refers to them only in passing and towards the end of his text, and Sandrart does not mention them at all in his biography of Claude, although he does so elsewhere in his writings (as pointed out by M. Kitson, 'Turner and Claude', *Turner Studies*, II, no. 2, p. 3). Held, 1963, pp. 85–7, however, argues that the status of drawings, and even of the rough sketch, saw a general improvement during the seventeenth century.

197 Another edition appeared in 1627. The book's significance already noted by Oppé, 1941, p. 189, and Paul Hulton, 'Drawings of England in the seventeenth century … from the Van Der Hem Atlas of the National Library, Vienna', *Walpole Society*, XXXV, 1954, p. xiii. Constantijn Huygens and his brother Maurits, courtiers in The Hague, both received drawing lessons in the early seventeenth century. The former's son, Constantijn the Younger, became a proficient landscape draughtsman, as did the lawyer Jan de Bisschop (see A. R. E. De Heer, 'Het tekenonderwijs von Constantijn Huygens en zijn kinderen', in V. Freiser (ed.), *Soeticheydt des Buyten-levens. Leven en leren op Hofwijck*, Delft, 1988, pp. 43–63; J. F. Heijbroek (ed.), *Met Huygens op reis*, Exh. Amsterdam, Rijksmuseum, 1989; and R. E. Jellema and M. C. Plomp, *Episcopius. Jan de Bisschop (1628–1671)*, Exh. Amsterdam, Rembrandthuis, 1992). On the amateur tradition, see also W. Kemp, '… einen wahrhaft bildenden Zeichenunterricht überall einzuführen.' Zeichnen und Zeichenunterricht der Laien 1580–1870. Ein Handbuch, Frankfurt-am-Main, 1979.

198 Among the earliest records are statements by Sandrart, especially 1925 edn, pp. 184 and 209, and Baglione, 1642, pp. 335–6; and a drawing of around 1650 by Richard Symonds of a portable painter's box. Much of the relevant material is discussed by P. Conisbee, 'Pre-Romantic *plein-air* painting', *Art History*, II, 1979, pp. 413–18 (Symonds' box is his fig. 25; Symonds himself has been the subject of a dissertation by Mary Beale, *A study of Richard Symonds*, diss. London, 1978, published New York and London, 1984). See also P. Galassi, *Corot in Italy. Open-air painting and the classical landscape tradition*, New Haven and London, 1991 (especially pp. 11–18). Michael Kitson, in a letter to me of 3 May 1998, believed that Rosa's interest in painting out of doors, as recorded by Passeri (quoted by Jonathan Scott, *Salvator Rosa*, 1995, p. 5), might 'give a clue to the fact that it was in Naples in the early seventeenth century that oil sketching from nature first began in European art. It would then have been carried to Rome by someone like Goffredo Wals or Filippo Napoletano'.

199 Quoted from Allan Cunningham's life of Gainsborough of 1829 by William T. Whitley, *Thomas Gainsborough*, London, 1915, p. 306.

I
DRAWINGS BY OR ATTRIBUTED
TO VAN DYCK

1 VAN DYCK

A dead tree overgrown with brambles

Pen and brown ink over red and black chalk, touched with brown wash and yellow and blue chalk; an oil patch, left, disguised with oil paint, now discoloured. 352 × 298 mm.

Inscribed by the artist: *afgevallen bladeren / ende op sommighe plattsen / schoon gruen gras doorkyken*; there is a second, illegible inscription down the right edge of the drawing.

PROVENANCE: William, 2nd Duke of Devonshire, and by descent.

Chatsworth, Devonshire Collection (1008)

SELECTED LITERATURE AND EXHIBITIONS: Exh. London, 1977, no. 199; Adler, 1982, no. 70, fig. 156; Vergara, 1982, pp. 83–4, fig. 57; Held, 1986, no. 116; Exh. London, 1996–7, repr. p. 87.

The inscription on the drawing may be literally translated as follows: 'fallen leaves and in some places fresh [*schoon* = clean] green grass peep through'. This suggests that the drawing was made in spring. The spelling of 'gruen' – normally 'groen' – is unusual.

This and the larger study of a *Fallen tree-trunk* now in the Louvre (cat. 2) appear to have been made at the same time and in connection with Rubens' *Wild boar hunt* of c.1618 now in Dresden (see figs 1a and 2a). The relationship between the Louvre drawing and the painting is close: both depict the same fallen tree from a similar angle. The present drawing was not repeated in the picture, although the encrustation of brambles at the lower left corner of the painting includes some almost identical passages, suggesting that it was consulted by the artist (see fig. 1a). A further drawing at Chatsworth (cat. 3) depicts the same tree as the one studied in the Louvre drawing, but from the side.[1]

The penwork in both the present drawing and that in the Louvre is so strongly reminiscent of Van Dyck, with its nervous angularity and extraordinary vigour, that an attribution to him of both sketches is here proposed. Drawings by Rubens, to whom they are usually given, offer wholly inadequate comparative material, but Van Dyck's are compatible, particularly in the case of the Louvre drawing (see further under cat. 2). The handwriting on the present sheet, surely by the draughtsman, noting a detail that was not fully communicated by his pen, has also been described as uncharacteristic of Rubens.[2] In fact it is again wholly different and much closer to Van Dyck's hand, as revealed, for example, by some of his notes in his Italian sketch-book, like those on the second folio (see fig. 1b),[3] as well as by the inscriptions on his drawings of a *Landscape near Genoa*, of *Rye from the north east* (cats 6 and 12), and his writing in his letter to Franciscus Junius of 1636.[4] The related Dresden painting was made when Van Dyck was assisting Rubens in his studio, and some of its stocky, muscular figures in the centre, with their shocks of thick hair, are so reminiscent of those in Van Dyck's early oil paintings, such as the *Samson and Delilah* at Dulwich,[5] that his participation in designing and also executing the oil seems likely. Some of the dogs in the picture are also analogous to those in, for example, Van Dyck's *Venus and Adonis* recently sold in New York.[6]

The objections to the attribution to Van Dyck evaporate when it is remembered that 1618, the approximate date of the Dresden painting, is the very year in which Rubens referred to Van Dyck as 'the best of my pupils' (see Biography, p. 8), and the year in which Rubens' *Decius Mus* tapestry cartoons, on which Van Dyck is recorded as an assistant, were completed. This was a period during which Rubens was under particular pressure from his patrons, and he must have been forced to 'farm out' some of his work to his most able collaborators (see further the Introduction, pp. 19–21).

A drawn variant of the composition of the related painting is in Vienna, and seems very probably to be another sketch for the painting by Van Dyck as well, the style being close to that of the Antwerp sketchbook as well as the Louvre drawing.[7]

1 Another, anonymous school variant of the Dresden composition is in the British Museum (Hind 112, as Rubens).

2 By Held, 1959, under no. 131. The handwriting in Rubens' Costume Book and the comparable inscriptions on the drawings of *Peasants at a Kermesse* and of *Trees at sunset* (Hind 33 and 108, Held, 1986, nos 193 and 226) in the British Museum do indeed look different. Held nonetheless maintains Rubens' authorship of the drawing (1986, no. 116).

3 The lines that read *Don fabricio malguernero / Dottore in Palermo*. The last word of the script, *Jasinto*, is in the same type of handwriting, whereas the others are in Van Dyck's more florid Italian hand. See further the next note.

4 I am grateful to Professor Dr Katlijne Van der Stighelen, who wrote to me on 23 March 1998 following my enquiry to her for independent advice on the inscription: 'In my view the handwriting cannot be Rubens' own as you and Julius Held have already suggested. I am not a specialist in Van Dyck drawings, but I do agree that the sketchy technique of the Chatsworth sheet is not very similar to contemporary drawings by Rubens. I have been looking for other examples of Van Dyck's 'casual handwriting' and in my view there are some reasons to suppose that the words on the Chatsworth drawing are written by Van Dyck.' She goes on to compare the examples quoted above, as well as the general appearance of the handwriting in Van Dyck's Antwerp sketchbook; and to note that Rubens seems never to have spelt the word 'gruen' with a 'u'. I have also noticed that Rubens appears practically always to have separated two consecutive 'o's rather than joining them as here in the word 'schoon'; this is characteristic of Van Dyck, as are the forms of the other letters of the inscription.

5 See Exh. Washington, 1990–91, no. 11, where dated to 1619–20 (the painting is oddly rejected by Larsen, no. A38).

6 Larsen 310; Christie's, New York, 29 January 1998, lot 63, repr.

7 Exh. Vienna, *Rubenszeichnungen der Albertina*, 1977, no. 71, repr. For the landscape elements compare also the drawing of *Venus and Adonis* in the British Museum, Hind 23, Vey 25 (1910-2-12-210).

Fig. 1a Rubens, *Landscape with a boar hunt* (detail of fig. 2a).

Fig. 1b Van Dyck, *Folio 2 of Italian Sketchbook*, London, British Museum (detail).

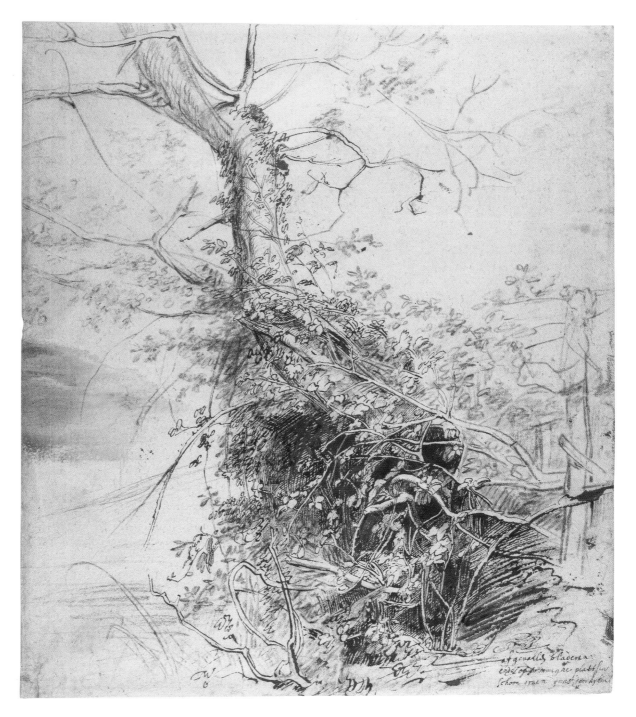

2 VAN DYCK

A fallen tree

Pen and brown ink over black chalk on pale buff paper. 600 × 501 mm.

PROVENANCE: Saint-Morys; acquired with his collection, seized as *émigré* property during the French Revolution.

Paris, Musée du Louvre, Département des Arts Graphiques (20.212; photo RMN)

SELECTED LITERATURE AND EXHIBITIONS: F. Lugt, *Musée du Louvre. Inventaire général des dessins des écoles du nord, école flamande*, II, 1949, p. 20, no. 1034, pl. XXXI; Burchard and d'Hulst, 1963, no. 104, pl. XXXI; *Rubens, ses maîtres, ses élèves*, Exh. Paris, Louvre, 1978, no. 14; Adler, 1982, p. 58 and pp. 76–7, no. 18a, fig. 58; Vergara, 1982, pp. 84–6, fig. 58; Held, 1986, no. 115, pl. 113; J. Labbé and L. Bicart-Sée, *La collection Saint-Morys au Cabinet des Dessins du Musée du Louvre (I)*, Exh. Paris, Louvre, 1987, pl. 33; Exh. London, 1996–7, p. 84, fig. 81.

See the previous number. This magnificent and celebrated study is one of the most impressive drawings from nature to survive from the seventeenth or indeed any century. It has since the nineteenth century been attributed to Rubens, because of its relationship to his painting of around 1618, the *Landscape with a wild boar hunt*, now in Dresden (fig. 2a).[1] In the painting the tree-trunk is more twisted and a new branch extends to the right.

The connection with Rubens would be unproblematic were it not for the difficulty in finding any stylistically comparable drawings among the corpus of Rubens' authentic works, in particular in the years around 1618: the angular and hurried underdrawing in black chalk, which blocks in complete areas of the middle-distance and trees, the fine shading around the fallen trunk in thin meandering parallel skeins drawn with the pen which adhere unequivocally to the forms described (Rubens' approach to shading is always more painterly), the strong directional slant created in the more distant foliage, and the loose ends to the composition, which convey an impression of urgency, in all these aspects the drawing differs fundamentally from Rubens' more willowy and temperate manner. Indeed, the contrast with Rubens could hardly be more stark: one studies his sketches well-nigh in vain for moments of comparability.[2]

On the other hand, these un-Rubensian qualities, as well as the energetic, spiralling line and the abundant parallel shading (wholly different again to Rubens), may be compared with a number of drawings by Van Dyck. The technical similarity of his preliminary study in Hamburg of the *Taking of Christ* is suggestive (see fig. 11):[3] the angular black chalk underdrawing of the trees (like that to the right of the Louvre drawing), the use of the same medium to block out whole areas of tone, and the vigorous yet crisply precise penwork, applied in thin lines with speed and discipline. Further analogies of detail are apparent in the vegetation in the *Study of cows* at Chatsworth, which is often thought to be a signed work by Van Dyck (fig. 6), albeit possibly based on a Rubens design,[4] and again in the right foreground of the drawing in Rotterdam of the *Ypres Tower at Rye* (cat. 15). Above all the links with the Chatsworth *Dead tree overgrown with brambles* (cat. 1) permit the transference of the drawing from Rubens to Van Dyck, a well-worn path for drawings by these two artists.[5] That the analogies with Van Dyck's other landscape drawings, which are later – most of them dating from the fourth rather than the second decade of the seventeenth century – are not closer reflects the extent of the artist's development (see further the Introduction, p. 19).

As is noted under cat. 1 above, the related painting in Dresden was executed while Van Dyck was working in Rubens' studio, and in style the oil, too, is in certain parts as reminiscent of him as of Rubens; and drawings such as these, perhaps made at Rubens' behest, could have remained in the older master's studio (and Rubens himself may have made studies of the same motif). It should also be noted that the drawing was initially classified at the Louvre as *École flamande* by Morel d'Arleux, and only later given to Rubens because of its connection with the Dresden painting.[6]

1 Adler, *op. cit.*, no. 18, fig. 53.

2 Compare the Cambridge drawing of a *Path through an orchard*, Adler no. 72, which is also repr. Exh. London, 1996–7, p. 89, fig. 86, where dated *c*.1615–18, the same period as the present work. Compare also the later *Entrance to a wood* in Oxford (Held, 1986 edn, no. 228, fig. 200 in reverse – a better reproduction in Exh. London, 1996–7, p. 91, fig. 88) and the two drawings in the British Museum, the *Landscape with wattle fence* and the *Trees reflected in water*, repr. *op. cit.* p. 93, figs 89–90. These three drawings are respectively Adler, nos 74, 75 and 77. The different handling of the Louvre drawing, which was especially apparent in the London exhibition, was already remarked upon, for example, by Vergara, 1982, p. 84.

3 Vey 86, Exh. New York-Fort Worth, 1991, no. 34. Compare also the penwork in the *Christ carrying the cross* in Antwerp, Vey 13, Exh. *cit.*, no. 4, with its comparable patches of cross-hatching, stippling and skeins of lines.

4 Chatsworth inv. 969. Pen and brown ink, touched with brown wash. 318 x 515mm. Adler, *op. cit.*, no. 27b, fig. 81; Held, 1986 edn, pp. 13–14, fig. 2. The early inscription on the drawing, *Ant. van dyck*, is generally believed to be autograph, although the design was engraved by Paulus Pontius as after Rubens. Other versions of the drawing are known and listed by Adler and Held, two of them in the British Museum.

5 Compare also the central foliage with that in the *Allegory of Brescia* after Titian, Vey 155, usually given to Van Dyck (although to Rubens by Held, 1986 edn, no. 30). M. Jaffé compared the Louvre sheet to the underdrawing of the version of the *Landscape with a shepherd* in a private collection, which he believed to be by Rubens (*Burlington Magazine*, CXI, 1969, p. 436, fig. 19), but its authenticity has been doubted by J. R. Martin and Julius Held (see Adler no. 24, with literature), and the underdrawing displays copious amounts of zig-zag hatching that is difficult to reconcile with the Louvre drawing, or with other works by Van Dyck or Rubens.

6 I am grateful to Catherine Legrand for drawing this to my attention. See Jacqueline Labbé and Lise Bicart-Sée, *La collection Saint-Morys au Cabinet des Dessins du Musée du Louvre (II): Répertoire des dessins*, 1987 (inv. no. 20.212).

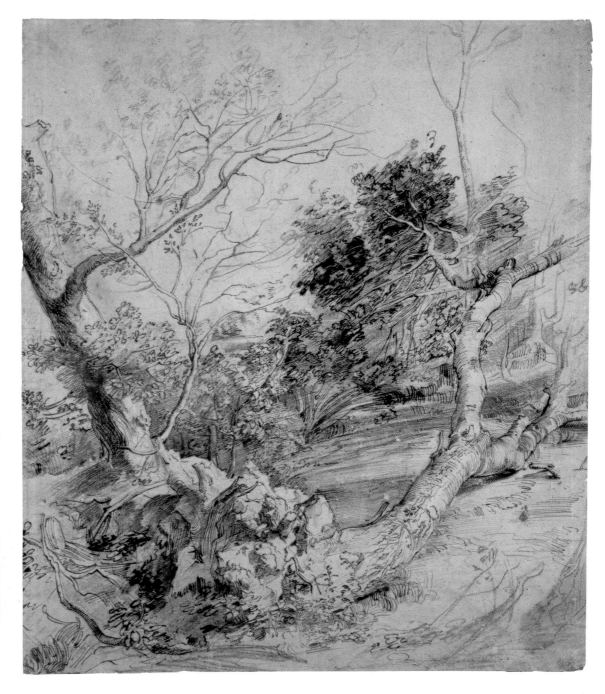

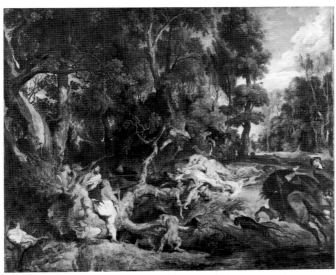

Fig. 2a Rubens (assisted by Van Dyck), *Landscape with a boar hunt*, *c*.1618, oil on panel, 137 × 168.5 cm. Dresden, Staatliche Kunstsammlungen, Gemäldegalerie.

3 VAN DYCK

Study of a fallen tree

Black chalk, touched with red chalk and yellowish-green wash. 184 × 310 mm.

PROVENANCE: William, 2nd Duke of Devonshire, and by descent.

Chatsworth, Devonshire Collection (985)

SELECTED LITERATURE AND EXHIBITIONS: Burchard and d'Hulst, 1963, no. 103; Adler, 1982, no. 28a, fig. 85; Held, 1986 edn, no. 117, fig. 117; Exh. London, 1996–7, p. 86, fig. 83.

The tree depicted is the same as that in the Louvre drawing (cat. 2), but seen from the side. The sketch was perhaps retained in Rubens' studio (unless Rubens himself made a sketch from the same motif, which is equally possible), as the same tree, similarly observed, appears in his painting of *Ulysses and Nausicaa* of the 1630s (fig. 3a).

A comparison with the Hamburg drawing of the *Taking of Christ* (fig. 11), is instructive. The abstract patterns of the branches as they taper away to the right in the present drawing are wholly consistent with Van Dyck's treatment of the branches in black chalk behind Christ.[1] Once more, the handling of the medium seems distinct from Rubens' more lyrical line. Black-chalk figure studies by Van Dyck of around 1618 also support the abandonment of the attribution to Rubens, which has been generally accepted hitherto, in favour of one to Van Dyck.[2]

1 The best reproduction of this drawing is in Exh. New York–Fort Worth, 1991, no. 34. In the 1929 typescript catalogue of the drawings at Chatsworth, the present sheet is listed as by 'Rubens or Van Dyck'.

2 Compare, for example, the *Study of Malchus* from Rhode Island, Exh. New York–Fort Worth, 1991, no. 35 (Vey 87).

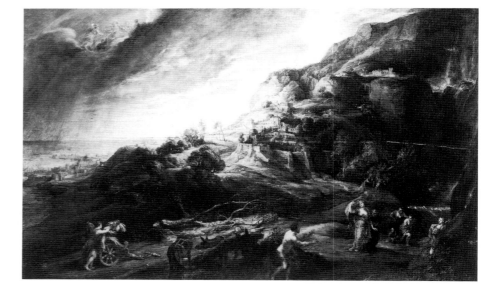

Fig. 3a Rubens, *Ulysses and Nausicaa*, panel, 126.5 × 205.5 cm. Florence, Pitti Palace.

4 VAN DYCK

A study of plants: oak leaves, needle furze and Mercurialis annua

Pen and brown ink with brown and grey wash over black chalk. 169 × 144 mm.

Inscribed (by J. Richardson, senior): *Van Dyck*.[1]

PROVENANCE: J. Richardson, senior (L.2184); Mrs L. Blackman, Liverpool; sale, London, Sotheby's, 10 May, 1961, lot 36.

Paris, Collection Frits Lugt, Institut Néerlandais (7490)

SELECTED LITERATURE AND EXHIBITIONS:
Exh. London–Paris–Bern–Brussels, 1972, no. 34; Vey 297; Exh. New York–Fort Worth 1991, p. 270.

The drawing shows on the left and top, oak coppice (*Quercus robur*), in the centre dog's mercury (*Mercurialis annua*) and on the right English broom (*Genista anglica*). The two latter plants are found chiefly near the fringes of woodland.

The traditional attribution seems plausible despite the steely cross-hatching, which is unusual for Van Dyck and harsh in comparison with no. 19, with which it has usually been associated because of its similar subject-matter. The present work is reminiscent of Jan Brueghel the Elder and could be earlier, and the rigid hatching has links with the Chatsworth *Dead tree overgrown with brambles* (cat. 1) as well as with the *Study of the head of a child* in the Uffizi (Vey 118), which may date from Van Dyck's years in Italy. The attribution of cat. 1 to Van Dyck rather than Rubens bolsters the traditional connection with the former, with its comparable displays of hatching and vegetation. It is therefore placed early in this catalogue, although a date as late as around 1630 might be advanced, more tentatively, for the present sheet.

That the young Van Dyck was already a consummate painter of plant details of this kind before his departure for Italy is demonstrated by several works, such as his *St Jerome* of *c*.1618 in Dresden, which in the foreground includes detailed depictions of shrubs and ferns.[2] Karel van Mander in 1604 encouraged painters to decorate their landscape foregrounds with vegetation.[3] Like those by Jacques de Gheyn and Hendrick Goltzius, such studies recall the celebrated *Piece of turf* (Rasenstück) and other drawings by Dürer.[4]

1 See L.2993–6. A similar inscription with Van Dyck's name, unusual for Richardson in being on the *recto* of the original sheet, appears on cat. 57 below.

2 Repr. Exh. Washington 1990–91, no. 8; Larsen 218.

3 As noted by Buijsen, 1992–3, p. 48.

4 As noted by Van Hasselt in Exh. 1972 (see Literature above).

5 VAN DYCK

Sketch of a hut on fire

Pen and brown ink with grey and brown wash on grey paper. 202 × 139 mm.

Inscribed upper right in brown ink: *g[e]elbr... / verbrant*; centre: *bau[w?] / rookt* and below by a later hand: *Dyk*

PROVENANCE: F. J. O. Boijmans.

Rotterdam, Museum Boijmans Van Beuningen (VD16)

SELECTED LITERATURE AND EXHIBITIONS: Vey 111; Exh. New York–Fort Worth, 1991, no. 44.

This exceptionally bold sketch, executed largely with the brush, stands apart not only from other drawings by Van Dyck but from its period as a whole for its wholly informal and powerfully abstract touch. It can be placed in Van Dyck's Italian years (1621–7) as it was made on the *verso* of a sketch of *St Matthew and the Angel* (see fig. 5a), a study for a painting now in the collection of the Marchesi F. and P. Spinola in Genoa.[1]

A painting of a *Fire at night*, said to be the work of Van Dyck, is listed in the 1678 and 1685 inventories of Alexander Voet, but no longer seems to exist.[2]

1 Repr. in Exh. New York–Fort Worth 1991, p. 164, fig. 1. The autograph status of the painting has been questioned, but it seems certainly to record a Van Dyck composition.

2 See the Introduction, p. 10.

Fig. 5a *Recto.*

6 VAN DYCK

Landscape near Genoa

Pen and greyish-brown ink and greyish-brown wash, with some blue watercolour in the sky, retouched in brown wash (perhaps by a later hand). 273 × 370 mm.

Inscribed by the artist: *fuori de Genua / quarto*

PROVENANCE: Sir Frederick Gore Ouseley; St Michael's College, Tenbury Wells; purchased in 1919 by George V.

Windsor, The Royal Collection (12972) © Her Majesty The Queen
Lent by Her Majesty The Queen

SELECTED LITERATURE AND EXHIBITIONS: Vey 282; White and Crawley 353.

The scene is populated by a rider crossing the bridge on the left, followed by a cowherd with his cattle, while another horseman appears on the right.

Apart from the previous drawing (cat. 5) and the insubstantial views in the Italian Sketchbook (see Introduction, figs 17–19), this is the only remaining landscape known to have been drawn by Van Dyck, as the inscription informs us, in Italy. It was presumably made from nature at some point between 1621–7, but as Van Dyck visited Genoa every year while he was in Italy it is difficult to be more precise. The treatment of the foliage already resembles his work in the 1630s (compare cat. 9), so that it may date from near the end of his Italian sojourn. The handling of the wooded hill in the distance to the right and of the foreground rocks might suggest some contact with Dutch Italianate artists such as Poelenburch and Breenbergh (see cats 44 and 46).[1]

Although departing from the intensely energetic manner that characterizes Van Dyck's early drawings, the *Landscape near Genoa* reveals that he was yet to develop fully the refined penmanship and atmospheric crispness of his landscapes of the 1630s.

The location mentioned in the inscription may be Quarto dei Mille, a village then situated approximately five miles or eight kilometres outside Genoa on the road to Nervi.

1 For the rocks compare Breenbergh's two-sided drawing *In the park of Castello Bomarzo*, now in the Lugt Collection, Röthlisberger, 1969, nos 42–3.

7 VAN DYCK

Landscape with a farm building

Pen and brown ink with brown wash. 297 × 198 mm.

Signed and dated by the artist: *A: van dyck F. 1632*
[?, cut away][1]

PROVENANCE: J. Richardson, senior (L.2184); S. Meller,
Budapest; O. Wertheimer, Paris; Dr M. Hartmann, Basel.

Private collection, Switzerland

SELECTED LITERATURE AND EXHIBITIONS: Vey 283;
Exh. New York–Fort Worth, 1991, pp. 266–7.

The inscribed date is not fully legible, but the
drawing probably belongs in the early 1630s. Its
unwieldy penwork and broad wash stand somewhat
apart from Van Dyck's other landscapes of the
1630s, the Washington sheet (cat. 8) providing the
closest analogies (the wiry lines across the fore-
ground; the brush outlines and hatching towards the
left of both sheets). The drawing retains something
of the vigour of the Louvre *Fallen tree* (cat. 2), the
spiralling lines towards the upper right of which are
echoed in a similar position on the present sheet.
The shading in freely sketched, narrow parallel lines
becomes a prevalent characteristic of Van Dyck's
later landscapes. The penwork is also somewhat
reminiscent of Italian draughtsmen,[2] including
Guercino and Mola (see cats 28 and 51).

1 Read by Vey as '162...', and therefore dated in the 1620s,
 but Ludwig Burchard thought he could make the date out as
 1632, which looks plausible (notes in the Rubenianum,
 Antwerp).

2 As suggested by Brown in Exh. New York–Fort Worth, 1991,
 p. 266.

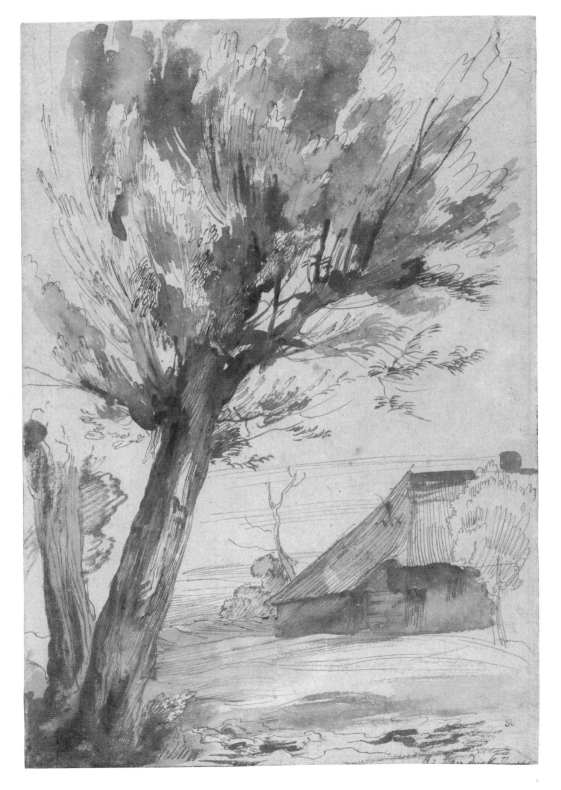

8 VAN DYCK

Two trees among bushes

Pen and brown ink with brush and brown wash.
201 × 261 mm.

Signed: *A: van dyck*

PROVENANCE: P. H. Lankrink (L.2090); J. Richardson, senior (L.2183); Thomas Hudson (L.2432); Joshua Reynolds (L.2364); the Earls Cowper; Lady Lucas; Mrs Spencer Loch; her sale, London, Christie's, 1 July 1969, lot 68.

Washington, National Gallery of Art; Syma Busiel Fund (1970.14.1)

SELECTED LITERATURE AND EXHIBITIONS: Vey 302; Exh. New York-Fort Worth, 1991, no. 88.

The date of the drawing has been disputed, but the analogies between the description of the scrub on the left with the tip of the brush and the passages to the left of cat. 7 suggest that it should be assigned like that sheet to the early 1630s. The dabbed foliage, especially in the crest of the tall tree on the left, is also comparable to cat. 5 and the penwork seems removed from the refinement of Van Dyck's later landscapes.

In spite of the unfinished state of the drawing, the presence of the artist's signature suggests that a free sketch from nature such as this could be appreciated on its own terms by his contemporaries.

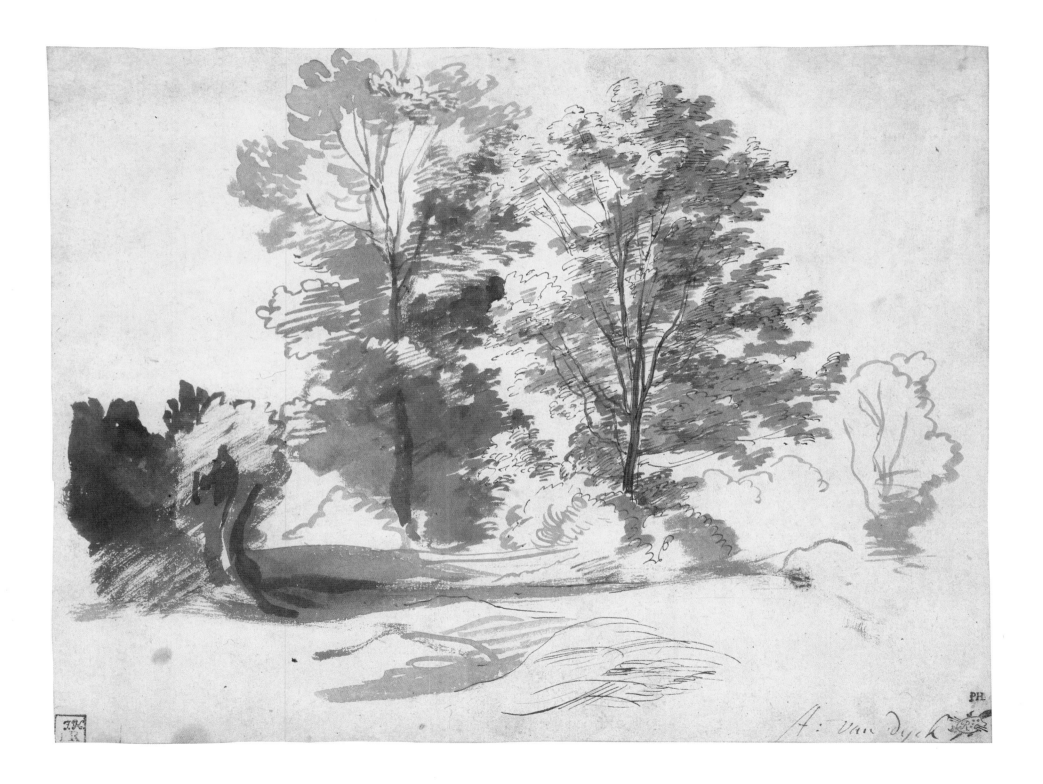

79

9 VAN DYCK

Two entwined trees

Pen and dark brown ink with brown wash and touches of watercolour. 278 × 360 mm (top corners made up). Watermark, cardinal's hat with the letters ND.

Inscribed: *A. V. Dyck*

PROVENANCE: Joshua Reynolds (L.2364); W. Mayor (L.2799); Dr A. Stix (L.2317a); A. Schmid (L.2330b).

Vaduz, Collection of the Prince of Liechtenstein

SELECTED LITERATURE AND EXHIBITIONS: Vey 301; Exh. New York–Fort Worth, 1991, no. 87.

The somewhat dry penwork resembles that of cat. 8 and the drawing may be only marginally later, perhaps from early in Van Dyck's English years. The use of colour also seems more tentative than in the more full-blooded watercolours (cats 20, 22–5), which are probably later.

As Van Dyck made the drawing he may have considered, in the back of his mind, the potential use of entwined trees as a decorative or even symbolic adjunct to the landscape backgrounds of his portraits. The motif was not original to him, and entwined trees are encountered in landscape art by the time of Titian and Campagnola, in whose work they become a regular feature. They also appear in compositions by the Carracci,[1] and by their northern contemporary Abraham Bloemaert (1564–1651).[2] Its potential as a symbol of, for example, love or unity, although not confirmed in published emblems, is suggested not only by the motif itself (the concept of interlocking forms) but also by the backgrounds of

numerous paintings in which such symbolism is appropriate,[3] although entwined trees also appear in neutral contexts. In portraits by Van Dyck they are found several times, including the *Sir George Villiers and Lady Katherine Manners as Adonis and Venus*, recently on the art market,[4] the *Woman and child* of c.1620–21 in the National Gallery, London,[5] the *Portrait of a boy as Tobias* of c.1623–5 in a private collection,[6] and the *Portrait of Baron Arnold le Roy of Zuyder Wijn* of c.1628–32 in the Metropolitan Museum.[7] They also emerge above the pair of lovers depicted to the left of Rubens' *Garden of Love* in the Prado.

Although not followed precisely, the present drawing was certainly referred to by Van Dyck when painting the *Portrait of James, 7th Earl of Derby with the Countess of Derby and their Daughter*, now in the Frick Collection, New York, a work of the later 1630s (see figs 9a–b).[8] Many parts of the configuration of the branches are identical, although the artist significantly thickened the trunks, omitted the tall vertical wisp to the right of them, and adjusted or simplified other details. The idea that the artist intended the entwined trees to symbolize the ideal of family unity seems reasonable, and the connection with the painting, which has not previously been noted, lends some support to the conjecture that the drawing was executed in England.

Fig. 9a Van Dyck, *Portrait of James, 7th Earl of Derby with the Countess of Derby and their Daughter*, canvas, 246.4 × 213.7 cm. New York, The Frick Collection.

Fig. 9b Detail of fig. 9a.

1 See Exh. Paris, 1990, no. 80. A drawing in Rotterdam attributed by Benesch to Jean Cousin also concentrates on the motif (inv.N.165).

2 For example, a drawing in the Rijksmuseum, inv.1898 A 3740 (repr. Exh. Amsterdam, 1987, no. 3).

3 For example, the *Rape of Ganymede* by Paul Bril in the Antwerp Museum voor schoone kunsten (inv. 5089), in the background to Hendrick Goltzius' engraved *Portrait of Josina Hamels* (Bartsch 213) and in Domenichino's frescoes in the National Gallery (especially NG 6287, *Apollo pursuing Daphne*).

4 Exh. Washington, 1990–91, no. 17.

5 NG 3011, Larsen 81 (that the trees are entwined is not clear in reproductions).

6 Larsen 398; Exh. Genoa, 1997, no. 48.

7 Larsen 544. The *Portrait of Sebastian Leerse with his wife and son* in Kassel is suggested by Vey, although the trees are there rather different (the painting is Larsen 539).

8 Larsen 833.

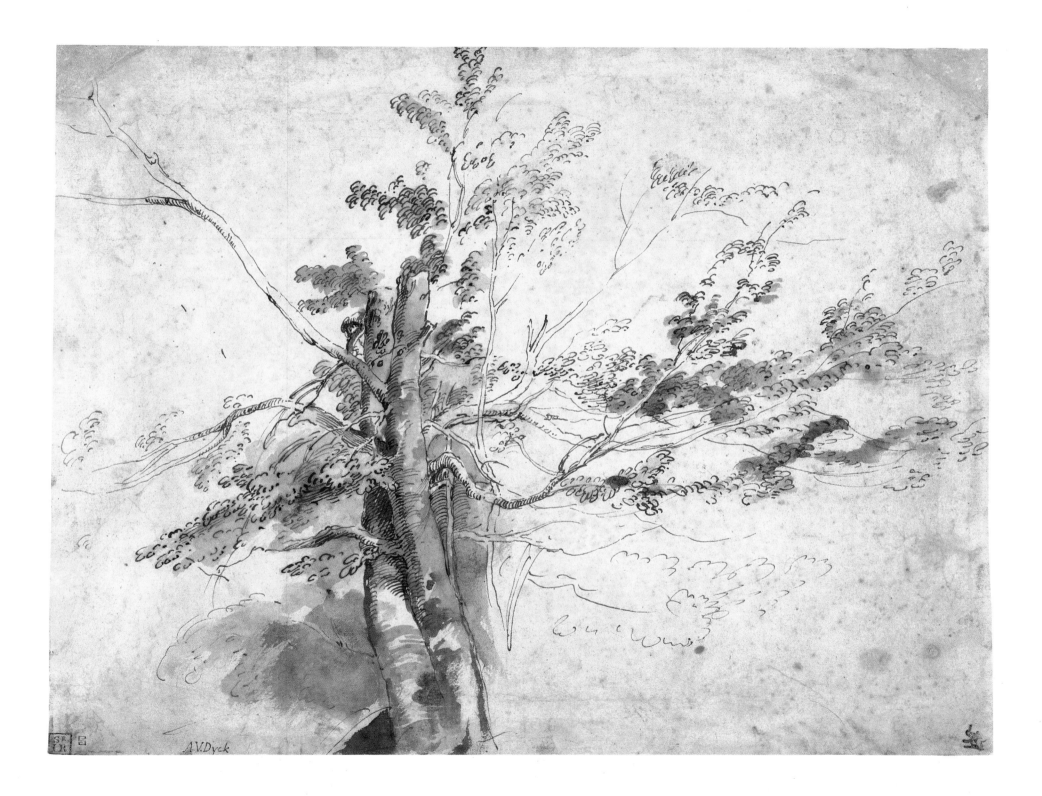

A.V.Dyck

81

10 VAN DYCK

Farmhouse near a brook with cattle

Pen and brown ink with brown, green and blue water-colour, touched with grey wash and graphite by a later hand. 280 × 406 mm. Watermark: Cardinal's hat with the letters ND.

PROVENANCE: R. Houlditch (L.2214); W. Russell; A. W. Thibaudeau, from whom purchased.

London, British Museum (1885-5-9-46)

SELECTED LITERATURE AND EXHIBITIONS: Hind 80; Vey 284; Exh. New York–Fort Worth, 1991, pp. 266-7.

The nearer tree is stylistically close to the entwined trees in cat. 9, with which the present sheet shares the same watermark. This suggests a date in the 1630s, despite the existence of looser analogies in the colour and handling of the tree to the right in the *Stoning of Stephen* at Tatton Park, painted in Italy *c.*1623-5.[1]

The overall effect of the drawing has been undermined by later rework in grey wash and graphite, and the grid of pen lines in the centre and the shaded passages below are now especially difficult to comprehend. The nearer tree resembles the one in cat. 25, but seen from the other side. The potential symbolism of a dead or dying tree was exploited by Van Dyck in his painting of *Cupid and Psyche* (see the Introduction, p. 22 and fig. 14).

The setting is unique in Van Dyck's work and anticipates those later depicted repeatedly by David Teniers the Younger, who generally populated them with carousing peasantry (see cat. 56).

1 Larsen 471. See A. Laing, *In Trust for the Nation*, Exh. London, National Gallery, 1995, no. 49, repr. in colour.

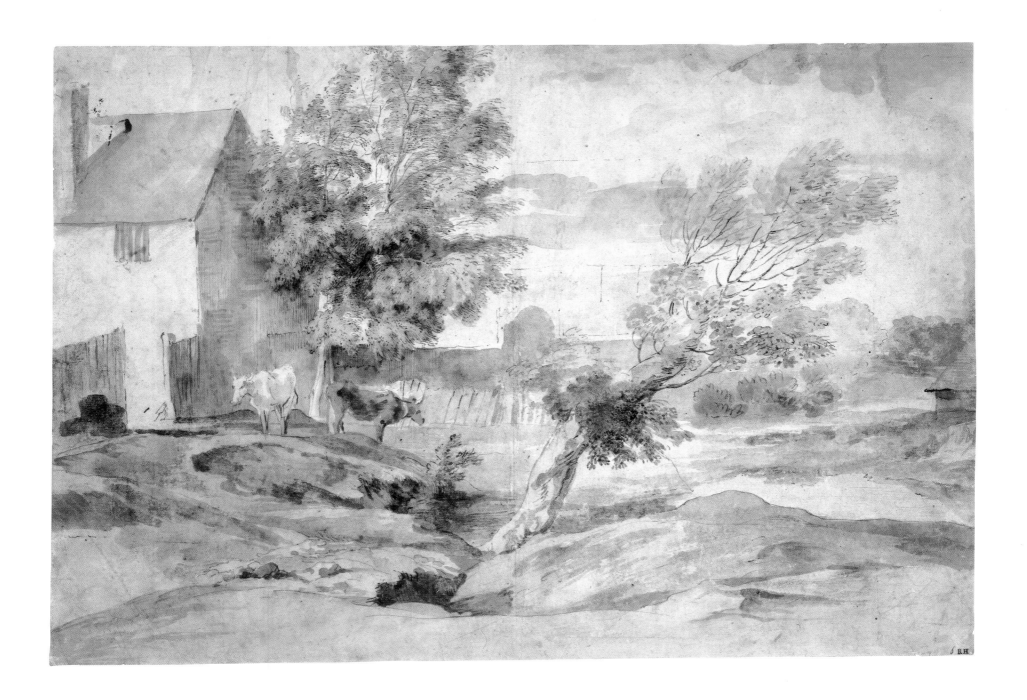

11 VAN DYCK

View of Antwerp

Pen and brown ink on brown paper. 152 × 228 mm. An extra strip of paper joined on the right. Watermark: eagle.

Signed and dated: *van dyck. F: aᵒ. 1632* and numbered: *110*

PROVENANCE: A. M. Bernard; Miss T. M. Bernard, Ipswich; Mrs M. Wilson; sale, London, Sotheby's, 21 March 1973, lot 8.

Koninklijke Bibliotheek/Bibliothèque Royale Albert Iᵉʳ, Brussels (F.27536)

SELECTED LITERATURE AND EXHIBITIONS: Vey 287; Exh. New York–Fort Worth, 1991, pp. 266 and 268; Exh. Antwerp, 1991, no. 25.

The drawing shows the harbour front with Steen Castle to the left of the imposing tower of the Cathedral. Although apparently drawn on the spot, the topography is inaccurate, as the two buildings are unrealistically close together and too near the water.

The date of 1632 on the drawing conflicts with the received wisdom concerning Van Dyck's portrait of *Maria de' Medici*, in which an almost identical vista appears in the background (fig. a).[1] The painting is usually dated 1631, because the sitter's secretary, Pierre de la Serre, admired 'le nouveau portrait' of her in December 1631. Conceivably the picture was still unfinished at that time; or La Serre was referring to another portrait.[2]

In style the drawing prefigures the 1633 *View of Rye* now in New York (cat. 12). The lines are more evenly applied here, the effect resembling an etching, and they lack both the variety and the detail of the later drawing. By 1 April 1632, Van Dyck was in London and remained there for the rest of the year, thus the drawing must be from before this date. On 28 January he was still in The Hague, painting the portrait of Constantijn Huygens who recorded the sitting in his diary, so that the present sketch was presumably made in February or March.

1 Musée des Beaux-Arts, Bordeaux; Larsen 511.

2 Brown, 1982, p. 131, refers to the three-quarter-length portrait in the collection of Lord Radnor at Longford Castle, which is usually rejected (Larsen A96/2). Ten versions apart from the Bordeaux painting and two *grisailles* are listed by Larsen, nos 512 and A96/1–9, the majority (including the Radnor picture) without the view of Antwerp behind.

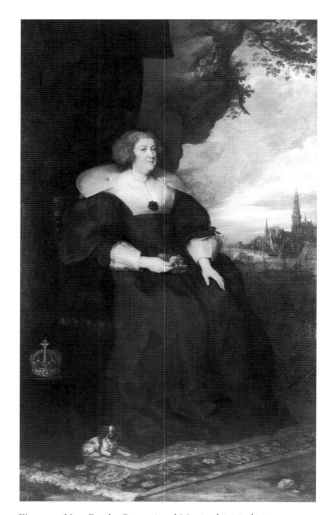

Fig. 11a Van Dyck, *Portrait of Maria de' Medici*, canvas, 246 × 148 cm. Bordeaux, Musée des Beaux-Arts (photo: Lysiane Gauthier).

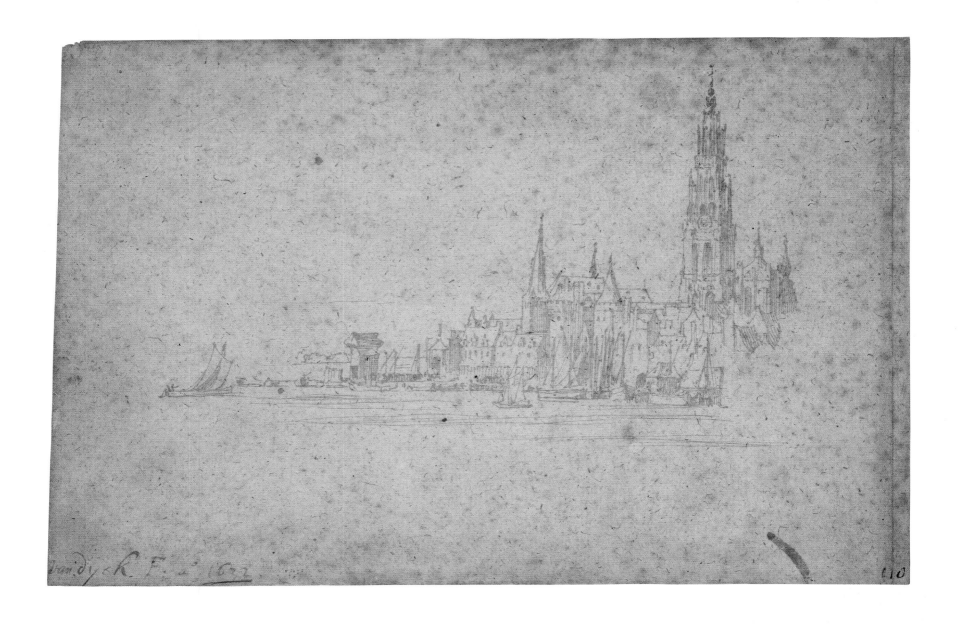

A view of Rye from the north east

Pen and brown ink. 202 × 294 mm.

Inscribed by the artist: *Rie del naturale li 27 dAug^to 1633*; and (probably also by the artist: *A Vand* [cut away]

PROVENANCE: J. Richardson, senior (L.2183); J. van Rijmsdijk (L.2167); C. Fairfax Murray; J. P. Morgan.

New York, The Pierpont Morgan Library (III, 178)

SELECTED LITERATURE AND EXHIBITIONS: A. M. Hind, 'Van Dyck's Landscape Drawings: a Discovery', *Illustrated London News*, 20 March 1937, pp. 484–5; Vey 288; Exh. Paris–Antwerp–London–New York, 1979–80, no. 32; Exh. London, 1972, no. 122; Exh. London, 1982–3, no. 81; F. Stampfle, *Netherlandish Drawings ... in the Pierpont Morgan Library*, 1991, no. 272; Exh. New York–Fort Worth, 1991, no. 73.

Rye, situated on the Sussex coast and one of the Cinque Ports, was in Van Dyck's day the busiest harbour on the south coast of England. There were regular sailings for Dieppe, the commonest route to the Continent, but these and the local fishing trade gradually diminished from the sixteenth century with the inexorable silting-up of the harbour, seen here on the left, and of Romney Marsh. It now lies more than two miles from the sea.

The town is still dominated by the Gothic church of St Mary (see fig. 12a), a mixture of Transitional, Norman and Early English styles. Below this, the drawing shows the twin towers of the Landgate at the entrance into Rye of the London Road, studied from the west in another drawing by Van Dyck (see fig. 15b). The gate, which like the Ypres Tower (here visible on the left – see also cats 14–15) still survives, formed part of Rye's defensive walls and was constructed in the fourteenth century. To the right of it is the chapel of the Austin Friars. Outlined immediately to the right of the Ypres Tower are the distant, drum-like forms of Camber Castle (sometimes called Winchelsea Castle) which lies about a mile beyond the town.

The drawing is the most elaborate and splendid of the five that Van Dyck is known to have made of Rye (see nos 13–15, and cat. 15, fig. 15b). Dated 1633, it was drawn from the cliffs near Playden to the north east of the town. The *repoussoir* of grass and brambles is an unusual and Rubensian feature, perhaps added as an afterthought in darker ink and with a thicker nib. Elsewhere, the penwork is delicate and precise in recording such details as the nets strung between the jetties, the miniature figures in the lower centre as they pass the poles by the edge of the road, the long ladder propped against the roof of the nearest large building, and innumerable other details.

Of the other drawings of Rye, only that now in the Uffizi (cat. 13) is also dated, but in the following year, when Van Dyck is known to have sailed for Flanders. No such journey is recorded in August 1633, but this or some other reason must have brought him to the town at that time.[1]

Van Dyck's drawing formed the basis of a depiction of the town by Wenceslaus Hollar, executed in silverpoint and engraved as an illustration on his Map of Kent of 1659 (fig. 12b).[2] The drawing of Rye by Jacob Esselens included here (cat. 60) depicts a similar vista, taken from slightly further east so that Camber Castle appears in the distance to the left of the Ypres Tower. The view was represented again in a late seventeenth-century painting of Rye from the north east now in the local Rye Museum.[3]

When copied by Hollar, the drawing was presumably still in England, where it was later seen by George Vertue. In his notebooks he questioned the authenticity of the drawing: 'it planely enough appears to be some free strokes on the foreground like his pen and his hand, but all the small and distant part I.Q^u. if it is his pen'.[4] Modern commentators have rightly disagreed.

Fig. 12a *View of Rye from the north east* (recent photograph; Peter Greenhalf, Rye).

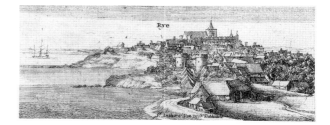

Fig. 12b Hollar, *Map of Kent* (detail), etching. London, British Museum.

1 Documents of 26 August 1633 – one day before the drawing – record that Queen Henrietta Maria tried to place Van Dyck's brother, Theodoor, a Norbertine friar, in her service. Theodoor is thought to have visited London at that time and Van Dyck might therefore have met him at Rye, or taken him there, on 27 August. But if they had been in London the previous day they must have ridden through the night.

2 The connection with Hollar's map was discovered by A. M. Hind (see Lit. above). Hollar's preparatory drawing is illustrated in Exh. New York–Fort Worth, 1991, p. 236, fig. 2.

3 The painting has been attributed to the circle of Hendrick Danckaerts, and shows the town from a similar but more elevated viewpoint.

4 See *Walpole Society*, XXVI, 1937–8, p. 60.

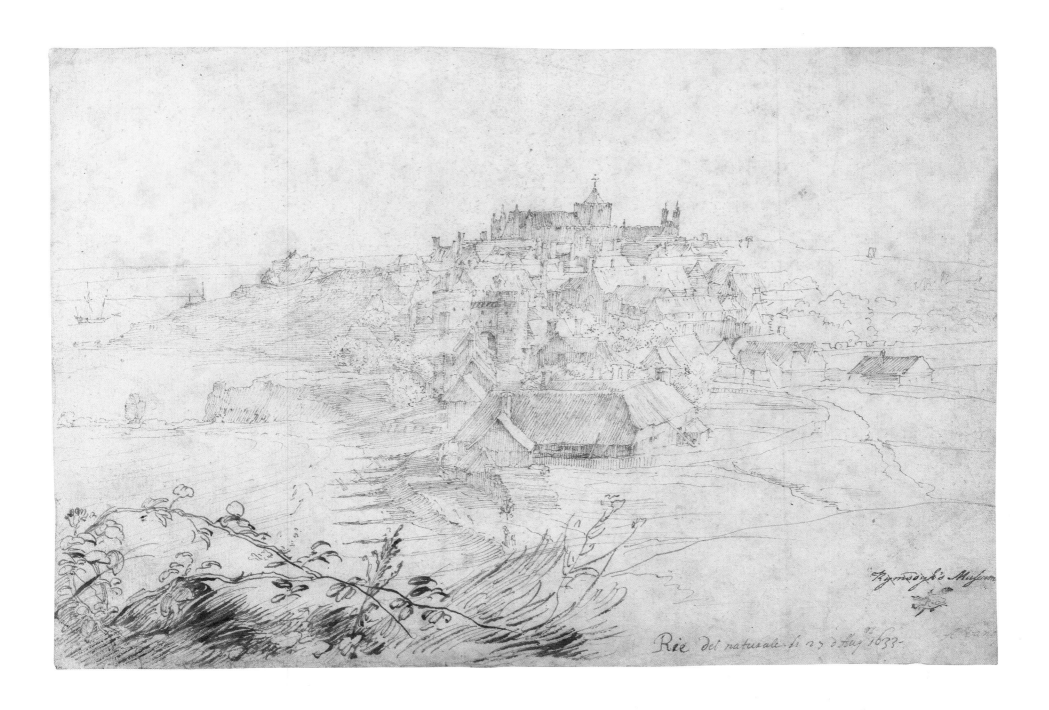

Ric del naturale li 27 d'Aug 1633-

13 VAN DYCK

A view of St Mary's, Rye

Pen and dark brown ink. 160 × 270 mm. Watermark: jug.

Signed and dated: *van dyck F 1634*

PROVENANCE: listed in the 1793 inventory of Leopoldo de' Medici.

Florence, Gabinetto disegni e stampe degli Uffizi (762P; photo: Bardazzi Fotografia)

Exhibited in Antwerp only

SELECTED LITERATURE AND EXHIBITIONS: Vey 289; Kloek, 1975, no. 411; Exh. London, 1982–3, no. 82; Exh. New York–Fort Worth, 1991, p. 234.

St Mary's dominates the town of Rye. A Romanesque church, much of what is visible in the drawing consists of Gothic and Tudor additions made when the town's community still flourished from the sea trade (see further cat. 12 above).

The church is observed from the sea (now dry land, see fig. 13a) and the drawing was perhaps made by Van Dyck on leaving England for Flanders in the spring of 1634. The Cambridge drawing (cat. 14) was made nearby – the buildings from the church to the arch on the extreme right appear in both, but observed from a different angle – and probably on the same occasion.

The style, especially of the foreground rocks, seems to be informed by Leonardo da Vinci (see fig. 13b),[1] whose drawings now at Windsor, including the one reproduced here, Van Dyck could have known in the collection of his patron, Thomas Howard, Earl of Arundel.[2]

Fig. 13a *View of Rye* (recent photograph).

Fig. 13b Leonardo, *Study of rocks*, pen and brown ink over black chalk, 185 × 268 mm. Windsor, The Royal Collection © Her Majesty The Queen.

1 Windsor Castle, the Royal Library, inv. 12394.

2 I am grateful to Jane Roberts for confirming this surmise. Some of the drawings were in London by 1627 (see *Leonardo da Vinci*, Exh. London, Hayward Gallery, 1989, p. 18).

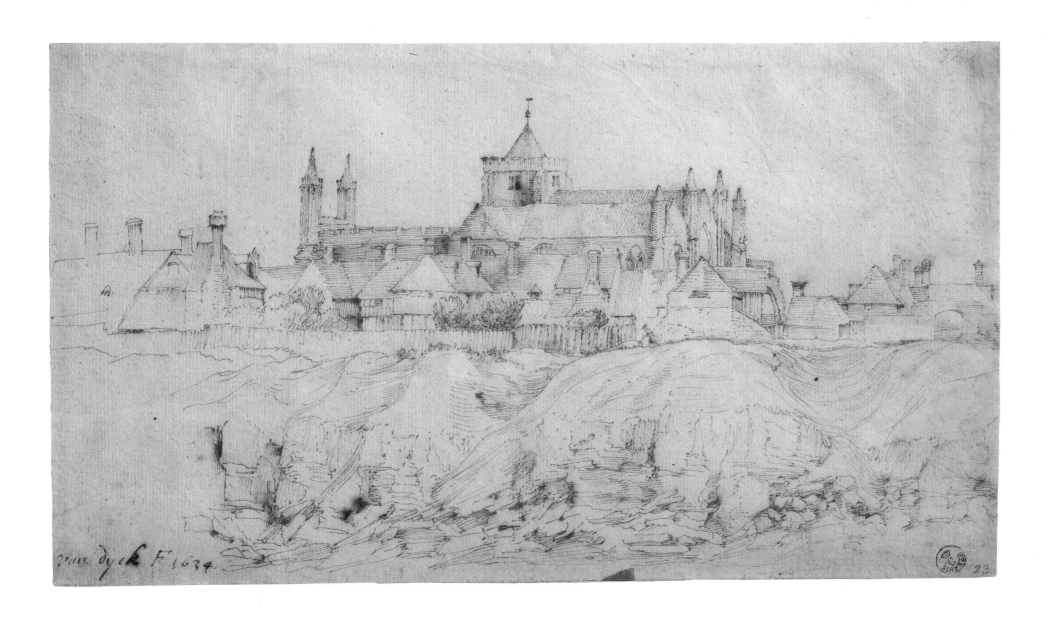

van dyck F 1634.

View of the coast at Rye with the Ypres Tower

Pen and brown ink. 189 × 298 mm.

Signed: *Ant⁰ v. dyck* F.

PROVENANCE: J. Richardson, senior (L.2184); Miss
H. Solly; her sale, London, Sotheby's, 21 December 1936,
lot 39a, bt Colnaghi for Ingram; Sir Bruce Ingram, by
whom bequeathed, 1963.

Cambridge, Fitzwilliam Museum (PD.282–1963)

SELECTED LITERATURE AND EXHIBITIONS: Vey 290;
European Drawings from the Fitzwilliam, Exh. New York,
Pierpont Morgan Library, and elsewhere, 1976–7, no. 69;
Exh. New York–Fort Worth, 1991, p. 238.

The view was taken from a boat to the south of Rye
(see fig. 14a), from a position about 100 metres to
the west of cat. 13, and like that drawing the present
sketch probably dates from 1634. Some of the
same buildings appear in both, with the east end of
St Mary's church here on the extreme left. The sheet
is of a similar size to the Rotterdam drawing of the
Ypres Tower at Rye (cat. 15).

The tower was lifted from the Cambridge drawing
for the building in the background of Van Dyck's

Portrait of Everhard Jabach of *c.*1636–7 now in the
Hermitage, St Petersburg,[1] and again in the portrait
of *Theodorus Rogiers* engraved after Van Dyck by
Pieter Clouwet for the *Iconography*, Van Dyck's
series of portraits of distinguished contemporaries
(figs 14b–c).[2] The composition of the latter follows
that of Jabach's portrait closely, and the engraving
appears to have substituted Rogiers for the original
sitter, for unknown reasons (Jabach does not feature
in the *Iconography*).

Neither sitter was particularly associated with Rye
and the tower was probably employed only as a
symbol of fortitude in general terms, the reason for
the appearance of castles in many other portraits of
the period, including some by Van Dyck.[3]

In the drawing Van Dyck captures evocatively the
evening sunlight glancing along the clifftops and the
upper part of the tower, and passing through the
shallow arch at the roofline.

1 Larsen 883.

2 Mauquoy-Hendrickx 156.

3 Indeed, the same drawing might have inspired the building
glimpsed in the background of the *Equestrian Portrait of
the Prince of Savoy-Carignan* in Turin (repr. Exh.
Washington, 1990–91, no. 71; Larsen 986). Another tower
(not unlike that in cat. 23) appears in the landscape
background of the double portrait of *Charles I and
Henrietta Maria* now at Kremsier or Kromeríz in the Czech
Republic (Larsen 806; Exh. Washington, 1990–91, cat. 62),
the details of which are clearer in Robert van Voerst's
engraving of the picture of 1634 (Hollstein 3, repr.
A. Griffiths, *The Print in Stuart Britain 1603–1689*, Exh.
London, British Museum, 1998, no. 42). Brown and
Filipczak suggest linking the motif with Jabach's travels
through Rye (respectively in Exh. New York–Fort Worth
1991, p. 238, and Exh. Washington 1990–91, p. 59).

Fig. 14a *View of Rye* (recent photograph).

Fig. 14b Van Dyck, *Portrait of Everhard Jabach*, canvas,
113 × 1.5 cm. St Petersburg, Hermitage Museum.

Fig. 14c P. Clouwet after Van Dyck, *Portrait of
Theodorus Rogiers (Theodoor Rasier or de Rasières)*,
from the *Iconography*, engraving, 281 × 201 mm.
London, British Museum.

THEODORVS ROGIERS
ANTVERPIENSIS. CÆLATOR IN ARGENTO

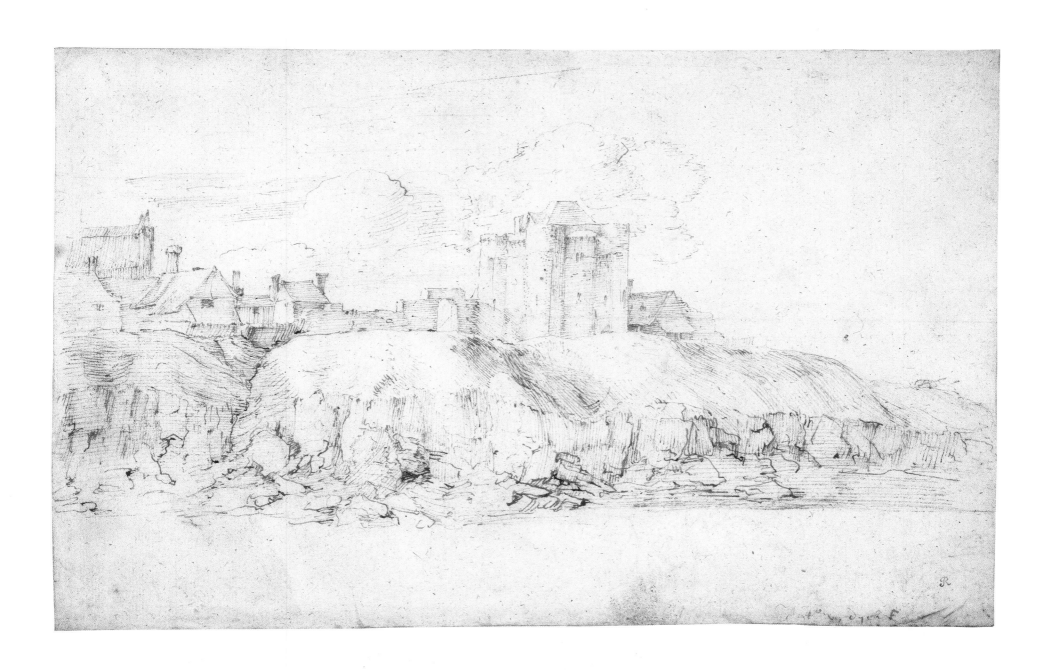

91

15 VAN DYCK

The Ypres Tower at Rye

Pen and brown ink. 193 × 298 mm.[1]

Signed or inscribed, lower right: *A. van dyck*

PROVENANCE: De Robiano sale, Amsterdam, 15–16 June 1926, lot 368; F. Koenigs; presented by D. G. van Beuningen, 1941.

Rotterdam, Museum Boijmans Van Beuningen, (V.18)

SELECTED LITERATURE AND EXHIBITIONS: Vey 291; Exh. London, 1987, no. 54; Exh. New York–Fort Worth, 1991, no. 74.

See cats 12–14. Like them, the drawing was presumably made in 1633–4. The tower (see fig. 15a) was originally the keep of the castle at Rye constructed by Peter of Savoy in the mid-thirteenth century. It was later named after John of Ypres, who bought it in 1430. In World War II the roof and uppermost section of the building were destroyed.

In this and one other drawing of the *Landgate at Rye* by Van Dyck (fig. 15b), which has been extensively reworked by a later hand, the artist concentrated on a specific motif of the town's medieval architecture.[2] Together with the views from the north east and the south (cats 12–14) the five drawings of Rye would have provided useful strategic information about this important seaport, but the artist's motives for making them may have lain in their potential for incorporation into the backgrounds of his portraits, as occurred with cat. 14.

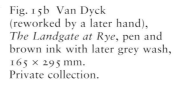

Fig. 15a *The Ypres Tower today* (recent photograph).

Fig. 15b Van Dyck (reworked by a later hand), *The Landgate at Rye*, pen and brown ink with later grey wash, 165 × 295 mm. Private collection.

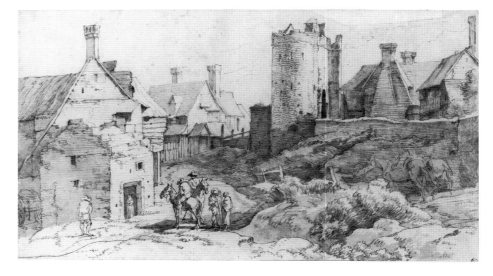

1 The area of the drawing to the left of the tower is damaged.

2 Sold Christie's, Amsterdam, 13 November 1995, lot 87, repr. The underlying penwork is by Van Dyck. Johan Bosch van Rosenthal identified the view and attributed the drawing to Van Dyck. The *verso* has a fragmentary sketch of the top of some trees (in the manner of cats 17–18) and is inscribed: *A Vandek julienne* and, according to a note on the mount, was sold, Paris, 1767, lot 150. It has recently been published by H. Faber, 'Sir Anthony van Dyck: The Landgate at Rye aus einem Skizzenbuch von 1633–34', *Delineavit et Sculpsit*, 19, 1998, pp. 8–13

16 VAN DYCK

A beached ship at low tide

Pen and brown ink. 195 × 290 mm.

Signed: *A: van dyck*

PROVENANCE: J. Richardson, senior (L.2184); sale, London, Christie's, 19 November, 1952, lot 6; H. M. Calmann; M. Kroyer; Ian Scott, by whom sold, London, Christie's, 5 July 1994, lot 113.

Private collection

SELECTED LITERATURE AND EXHIBITIONS: Vey 292.

This richly evocative drawing is made with breath-taking control and sensitivity. The delineation of the rigging, with lines reduced to an almost unbelievable thinness, is extraordinarily precise. The lack of strong contrasts and shadows suggests an overcast stillness, broken only by the entrance of a bird on the right, a somewhat perfunctorily drawn creature that might have strayed from a landscape by Bruegel or Joos de Momper.

Ships appear in the backgrounds of several portraits by Van Dyck, but never in the form seen here (they are usually depicted in full sail, suggesting positive connotations that a beached ship could hardly convey). Difficult to date, the drawing was perhaps made in around 1634, like the dated *Trees on a hillside* (cat. 17). The signature is almost identical to that on cat. 18, and all three drawings may show the same hillside with two huts at its foot. Whether the view is an English one, as has often been assumed, it is impossible to know for certain, although the surmise is reasonable.[1]

1 See further under cat. 17.

A: van dyck

95

17 VAN DYCK

Trees on a hillside

Pen and brown ink. 185 × 280 mm (made up with two patches at top left and lower-left centre).

Signed and dated by the artist: *van dyck F: 1634*

PROVENANCE: P. H. Lankrink (L.2090); J. Richardson, senior (L.2184); Richard Payne Knight bequest, 1824.

London, British Museum (Oo.9–49)

SELECTED LITERATURE AND EXHIBITIONS: Hind 83; Vey 294; Exh. London, 1982–3, no. 83.

Both the following drawing (cat. 18) and the previous one (cat. 16) may depict the same hillside. Here the variety of the penwork is more marked, from the calligraphic freedom of the *repoussoir* on the left to the detailed passages in the middle-distance. Two cottages are visible, one behind the trees on the hill in the centre and another, perhaps two, to the right. The freshness of handling and the unconventionalized, informal composition are especially marked, and the atmosphere is conveyed convincingly.

Whether the drawing, which is dated 1634, was made in England or Flanders is uncertain. Van Dyck was in Antwerp in 1634 by 28 March, and seems to have spent the rest of the year there. The high-pitched gables of the cottages are reminiscent of those in Flemish landscapes of the period (e.g. by David Vinckboons) and the foliage is perhaps too full for the first stages of spring.[1] Nonetheless, the patches of greenery in the centre of the Uffizi drawing of Rye (no. 13), also dated 1634, are comparable, and the steep slope would be characteristic of the Sussex landscape. We will probably never know for certain where cats 16–18 were made.

In Van Dyck's portrait of *Prince Rupert*, now in Vienna, the artist followed a section of the present drawing, to the right of centre, rather closely (see figs 17a–c).[2] The painting, usually thought to have been executed in Holland in 1632, therefore cannot have been completed before 1634. The sitter was then fourteen years old (he was born on 17 December 1619),[3] and while the Prince's appearance in the Vienna portrait does not disqualify the possibility that it was begun only in 1634, it seems more likely that Van Dyck took his likeness in the form of a sketch two years before, and finished the picture later.

1 Oppé, 1941, p. 190.

2 Larsen 561.

3 The pendant portrait (Larsen 560) of his brother Charles Louis, born almost exactly two years earlier, could also have been completed in 1634 (when he was sixteen). For the style and architectural background compare, for example, the *Portrait of the Abbé Scaglia* from the Camrose collection of *c.*1634–5 (Larsen 989).

Fig. 17a
Van Dyck,
*Portrait of Prince
Rupert*, canvas,
175 × 95.5 cm.
Vienna,
Kunsthistorisches
Museum.

Fig. 17b Van Dyck, *Portrait of Prince
Rupert* (detail of fig. a).

Fig. 17c Detail of cat. 17.

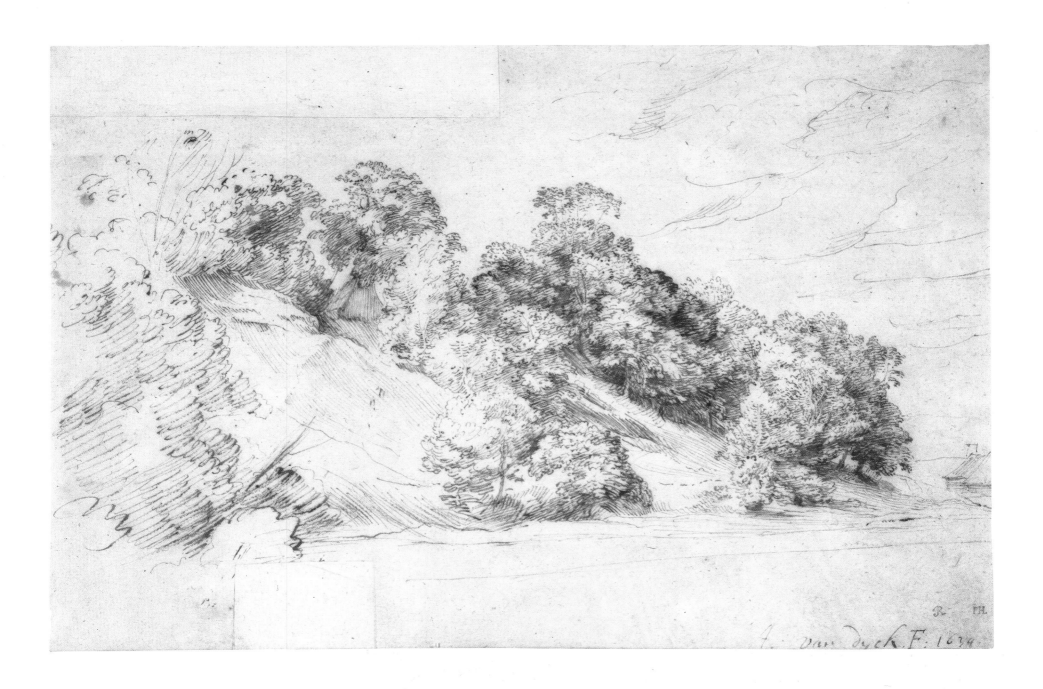

f. van dyck. F: 1634.

18 VAN DYCK

A wooded slope with farm buildings

Pen and brown ink. 189 × 299 mm. Watermark: jug.

Inscribed, lower right, by the artist: *A: van dyck* and on the *verso*: *Mon ... / Monsieur*

PROVENANCE: J. Richardson, senior (L.2184); Earl of Warwick (L.2600); purchased from P. & D. Colnaghi.

London, British Museum (1897–4–10–16)

SELECTED LITERATURE AND EXHIBITIONS: Hind 84; Vey 293; Exh. London, 1987, no. 58.

Like the previous drawing (cat. 17), the present sketch was probably made in 1634, either in England or Flanders. Once again, Van Dyck concentrates on the middle distance, but here the screen of trees is knit together by lines of parallel hatching in a manner reminiscent of his earlier drawing in the Louvre (cat. 2). The precision of the penwork implies an unremitting, sharply focused gaze and evokes a crisp, splintery clarity of light.

Comparable passages of landscape appear in the background of the *Portrait of an elderly woman* of 1634 in the Kunsthistorisches Museum, Vienna and the *Portrait of Isabella van Assche* of the same period in Kassel.[1]

1 Larsen 963 and 1016 respectively. The observation was made by White and Stainton in Exh. London, 1987, no. 58.

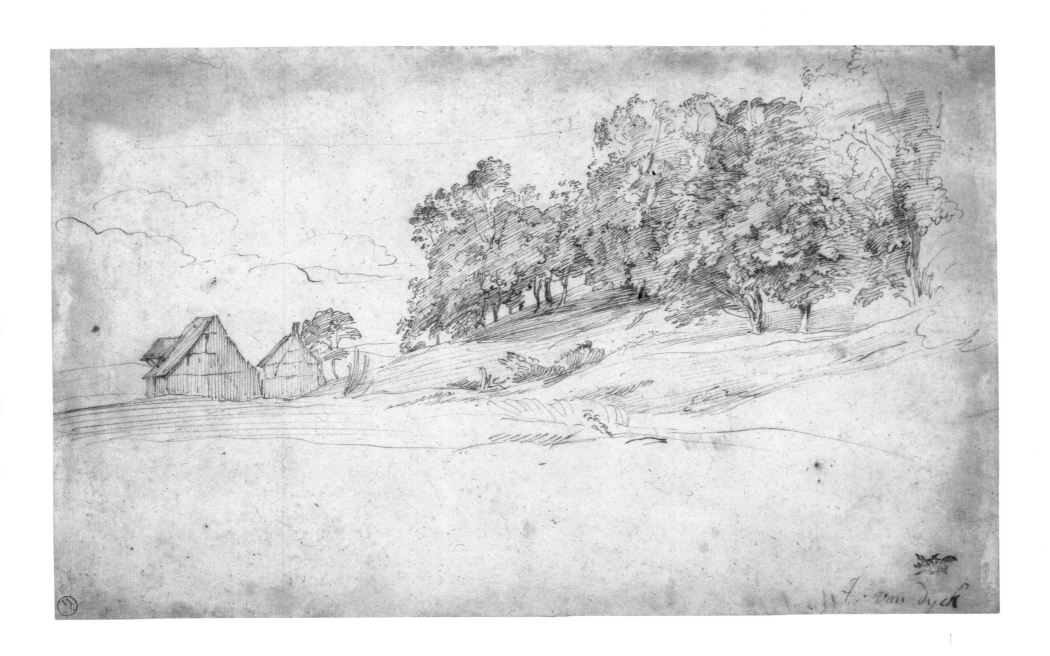

A study of plants, with corn sow-thistle, nettles and a daisy

Pen and brown ink with brown wash. 213 × 327 mm. Watermark: bunch of grapes.

Inscribed by the artist, upper right: *on bord cron semel. Soufissels, nettels. gras. trile gras. / nyghtyngale on dasy / foernen* and signed or inscribed: *A vandijck*

PROVENANCE: J. Richardson, senior (L.2184); W. Russell; A. W. Thibaudeau, from whom purchased.

London, British Museum (1885-5-9-47)

SELECTED LITERATURE AND EXHIBITIONS: Hind 85; Vey 296; Exh. London, 1972, no. 123; Exh. London, 1982–3, no. 84; Exh. London, 1987, no. 55; Exh. New York–Fort Worth, 1991, no. 85.

The drawing probably represents the following plants: on the extreme left greater celandine (*Chelidonium maius*), in the centre the large prickly leaves of corn sow-thistle (*Sonchus arvensis*), with behind stinging nettle (*Urtica dioica*), in the foreground common quaking grass (*Briza media*), top right a daisy (*Bellis perennis*) and to the right lady fern (*Athyrium filix-femina*). The inscribed name 'nyghtyngale', an early spelling of nightingale that is recorded in the *Oxford English Dictionary*, can refer either to herb robert (*Geranium robertianum*), greater stitchwort (*Stellaria holostea*), to *Arum maculatum*, or to other, less precisely determined cuckoo flowers. Spring is suggested by the types and sizes of the identifiable plants, which bring to mind King Lear's reference to 'Hardokes, Hemlocke, Nettles, Cuckoo flowres, Darnel and all the idle weedes that grow in our sustaining corn'. With the exception of the thistle, it is only as deleterious or useless vegetation that they could have had any emblematic meaning – unlikely raw material for use in Van Dyck's portraits, as has been suggested in the past.[1] (A mythological or biblical scene involving death is more probable.) The inscriptions in English suggest the country in which the drawing was made, and the style points to around the mid-1630s. The study of a similar motif in the Lugt collection (cat. 4), with its more angular line and impetuous shading, looks to be earlier.

Vegetation appears in the foreground of numerous works by Van Dyck from all periods of his career, but never in the precise form seen here. The thistle in the foreground of his portrait of *Lord George Stuart, seigneur d'Aubigny* of the late 1630s in the Earl of Darnley's collection is perhaps the closest, although much of this work was probably executed by studio assistants.[2] Some of the vegetation in the foreground of two works in the National Gallery in London are comparable, *Charles I on horseback* (see figs 1 and 20a) and the *Portrait of the 1st Earl of Denbigh*.[3]

1 For examples of the symbolism of plants and flowers in portraits of the period, including the potential symbolism of the thistle as an emblem of fidelity, see Exh. Haarlem, 1986, e.g. cat. 20.

2 See Exh. London, 1982–3, no. 61, repr., where Sir Oliver Millar points out that a rose and thistle were combined as emblems of the King by Peacham in his *Minerva Britannia*, 1612, 12, and in Wither's *Collection of Emblemes*, 1635, bk.iv, 24. The idea that the painting is a marriage portrait is worthy of consideration (the sitter secretly married Katherine Howard, daughter of the 2nd Earl of Suffolk, in 1638).

3 Larsen 795 and 512 respectively. A superior reproduction of the latter in Exh. London, 1982–3, colour pl. IV.

20 VAN DYCK

A study of trees

Pen and brown ink with brown wash and watercolour.
195 × 236 mm.

PROVENANCE: J. Richardson, senior (L.2184); Sir Joshua
Reynolds (L.2364); Richard Payne Knight, by whom
bequeathed, 1824.

London, British Museum (Oo.9–50)

SELECTED LITERATURE AND EXHIBITIONS: Hind 82;
Vey 303; Exh. London, 1982–3, no. 56; Exh. New
York–Fort Worth, 1991, p. 35.

The nearer tree just to the left of centre appears in a
similar form in Van Dyck's *Charles I on horseback*
in the National Gallery (figs 20a–b and fig. 1).
The date of this is uncertain, though probably
from after the artist's return to London in 1635.[1]
The inspiration for the portrait and its landscape
background was provided by Titian's *Charles V at
Mühlberg* of 1648 in the Prado.[2]

As elsewhere, Van Dyck employs the washes of
watercolour in the drawing both to clarify and
extend the description of the foliage. A copy of the
drawing, attributed to Thomas Girtin, is in a private
collection.[3]

1 As noted by Vey 303 (the painting is Larsen 795). Most
writers prefer a date in the late 1630s, though Larsen suggests
*c.*1635–6. A *modello* is in the Royal Collection (Larsen 793).
Vey kindly drew my attention to the mention of a drawing
by Van Dyck, now unidentified, in Thomas Lawrence's
collection, 'A Curious Landscape being a view on the Thames
which served for the back ground to the Picture of Charles I
on Horseback' (transcribed from p. 67 of the typescript copy,
in the British Museum, of the MS catalogue of Lawrence's
collection of drawings in the Royal Academy Library).

2 A comparison first made by Bellori, 1672, p. 260.

3 Photograph in British Museum file.

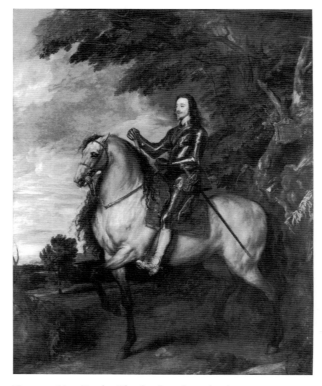

Fig. 20a Van Dyck, *Charles I on horseback*, canvas,
367 × 292.1 cm. London, National Gallery.

Fig. 20b Detail of fig. 20a.

21 VAN DYCK

Landscape with two tall trees

Pen and dark-brown ink. 198 × 306 mm (trimmed
irregularly). Watermark: fleur-de-lys with word of five or
six letters below.

Inscribed on the *verso* with the number from the Milford
collection: *N⁰ 165* and *Vandyke*

PROVENANCE: Richard Philipps, Baron Milford (L.2687);
Sir J. Philipps, Bt.; H. Calmann, from whom acquired by
F. Lugt, 1946.

Paris, Collection Frits Lugt, Institut Néerlandais (5922)

SELECTED LITERATURE AND EXHIBITIONS: Vey 308;
C. van Hasselt, *Flemish drawings of the seventeenth
century*, Exh. London–Paris–Bern–Brussels, 1972, no. 35.

Generally placed towards the end of Van Dyck's
English years, the composition has affinities with
the following drawing (cat. 22). The present work
is difficult to date although the sparing outlines
suggest that Van Dyck intended to include wash or
watercolour to complete the drawing, as was
apparently his manner in the mid-1630s. The water-
mark resembles that on the drawing from the
Metropolitan Museum (cat. 25).

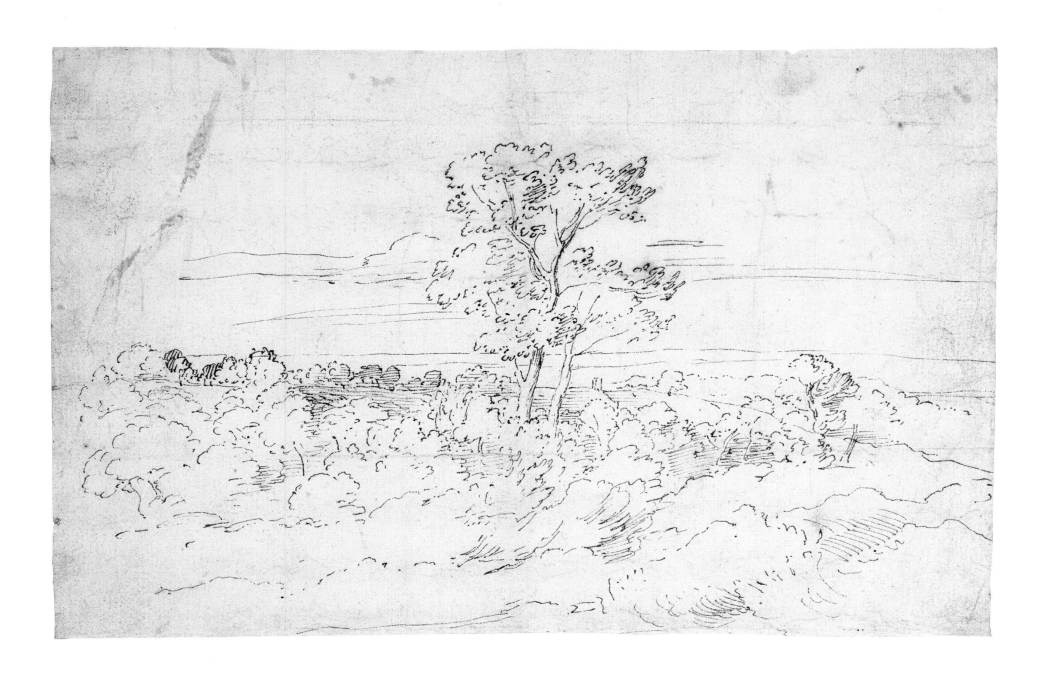

22 VAN DYCK

Wide landscape with a tall tree

Pen and brown ink with brown wash and watercolour.
189 × 363 mm.

PROVENANCE: N. A. Flinck (L.959); 2nd Duke of
Devonshire and descendants at Chatsworth; their sale,
London, Christie's, 3 July 1984, lot 58, bought
Schickman.

Los Angeles, The J. Paul Getty Museum (85.GG.96)

SELECTED LITERATURE AND EXHIBITIONS: Vey 307;
G. Goldner, *Catalogue of the collections, J. Paul Getty
Museum, European Drawings I,* 1988, no. 88; Exh. New
York–Fort Worth, 1991, no. 91; Exh. Wellesley–
Cleveland, 1993–4, no. 16.

This is one of Van Dyck's most spectacular
drawings in watercolour. Of an unusual, panoramic
format, it was probably made in the mid-1630s.
Although never directly cited in his paintings,
similar passages appear in the landscape back-
grounds of several of Van Dyck's portraits and in
the *Woman in mythological garb (Erminia)* in the
collection of the Duke of Marlborough, which also
includes a house with a white gable similar to the
one in the drawing.[1]

1 Larsen 1042, the connection first suggested by Vey. Jan
Mijtens (*c.*1614–70), active in The Hague, regularly used
comparable motifs (see especially the background of his
Portrait of six children in a landscape offered at Sotheby's,
New York, 30 January 1998, lot 9, repr.).

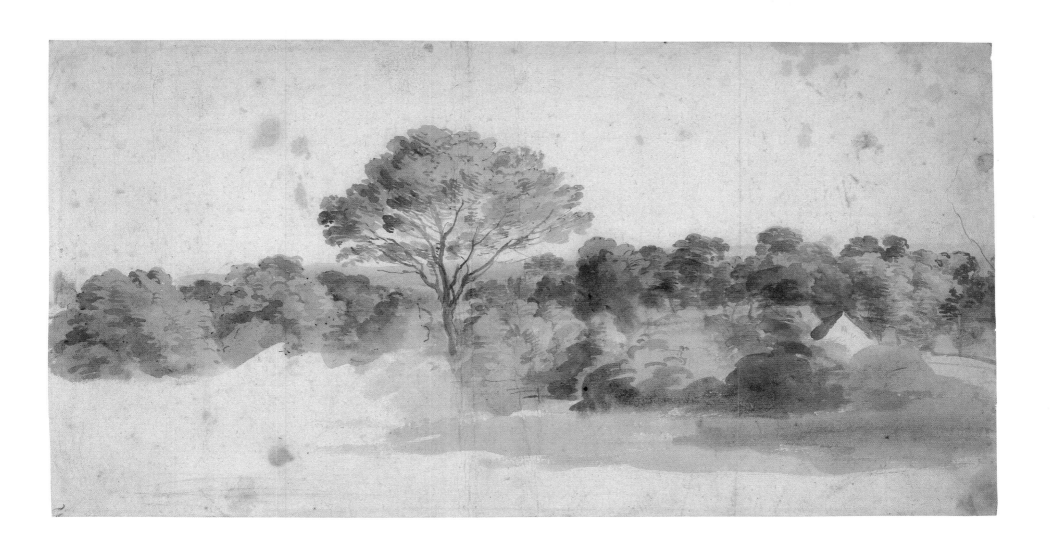

107

23 VAN DYCK

A hilly landscape with trees and a distant tower

Pen and brown ink with grey wash and blue and green water-colours with some gum arabic.[1] 228 × 330 mm.

Inscribed *verso*: *16 lanschappen van van dyck*

PROVENANCE: the Dukes of Devonshire, by descent.

Chatsworth, Devonshire Collection (1003)

SELECTED LITERATURE AND EXHIBITIONS: Vey 306;
Exh. London, 1982, no. 85; Exh. London, 1987, no. 57;
Exh. New York–Fort Worth, 1991, no. 90.

This view anticipates in its direct observation of a given motif many of the effects achieved by English water-colourists of the eighteenth and nineteenth centuries, from Paul Sandby and Thomas Gainsborough to Thomas Girtin and the young J. M. W. Turner (see also cat. 24). The location, which includes not only the tower but a less distinct church and other buildings in the centre, has not been identified. On grounds of style the drawing is datable to the mid-1630s, the same period as cat. 24. Its sketchy, unfinished appearance also relates it to cats 20 and 22.

The inscription on the *verso* in Dutch (see above) has been ascribed to N. A. Flinck (see fig. 23a). His collection was sold to the 2nd Duke of Devonshire in 1723/4 but included many fewer than sixteen landscapes by Van Dyck.[2]

Fig. 23a *Verso* inscription (photo: Courtauld Institute of Art).

1 On this medium, see cat. 34, n. 1.

2 See nos 22, 23 and Vey 305 (Introduction, fig. 21), and perhaps also cats 1 and 3, although their early attributional history is uncertain (the 1929 typescript catalogue of the drawings at Chatsworth lists cat. 1 as Rubens and cat. 3 as 'Rubens or Van Dyck').

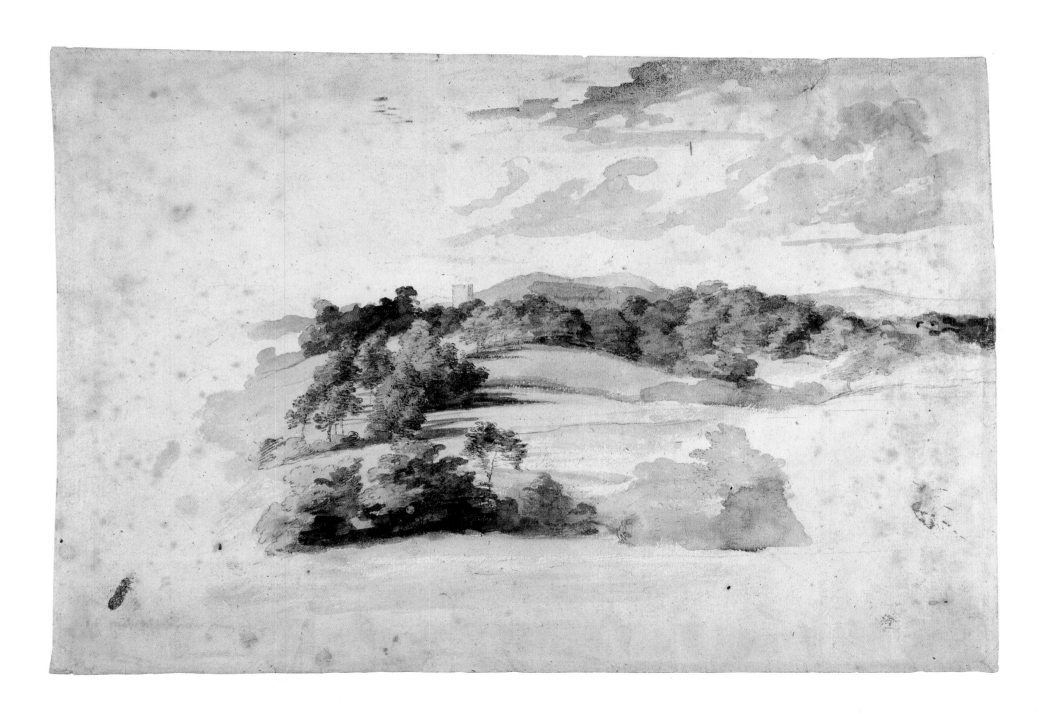

24 VAN DYCK

A coastal landscape with trees and ships

Pen and brown ink with watercolour and bodycolour.
189 × 266 mm.

PROVENANCE: J. Richardson, senior (L.2184); A. Pond
(L.2038); Sir William Fitzherbert, from whom purchased
by the Barber Institute in 1939.

*Birmingham, Barber Institute of Fine Arts, Birmingham
University (39.20; photo: Bridgeman Art Library)*

SELECTED LITERATURE AND EXHIBITIONS: Vey 304;
Exh. London, 1982–3, no. 86; *Barber Institute Catalogue*,
Birmingham, 1983, no. 37; Levey, 1983, pp. 106–7;
H. Miles and P. Spencer-Longhurst, *Master Drawings in
the Barber Institute*, Exh. London, Morton Morris and
Co., 1986, no. 11; Exh. New York–Fort Worth, 1991,
no. 89 (with further literature); *Art Treasures of England.
The regional collections*, Exh. London, Royal Academy,
1998, no. 98.

Neither the location depicted nor the date of the
present drawing is known, nor was it employed
directly for a painting.[1] The breadth of handling
suggests a period somewhat later than the drawings
of 1634 (cats 13 and 17) and it was therefore
almost certainly made in England.

Like the Chatsworth watercolour (cat. 23, *q.v.*)
the drawing suggests with a restricted range of
colours a sense of atmosphere as convincing as
any rendered in the same medium before the late
eighteenth century. Van Dyck's mastery of the
watercolour medium is revealed by the fluency of
his touch, the harmony of colour and the variety of
textures he deploys, ranging from the precise and
flawless penwork in the foreground tree to the
combined breadth and delicacy of the transparent
washes. Much of the middle-ground is rendered
entirely with the brush in a brilliant technical
display. The richly foliated trees suggest full
summer, and the long shadows moving to the left
indicate (as we are probably looking approximately
south towards the English coast) late afternoon,
with the sun low in the west. Movement of the air is
suggested by the angle of the masts and the flapping
sails of the ships in the distance. These are gathered
in a bay near a small town in an estuary, with a
further promontory indicated beyond. The location
cannot be identified, and although it is tempting to
think once more of Rye (see cats 12–15), the
absence of the church or any other landmark of the
town argues otherwise.

Ships are depicted in a comparable way in Van
Dyck's portraits of Algernon Percy, 10th Earl of
Northumberland, at Alnwick Castle.[2]

1 Professor Hamish Miles connected the elements of the
landscape with the background of the portrait of *Charles I
hunting* in the Louvre (here fig. 2) of around 1635 (see Exh.
cit., London, 1982–3, under no. 86, and 1986, under no. 11).

2 Larsen 924–5.

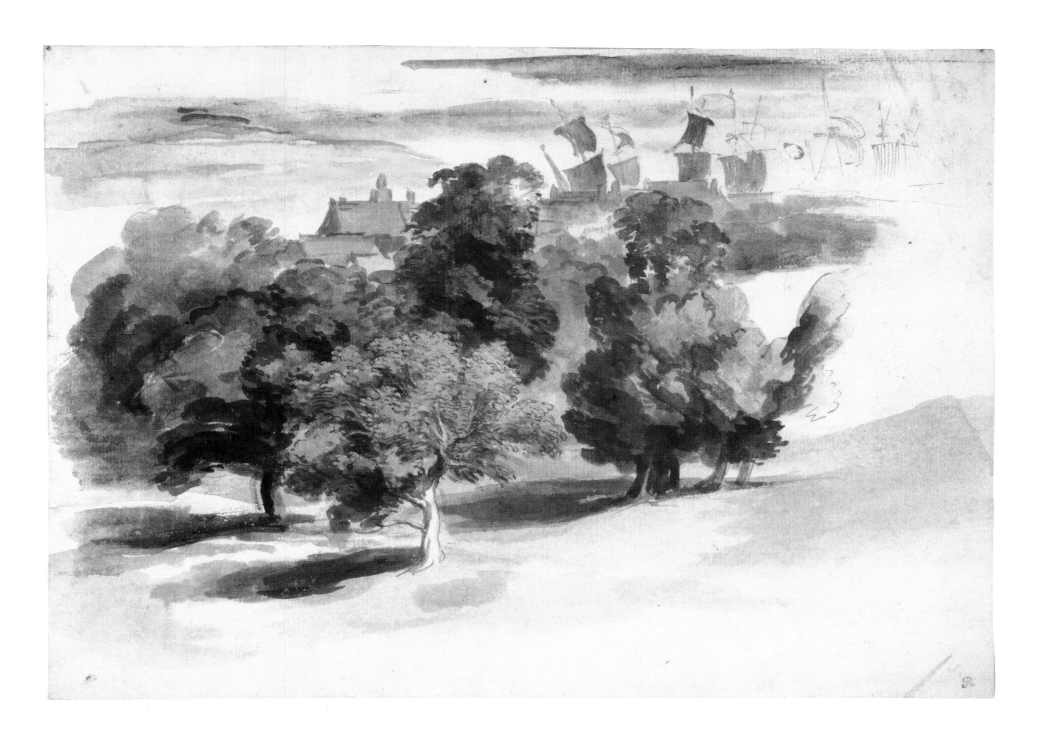

25 VAN DYCK

Landscape with a gnarled tree and a farm

Pen and dark-brown ink. 222 × 322 mm (cut irregularly).
Watermark: fleur-de-lys with indecipherable name below.

Inscribed on the *verso*: $N^o 278$ and in an early hand, in
Italian, with details of Van Dyck's date and place of birth
and death.

PROVENANCE: Baron Milford; Sir John Philipps, Bt.; Dr and
Mrs Frances Springell; Hazlitt, Gooden and Fox Ltd,
London; private collection; purchased, Lila Acheson Wallace
gift, by the Metropolitan Museum of Art.

*New York, Metropolitan Museum of Art, Lila Acheson
Wallace gift (1997.22)*

SELECTED LITERATURE AND EXHIBITIONS: Vey 300;
Exh. New York–Fort Worth, 1991, no. 86.

The reticent line of the drawing suggests a later date
than the studies of Rye (cats 12–15) of 1633–4.
The sparse use of the pen evokes a range of textures
and details, from the gnarled foreground tree-trunk –
comparable to that in cat. 10, *q.v.* – to the wispy lines
of the horizon. The watermark resembles that of
cat. 21.

The drawing was probably made from nature, and
the common symbolic *vanitas* connotations of a dead
or dying tree were perhaps not specifically intended
here, although Van Dyck was aware of the potential
symbolism of such a motif (see the Introduction, p. 22
and fig. 14).

II
DRAWINGS BY OTHER ARTISTS

26 DOMENICO ZAMPIERI, IL DOMENICHINO

(Bologna 1581–1641 Naples)

Landscape with river and cliffs

Pen and brown ink over black chalk. 257 × 268 mm.

PROVENANCE: bequeathed by the artist to his pupil, Francesco Raspantino; Carlo Maratta; Pope Clement XI; James Adam; King George III.

Windsor, The Royal Collection (1528) © Her Majesty The Queen
Lent by Her Majesty The Queen

SELECTED LITERATURE AND EXHIBITIONS: J. Pope-Hennessy, *The Italian Drawings at Windsor Castle. The Drawings of Domenichino*, London 1948, no. 1677, pl. 65.

This and two other drawings by Domenichino, one of which apparently shows the same stretch of river from further to the left (but looking more towards the right, see fig. 26a), were used in his pair of landscape paintings of around 1621–2, now in the Louvre, depicting *Hercules and Acheloüs* and *Hercules and Cacus* (fig. 26b). Probably painted while Domenichino was working in the Villa Ludovisi, they were first owned by Cardinal Ludovico Ludovisi. The *Hercules and Cacus* repeats with variations the escarpment, river and some of the trees to the left of the present sheet.[1]

Domenichino's landscape paintings underwent a considerable development during this period, when the drawings may also have been made.

Having trained with Denys Calvaert and the Carracci, he was at this time collaborating on landscape paintings in the Villa Ludovisi with Paul Bril (1554–1626) and Guercino (for whom see cat. 28). The influence of the Carracci is felt in the style of the drawing, but it is more convincingly naturalistic than almost any of their surviving productions.

Domenichino helped to establish landscape as a significant subject for painters in Italy, and can be seen as a bridge between the Carracci on the one hand and, on the other, the heroic ideal of Poussin (see cat. 45), who drew in Domenichino's studio on his arrival in Rome, and the more lyrical ideal of Claude Lorrain (cats 48–9).[2] As one of the leading artists active in Rome, Domenichino's work was probably of some interest to Van Dyck during his sojourn in the city. Although no direct contacts between them have been recorded, Van Dyck copied a Titian painting owned by the Ludovisi in Rome in his Italian sketchbook;[3] and according to Roger de Piles, writing in 1677, perhaps apocryphally, Domenichino and Van Dyck were among the painters commissioned by Lucas van Uffel in a competitive spirit.[4]

Fig. 26a Domenichino, *Landscape*, pen and brown ink over black chalk, 211 × 262 mm. Windsor, The Royal Collection (JPH 1678) © Her Majesty The Queen.

Fig. 26b Domenichino, *Hercules and Cacus*, canvas, 121 × 149 cm. Paris, Musée du Louvre (photo: RMN).

1 The other two drawings are Pope-Hennessy, *op. cit.*, nos 1674 (which suggests the general layout of the *Hercules and Acheloüs*) and 1678 (here fig. 26a, which includes the hut and some of the other architecture seen in the *Hercules and Cacus*). The connection does not seem to have been previously remarked. The date of the paintings is taken from Richard E. Spear, *Domenichino 1581–1641*, Exh. Rome, Palazzo Venezia, 1996–7, nos 36–7 (in *ibid.*, *Domenichino*, 2 vols, 1982, nos 82–3, pls 260–61, the paintings are placed a year later). Pope-Hennessy no. 1674 may also have formed the starting-point for the *Landscape with Erminia and the shepherds*

of the same period, also in the Louvre (Spear no. 84, pl. 262). The Louvre paintings are also catalogued by Stéphane Loire, *Musée du Louvre. Département des peintures. École italienne, XVIIᵉ siècle, I. Bologne*, 1996, pp. 189–94 and pp. 206–10.

2 See Denis Mahon, 'I primi anni del paesaggio ideale', in *Classicismo e natura*, Exh. Rome, Musei Capitolini, 1996–7, pp. 9–13.

3 See Adriani, 1940, under folio 56 *recto*.

4 See the Introduction, p. 28 and n. 55.

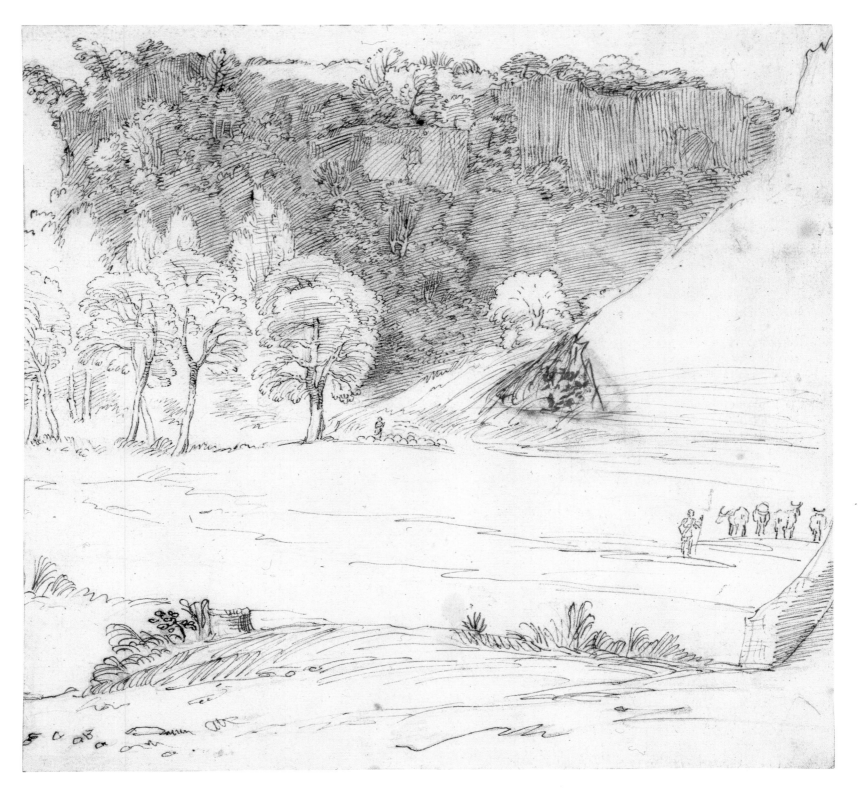

27 FILIPPO NAPOLETANO
(Naples or Rome *c.*1587–1629 Rome)

Landscape in Tuscany

Pen and brown ink with brown wash. 156 × 294 mm.

Inscribed, lower left: 26

PROVENANCE: Leopoldo de' Medici.

Exhibited in Antwerp only

Florence, Gabinetto disegni e stampe degli Uffizi (411P)

SELECTED LITERATURE AND EXHIBITIONS: Chiarini, 1972, no. 32; *ibid.*, in
Il seicento fiorentino, Exh. Florence, Palazzo Strozzi, 1986–7, II, p. 104,
under no. 2.152.

Filippo Napoletano[1] worked in Naples at the start of his career
(from 1600–13 or later), and came under the influence of northern
landscape painters while in the city, including Paul Bril and Adam
Elsheimer. In Rome soon afterwards, his penchant for landscape was
further developed through contact with the work of Agostino Tassi,
who was also inspired by Bril.

The drawing, one of a group of landscapes by Filippo in the Uffizi,
is thought to date from the artist's years in Florence (1617–21), as
the view depicted looks Tuscan. The style reflects his knowledge of
Jacques Callot, with whom he worked in the city (although few of
the latter's surviving drawings appear to have been made directly
from nature). In their spontaneous approach to the landscape and
fluid technique, Filippo's drawings encapsulate qualities that were
developed by Van Poelenburch and Breenbergh a few years later in
and near Rome (see cats 44 and 46), whither he himself returned in
the 1620s. His work was also important for Claude (see cats 48–9)
and, probably after a further visit to Naples, Salvator Rosa.

Writing in 1642, Giovanni Baglione asserted that Filippo worked
out of doors at Tivoli,[2] and the present drawing reveals his
competence when sketching directly from nature. His facility with the
brush, although perhaps inspired by Callot, anticipates the freedom
with which both Claude and Van Dyck used washes in their land-
scapes from the 1630s. The central fold suggests that the drawing was
made across the gutter of a sketchbook, and the *verso* of the left half
contains a rough landscape sketch in graphite.

1 His name has variants – Filippo de Llano, Liagno, d'Angeli or d'Angelo – but he is
generally called Filippo Napoletano.
2 *Vite*, ed. V. Marani, 1935, pp. 335–6. As pointed out by Sluijter-Seijffert, 1984,
p. 49, Baglione could have been referring to drawings rather than to paintings as is
usually assumed (he talks of *alcuni pezzi di paesi piccoli imitate dal naturale...* –
'some small landscape pieces imitated from nature').

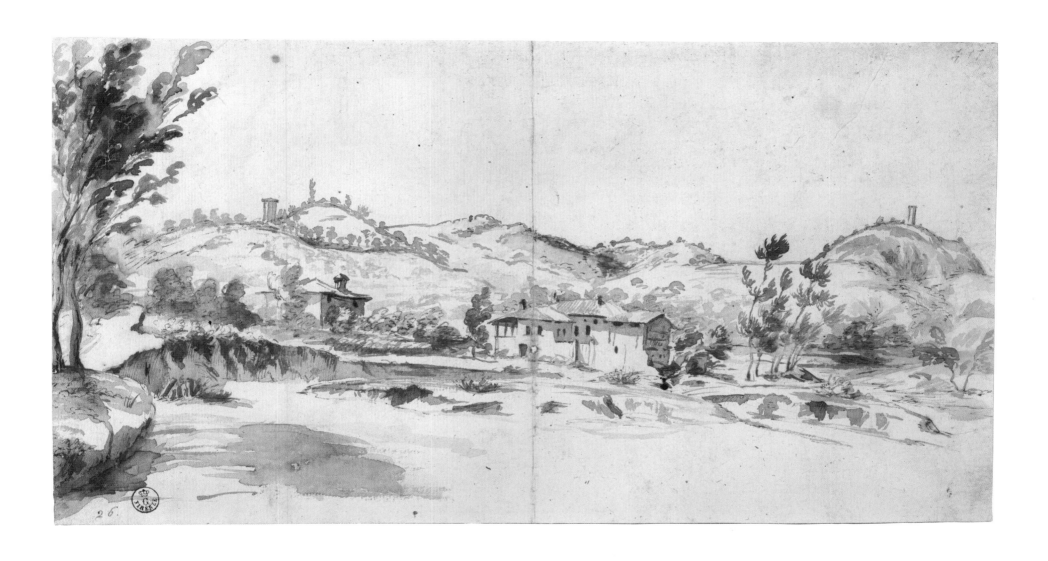

26.

28 GIOVANNI FRANCESCO BARBIERI, called IL GUERCINO

(Cento 1591–1666 Bologna)

Coastal landscape

Pen and brown ink. 148 × 281 mm.

PROVENANCE: Casa Gennari; King George III.

Windsor, The Royal Collection (2723) © Her Majesty The Queen
Lent by Her Majesty The Queen

SELECTED LITERATURE AND EXHIBITIONS:
D. Mahon and N. Turner, *The Drawings of Guercino in the Collection of Her Majesty the Queen at Windsor Castle*, 1989, no. 238; N. Turner and C. Plazzotta, *Drawings by Guercino from British Collections*, Exh. London, British Museum, 1991, no. 178.

Although less idealized than the majority of Guercino's landscape drawings, the *Coastal landscape* was probably not drawn directly from nature. Yet, celebrated as he was for the rapidity of his execution, the style of his penmanship, with its precision and linear striations, at times suggests a knowledge of northern landscapists.[1] In the present case the composition may also be compared with one by Van Dyck (fig. 28a),[2] although the connection must be indirect – Guercino's surviving landscape drawings may all have been made after he left Rome in 1623, the earliest dated one being from 1626.[3] The similarities between these two drawings perhaps chiefly reflects the admiration of both artists for the work of Titian (see fig. 28b).[4]

Van Dyck's interest in Guercino is documented in his Italian sketchbook, which contains a copy after the Bolognese master's painting of the *Magdalene with two angels* (Vatican Museums) – or after a preparatory sketch for it.[5] The picture was completed at the end of Guercino's period in Rome from 1621–3, years in which Van Dyck, in Rome in 1622 and 1623, could well have encountered him. During this period Guercino may have had contact with landscapists in the eternal city.[6]

Fig. 28a Van Dyck, *Landscape with a river*, pen and brown ink, 81 × 209 mm. London, Victoria and Albert Museum (D.911–1900).

Fig. 28b Titian, *Landscape with a castle*, pen and brown ink, 136 × 267 mm. London, British Museum (1895–9–15–832).

1 This apparent influence in some of Guercino's landscape drawings was suggested by Denis Mahon, *I disegni del Guercino della collezione Mahon*, 1967 (a corrected reprint of part of the exhibition catalogue, *Omaggio al Guercino*, Cento, 1967).

2 Vey 298, where rejected as a copy (wrongly in my view; the treatment of the scrub closely resembles that in the Uffizi drawing of Rye, here cat. 13). There are some slight sketches in red chalk on the *verso*.

3 See Mahon and Turner, *op. cit.*, pp. 101–2, for Guercino's landscapes. The inscription on the 1626 drawing in the Uffizi (590–P) does not, however, state that it was made from nature, as is there suggested. The chronology of Guercino's landscapes is uncertain, the only other date, 1635, being on the *verso* of one of a suite of three drawings at Windsor (Mahon and Turner nos 247 and 248–9).

4 Discussed by K. Oberhuber, *Disegni di Tiziano e della sua cerchia*, Exh. Venice, Fondazione Cini, 1976, no. 38.

5 See Adriani 140, folio 6 *recto*. Differences in the pose of the Magdalene suggest that Van Dyck saw a preliminary sketch rather than the completed work.

6 See S. Zuffi, 'Il paesaggio classico: Guercino e Van Poelenburgh', *Osservatorio delle arti*, 1990, no. 4, pp. 79–81.

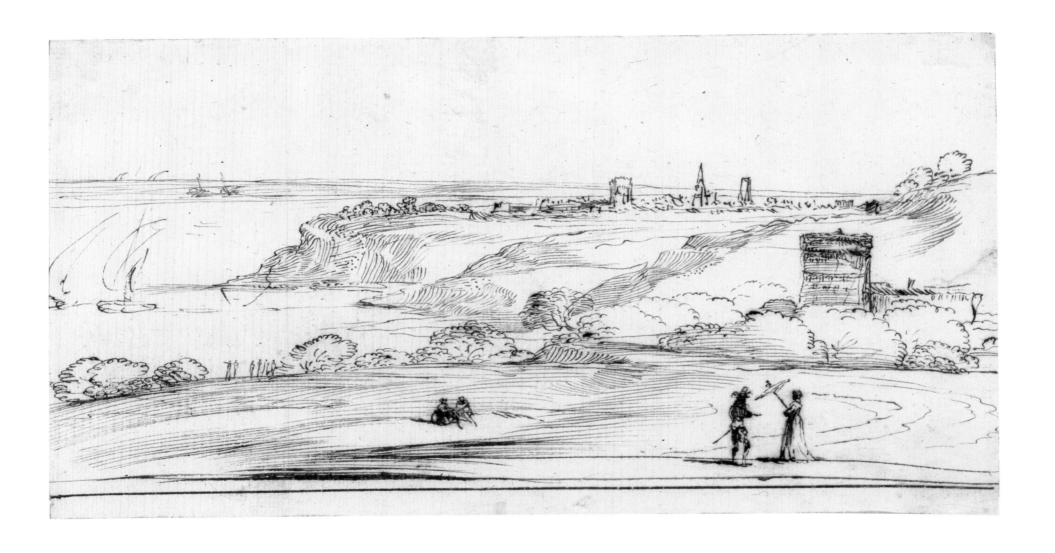

29 HENDRICK AVERCAMP

(Amsterdam 1585–1634 Kampen)

A flat landscape with a windmill, village, church and farm

Brush drawing in blue with some watercolour.
72 × 196 mm.

Monogrammed lower left in brown ink: *HA*

PROVENANCE: Grahl; A. O. Meyer; sale, Leipzig,
Boerner's, 19 March 1914, lot 105.

*Staatliche Museen zu Berlin – Preussischer Kulturbesitz,
Kupferstichkabinett (KdZ.6702; photo: Jörg P. Anders)*

SELECTED LITERATURE AND EXHIBITIONS: Grosse,
1925, pp. 18 and 23, pl. 1, fig. 2; Berlin, 1930, p. 72,
pl. 58; W. Schulz, *Die holländische Landschaftszeichnung
1600–1740*, Exh. Berlin, 1974, no. 6, fig. 11; C. Welcker
and D. J. Hensbroek-van der Poel, *Hendrick Avercamp
(1585–1634) en Barent Avercamp (1612–1679), schilders
tot Kampen*, 1979, no. T85.

Avercamp's precise rôle in the development of
Dutch landscape is difficult to assess because of
the uncertainty that surrounds his chronological
development. For an artist born as early as 1585,
his surviving drawings and watercolours display a
surprising degree of informality both in their style
and choice of subject-matter.

The present sketch, of an unknown location, is
unusual for him; his watercolours usually contain
large measures of bodycolour and are enlivened by
figures. It anticipates the work of Aelbert Cuyp
(1620–91) to a degree matched by few Dutch artists
before Pieter Molijn and Jan van Goyen (see cats
34–7). Yet the dominance of blue wash is reminis-
cent of late Mannerist artists such as David
Vinckboons and Joos de Momper.

Although trained in Amsterdam, Avercamp, a
mute from birth, was active for the most part in
Kampen on the Zuider Zee, specializing in winter
scenes set in and around the town. (The present
drawing was probably made nearby.) Despite
basing himself in a provincial centre, his works bear
comparison for their naturalism with any landscapes
produced by his contemporaries.

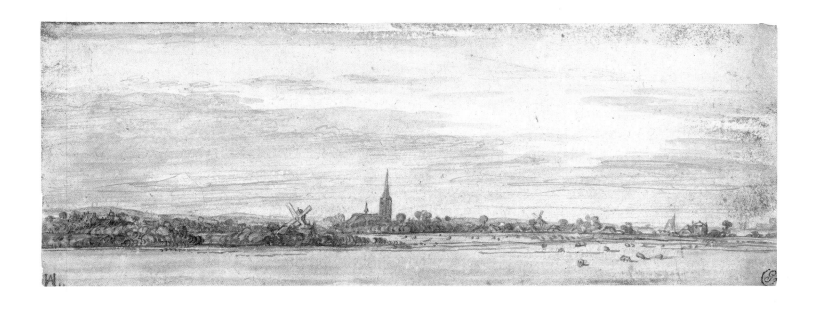

30 CLAES JANSZ. VISSCHER
(Amsterdam 1586/7–1652 Amsterdam)

Three trees in the woods near The Hague

Pen and brown ink over traces of graphite (the *verso* is exhibited; the *recto* also with grey wash, perhaps added later). 171 × 121 mm.

Inscribed: *1608 naet Leeven* [?] *aen de buijten cant / haech bos na grave* and on the other side: *1607 Lasarij tot Haerlem* and below: *19*

PROVENANCE: sale, Amsterdam, 12 February 1770, lot 328; C. van den Berg; his sale, Haarlem, 29 August 1775, lot 167; W. P. Kops; his sale, 14 March 1808, lot 47 (with another view of the Leper House in Haarlem), bt de Vries; sale, Hertzberger, Amsterdam, 20–23 January 1941, lot 1496, bt Mellaart.

Rotterdam, Museum Boijmans Van Beuningen (MB 1941/T13)

SELECTED LITERATURE AND EXHIBITIONS: M. Simon, *Claes Jansz. Visscher*, dissertation, Freiburg im Bresgau, 1958, nos 70–71; B. Bakker, 'Levenspilgrimage of vrome wandeling? Claes Janszoon Visscher en zijn serie *Plaisante Plaetsen*', *Oud Holland*, CVII, 1993, p. 99 and p. 114, n. 12; P. Schatborn, Exh. Amsterdam, 1993–4, under no. 324, n. 1.

Visscher was among the first artists to devote a considerable part of his output to the local topography of the Dutch Republic and whose drawings survive in reasonable numbers. Although the present work was undoubtedly made on the spot in 1608 (as the inscription confirms), the somewhat eccentric penwork of the young draughtsman retains a measure of late mannerist influence,

perhaps derived from David Vinckboons (1576–1632), whose work Visscher engraved and whose style is comparable.

Visscher, a prolific printmaker and publisher, in 1612 copied some of the anonymous series of etched views of villages near Antwerp that had first been issued in 1559 and 1561 after the so-called Master of the Small Landscapes. The plates, which were republished in 1601 by Theodoor Galle (who described them as designed by Cornelis Cort, which seems to be wrong) anticipate many of the reforms in landscape in the northern Netherlands in the seventeenth century. Visscher's copies of 1612 (claiming them to be after Bruegel, which also seems to be wrong) acted as a significant spur to this development, which was given yet further impetus in around 1612–13, when Visscher produced a set of twelve prints of landscapes near Haarlem entitled the *Plaisante plaetsen*. His preparatory drawings for these, five of which survive, were all made in 1607

in the vicinity of Haarlem, one of them being on the *recto* of the present sheet (only the *verso* is exhibited), which shows the *Lepers' Asylum in Haarlem* (fig. 30a).[1] Other artists, including Jan and Esaias van de Velde and Willem Buytewech (see cats 31–2) subsequently also depicted the local landscape in their paintings, drawings and prints, sometimes entrusting their copper plates to Visscher for publication in Amsterdam.

Although in style Van Dyck sought inspiration elsewhere, he cannot have failed to recognize the respectability accorded to naturalistic landscape as a genre of art in the northern Netherlands, and this may help explain why he and his contemporaries not only made but also preserved so many sketches from nature (see further the Introduction, section III). Visscher himself, as a Calvinist, would have viewed the landscape as a manifestation of God, and its representation, even in its unidealized state, as a pious activity.[2]

1 The prints, Hollstein nos 149–60 (the *Lazarus House* is no. 157), have been discussed recently by C. Schuckman, Exh. Amsterdam, 1993–4, no. 327. The other four preparatory drawings are in the Rijksmuseum (1902 A 4701–e, *recto* and *verso*), and in the Gemeentearchief in Haarlem (Simon, *op. cit.*, 1938, nos 38–9). Some of Visscher's preparatory drawings for his prints were made in the studio on the basis of drawings done on the spot, as elucidated by Jan Peeters and Erik Schmitz, 'Belangrijke aanwinst voor Gemeentearchief: een blad met twee onbekende tekeningen van Claes Jansz. Visscher', *Amstelodamum*, LXXXIV, 1997, pp. 33–44.

2 See Bakker, *loc. cit.*

Fig. 30a *Recto* of cat. 30.

31 ESAIAS VAN DE VELDE

(Amsterdam 1587–1630 The Hague)

Farms by the waterside

Pen and brown ink with brown and grey wash.
185 × 290 mm.

Inscribed (under the bridge): *EVV*

PROVENANCE: S. Duits Gallery, London; purchased from
W. A. Bruin, 1918 (as anonymous).

*Amsterdam, Rijksmuseum, Rijksprentenkabinet
(RP–T–1918:224)*

SELECTED LITERATURE AND EXHIBITIONS:
George S. Keyes, *Esaias van den Velde 1587–1630*,
1984, p. 232, no. D63, pl. 86; P. Schatborn and
M. Schapelhouman, *De verzameling van het
Rijksprentenkabinet in het Rijksmuseum. Kunstenaars
geboren tussen 1580 en 1600*, 1998, no. 314.

Few of Esaias van de Velde's surviving drawings
appear, like this one, to have been made directly
from nature, although his impact on the Dutch
naturalistic landscape tradition was considerable.[1]
In style the drawing resembles his *Frozen stream
before a farm*, dated 1619 and now in Leipzig, in
which the figurative staffage and mannered trees
denote a studio creation. Both drawings depict
wintry scenes which, for obvious reasons, were
rarely delineated out of doors.

Though innovative, Esaias' work retains elements
of a late-Mannerist artificiality, which is revealed
here in the repeating patterns of branches curving to
the right in unison. The iconography also harbours
allegorical features: that the wedge of the composi-
tion tapers towards the church on the right (possibly
the St Jakobskerk in The Hague) may not be with-
out significance, the abandoned and dilapidated
works of man in the frozen landscape contrasting
with the permanence of the realm of God. Like
Claes Jansz. Visscher and Willem Buytewech (see
cats 30 and 32), who also worked in Haarlem in the
second decade of the seventeenth century, many
artists and viewers of landscape art would have been
predisposed to 'read' compositions in this way.

Esaias' depiction of the plain landscape is punctu-
ated and balanced by few features, with a spare
use of line, qualities that were fixed upon by the
next generation of Dutch landscape draughtsmen,
including Rembrandt (see cat. 53).

A related painting, probably based on the
drawing, is thought to be the work of another
artist.[2]

1 The artist's drawing of *Spaarnwoude* in the Rijksmuseum
(Keyes, *op. cit.*, no. D133) is sometimes assumed to have been
made from nature, but the balancing curves of the trees argue
against this, as does the fact that it already includes much of
the staffage of the related print.

2 Keyes, *op. cit.*, p. 200, no. rej.40.

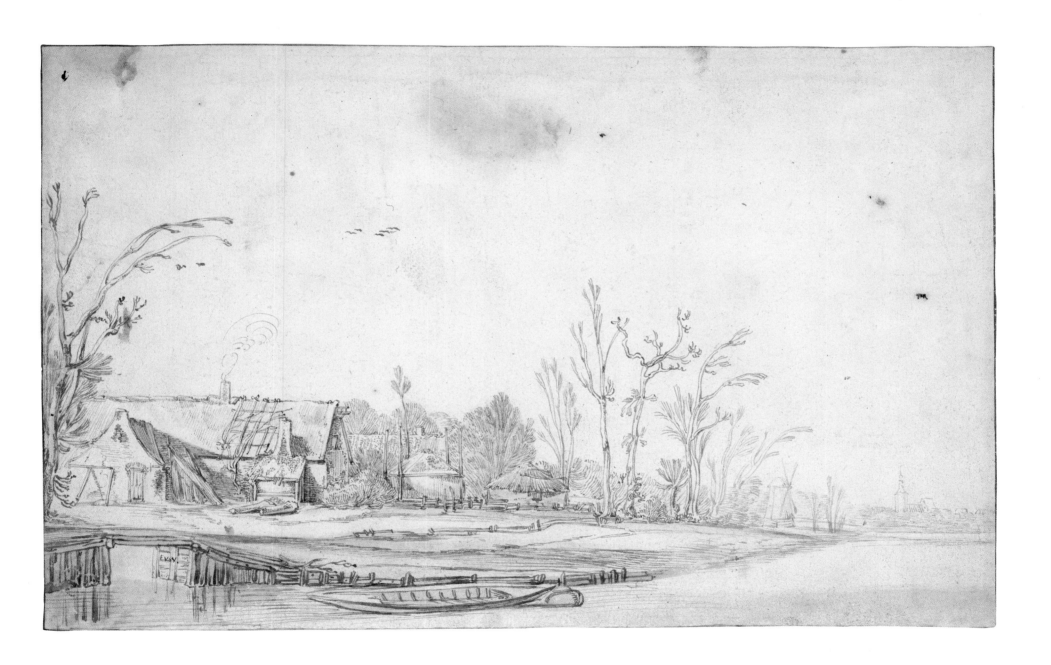

32 WILLEM PIETERSZ. BUYTEWECH
(Rotterdam 1591/2–1624 Rotterdam)

View of the ruins of Spangen Castle

Pen and brown ink. 144 × 350 mm.

Signed lower right in monogram: *WB*

PROVENANCE: M. Terisse, Paris; Frits Lugt.

Paris, Collection Frits Lugt, Institut Néerlandais (2356)

SELECTED LITERATURE AND EXHIBITIONS: Exh. New York–Paris, 1977–8, no. 23 (with previous literature); Exh. London, 1986, no. 36; Exh. Amsterdam, 1993–4, p. 102, fig. 179.

Spangen Castle near Rotterdam, observed here from the north west, was constructed in 1310 by the noble family after whom it was named. When torched by Spanish troops in 1572, the collapse of the skirting wall revealed the polygonal tower of a courtyard staircase.

In this, one of Buytewech's most impressive drawings, the precision of his penwork recalls Hendrick Goltzius' few studies of the landscape made directly from nature in around 1603 (fig. 32a).[1] The unusual treatment of the foliage in the taller trees also has connections with the etchings of Buytewech's contemporary, Hercules Segers (1589/90–1633/8). Somewhat rugged in style, the quality of line resembles a print – in contrast to the delicacy of Van Dyck's views of Rye (cats 12–15) – and Buytewech may have intended to produce an etching of the image. Similar subjects, especially the ruins of Brederode Castle near Haarlem, were commonly treated by Dutch artists in the first decades of the seventeenth century, evoking memories of the terrors experienced during the first half of the Eighty Years' War of independence from Spain, combined with more general *vanitas* associations, as well as reflecting a nascent curiosity in local monuments.

1 E. K. J. Reznicek, *Die Zeichnungen von Hendrick Goltzius*, 1961, no. 405. Compare especially the foreground hedgerow in the Buytewech with the distant tree in the centre of Goltzius' drawing.

Fig. 32a Goltzius, *Dune landscape near Haarlem*, pen and brown ink, 160 × 286 mm. Rotterdam, Museum Boijmans Van Beuningen.

33 CORNELIS HENDRICKSZ. VROOM

(Haarlem 1591/2–1661 Haarlem)

Landscape with trees among low hills

Pen and brown ink over indications in black chalk.
194 × 242 mm.

Signed and dated, lower right: *CVROOM A°1631*

PROVENANCE: De Gruyter; W. Pitcairn Knowles
(L.2643); R. P. Goldschmidt; C. A. Burlet; W. de
Gruyter; acquired in 1917.

*Staatliche Museen zu Berlin – Preussischer
Kulturbesitz, Kupferstichkabinett (KdZ.8501;
photo: Jörg P. Anders)*

SELECTED LITERATURE AND EXHIBITIONS: Berlin,
1930, p. 314; G. S. Keyes, *Cornelis Vroom: Marine and
Landscape Artist*, diss. Utrecht, 1975, no. D4, fig. 43;
W. W. Robinson, *Seventeenth-Century Dutch Drawings
... Abrams Collection*, Exh. Amsterdam–Vienna, etc.,
1991–2, under no. 31, fig. 1.

Although Cornelis Vroom was contemporary
with or younger than his fellow-Haarlem artists,
Willem Buytewech, Esaias van de Velde and
especially Hendrick Goltzius (see cats 31–2), his
contribution to the development of a naturalistic
style of landscape painting was almost as
significant, and no less idiosyncratic.

In the 1620s, his compositions already ennoble
the landscape, which he populates with unrealis-
tically tall, sentinal trees that cast no shadows.
In the 1630s he suffuses his designs in a more

subtle light, using increased stippling of the pen,
and the terrain is less artificially staged. The
present work belongs to this latter type and is
closely related in manner to another drawing,
also dated 1631, now in the Abrams collection in
Boston.[1] They display to best advantage Vroom's
unusual pen style which here effectively conveys
a sense of the sunlight penetrating the foliage.
Stylistically they prefigure the work of Jacob van
Ruisdael, especially in his etchings.

Whether the drawing was made from nature is
uncertain, although probable. On one occasion
Vroom produced a somewhat harshly penned
landscape on the basis of another that may have
been executed out of doors and in which the
touch is softer, resembling the present drawing
more closely.[2] The lack of an underdrawing here,
a feature (in graphite) of the Abrams drawing, is
not a reliable indication of its precedence.

The location has not been identified, but in
the context of Van Dyck the possibility that the
drawings were made in England, where an
artist named Vroom was recorded in 1627 and
apparently remained for a number of years,
should not be overlooked.[3]

1 See Keyes, *op. cit.*, no. D27, and W. W. Robinson,
op. cit., 1991–2, no. 31.

2 A drawing in the Lugt Collection, Institut Néerlandais,
Paris, formed the basis of a drawing now in the Yale
University Art Gallery (Keyes nos D31 and D26
respectively).

3 As mooted by Keyes, *op. cit.*, p. 14. The reference could
be to the artist's brother, Frederick Vroom (*c.*1600–67),
a more shadowy figure.

34 PIETER MOLIJN

(London 1595–1661 Haarlem)

Landscape with a road by a waterway

Watercolour with some gum arabic[1] over black chalk. 143 × 196 mm.

Signed and dated lower left: *P Molyn / 1630* [or 1636]

PROVENANCE: Carl Rolas du Rosey; his sale, Leipzig, 5 September 1864 and subsequent days, lot 4688; R. von Liphart; Franz Josef II, Prince of Liechtenstein; purchased through the Cassirer Gallery, Zurich, 1948.

Amsterdam, Rijksmuseum, Rijksprentenkabinet (1948:405)

SELECTED LITERATURE AND EXHIBITIONS: E. J. Allen, *The life and art of Pieter Molyn*, diss. Maryland, 1987, p. 154, fig. 180; Exh. Amsterdam, 1987, no. 27; P. Schatborn and M. Schapelhouman, *De verzameling van het Rijksprentenkabinet in het Rijksmuseum. Kunstenaars geboren tussen 1580 en 1600*, Amsterdam and London, 1998, no. 238.

Only the present sheet and two bodycolour drawings (one dated 1629) in Berlin survive among Molijn's prolific output to display his abilities with watercolour.[2] His manner of arranging his colours in horizontal bands to suggest atmospheric recession recalls earlier landscapists, including Joos de Momper (1564–1635), and the drawing may have been made on the basis of sketches from nature, rather than on the spot. But despite this degree of consideration, and unlike Van Dyck, whose *Wide landscape with a tall tree* (cat. 22), comparable in composition, retains the confident spread of Momper's world in a Baroque development, Molijn portrays the vulnerable, waterlogged constitution of his local terrain. The comparison is informative, revealing the concern for local colour, perhaps partly Calvinist-inspired, that preoccupied so many artists in the young Dutch Republic. The idyllic connotations manifested even in the most informal sketch by the Fleming give way in the Molijn to the muddy world of the foreground peat-digger and bargeman.

1 Although not commonly found in drawings of the seventeenth century, gum arabic is mentioned in Theodore de Mayerne's MS notes on priming paper (London, British Library, Sloane 2052; see E. van de Wetering, *Rembrandt. The painter at work*, Amsterdam, 1997, p. 62) and a source of 1598 is quoted by Marjorie B. Cohn, *Wash and gouache. A study of the development of the materials of watercolour*, Exh. Cambridge, Mass., 1977, p. 35 (I am grateful to Kim Sloan for this latter reference). Norgate, 1649 (1997 edn), p. 62, also mentioned it.

2 A few drawings by him with slight tints of green or yellow are, however, known. Allen, *op cit.*, p. 154, reads the date of the present sheet as 1636.

35 PIETER MOLIJN
(London 1595–1661 Haarlem)

Village in the dunes with a winding road

Black chalk and grey wash. 165 × 234 mm.

PROVENANCE: Van der Dussen; J. Barnard (L.1419, *verso*);
C. M. Cracherode, by whom bequeathed, 1799.

London, British Museum (Gg.2–307)

SELECTED LITERATURE AND EXHIBITIONS: Hind, IV,
1931, p. 130, no. 30, pl. LXXVII.

First recorded in a British Museum inventory of
1837 as by Meindert Hobbema, the drawing seems
inseparable from Pieter Molijn, the possibility of
whose authorship has been proposed in the past.[1]

The drawing is strikingly free in handling and
more immediate in its atmospheric description than
most of Molijn's works, and it may be a rare
surviving study by him made directly from nature.
In style it also contrasts with his watercolour
(cat. 34) and the likelihood that it was sketched out
of doors may explain its unusually liquid and
unselfconscious style. Characteristically, Molijn
concentrates on the particular qualities of the
windswept locality, turning his back on the tradition
for idealization in landscape art.[2]

In 1628 the artist was singled out for praise by
Samuel Ampzing in his description of Haarlem, the
Beschryvinge ende lof der stad Haerlem in Holland;[3]
and in 1647, Pieter Molijn and Cornelis Vroom
(see cat. 33) were praised above all other landscape
artists from Haarlem by Petrus Schrevelius in his
*Harlemum sive urbis Harlemensis incunabula,
incrementa, fortuna varia*[4] These sources reveal
that the non-classical, local style of landscape found
an appreciative audience in the northern Netherlands.

1 By Hind, *loc. cit.*, although he included the drawing in his
catalogue as 'Anonymous Dutch 17th Century'.

2 For another drawing by Molijn that was possibly drawn out
of doors, see Schatborn and Schapelhouman, *op.cit.*
(under cat. 34), no. 241

3 On p. 372.

4 On p. 394.

36 JAN VAN GOYEN
(Leiden 1596–1656 The Hague)

Two Figures standing on a Mound

Black chalk. 164 × 258 mm.

Signed and dated, lower right: *I. V. GOIEN 1627*

PROVENANCE: Pacetti collection, acquired in 1844.

Staatliche Museen zu Berlin – Preussischer Kulturbesitz, Kupferstichkabinett (KdZ.2740; photo: Jörg P. Anders)

SELECTED LITERATURE AND EXHIBITIONS: Berlin, 1930, p. 140, pl. 102; Beck, I, 1972, no. z.84.

Van Goyen's style was largely forged in Haarlem, where he studied in the studio of Esaias van de Velde (see cat. 31). The work of Pieter Molijn is also comparable (cats 34–5). In this early drawing, Van Goyen produced a design of a dynamic simplicity that approaches the latter's work more than his own master's.

Drawings of this type encapsulate the character of the contribution made in the 1620s by Van Goyen's generation to the development of landscape art in the Dutch Republic: a concentration on unassuming details of the terrain; the inclusion of local colour, not least in the figurative staffage; an apparently unselfconscious spontaneity; a lack of idealization; and a concern to replicate the atmospheric mood.

Many of Van Goyen's early paintings and drawings stand, as here, on the threshold between pure landscape and genre (figurative scenes of everyday life). In his later work the figures recede in importance, and he concentrated on compositions derived from sketchbook notations made from nature, frequently focusing on architectural motifs or village life as well as depicting the open landscape or shoreline.

37 JAN VAN GOYEN
(Leiden 1596–1656 The Hague)

Travellers halting on a country road by a river with a ferry

Pen and brown ink. 105 × 188 mm.

Signed lower right: *VG* and on *verso*: *N° 10*

PROVENANCE: J. Gigoux (L.1164); his sale, Paris, 20–23 March 1882, lot 321; anonymous collector 'G.R.' (L.1198); Baron de Beurnonville; his sale, Paris, 16 February 1885, lot 162; sale, Amsterdam, 25 June 1885, lot 107, bt Prestel; sale, Frankfurt, 12 November 1918, lot 163, bt Gaa; C. Gaa (L.538ª); his sale, Leipzig, 9 May 1930, lot 166.

Paris, Collection Frits Lugt, Institut Néerlandais (4479)

SELECTED LITERATURE AND EXHIBITIONS: Exh. Brussels–Rotterdam–Paris–Berne, 1968–9, no. 62; Beck, I, 1972, no. Z.14.

Between around 1624 and 1631, Jan van Goyen filled several small sketchbooks with precise landscapes in pen and brown ink, many of which seem to have been made from nature.

In the present drawing, from a sketchbook of around 1630, Van Goyen created a pictorial effect, grouping the four passengers together in the centre, placing two figures in conversation to the right, and including the ferry, laden with a horse-drawn, covered wagon, as it makes its way towards the nearer bank of the river. The composition resembles Van Goyen's finished paintings of the same period, and the concern for narrative detail, only occasionally found in landscapes sketches by Van Dyck and his non-Dutch contemporaries, was to remain a feature of many landscapes made in the northern Netherlands into the middle of the seventeenth century, including several by Rembrandt (see cat. 53).

38 PIETER JANSZ. SAENREDAM

(Assendelft 1597–1665 Haarlem)

The church and village of Assendelft

Pen and brown ink with watercolour. 230 × 385 mm.

Inscribed by the artist: *den: 15. Augustij. 1633 / van mijn pieter Saenredam / tot Assendelft, naer 'tleven geteeckent*

PROVENANCE: Von Beckerath collection, acquired 1902.

Staatliche Museen zu Berlin – Preussischer Kulturbesitz, Kupferstichkabinett (KdZ.5704; photo: Jörg P. Anders)

SELECTED LITERATURE AND EXHIBITIONS: Berlin, 1930, p. 261, pl. 189; P. T. A. Swillens, *Pieter Janszoon Saenredam*, 1935, no. 63, pl. 43; *Pieter Jansz. Saenredam*, Exh. Utrecht, 1961, no. 16, pl. 17; C. O. Baer, *Landscape Drawings*, n.d. (1973), no. 85.

The drawing is dated just twelve days earlier than Van Dyck's *View of Rye* from the Pierpont Morgan Library (cat. 12). The inscription on the latter includes the words *del naturale*, Saenredam's drawing *naer 'tleven*, choices' of language that neatly summarize the different ambitions of the two artists, ranging from the international and courtly to the more locally based and vernacular.

Saenredam's interest in landscape was limited, his chief concern being the recording of Dutch church architecture, both interior and exterior. This priority impresses itself on the viewer of the drawing of *Assendelft*, dominated as it is by the church of St Odulphus, which is delineated with particular precision. The more economical treatment of the peripheral buildings and trees (that on the left dabbed in almost impressionistically) and the wide expanse of open ground nonetheless reveal a debt to his contemporaries in Haarlem, in particular to Claes Jansz. Visscher (on whom see cat. 30).

Saenredam had himself provided illustrations for Samuel Ampzing's book describing Haarlem in 1628 (the *Beschryvinge ende lof der stad Haerlem in Holland*) and along with Visscher's *Plaisante plaetsen* his plates form a high point in the remarkable tradition of Haarlem topography in the first half of the seventeenth century.[1] Compared with the deft sweep of Van Dyck's watercolours we here encounter a greater concern for accuracy of record (down to the stork nesting on the church roof), but one that remains alert to the poetic harmonies of nature, evoking the presence of God in the local landscape: Assendelft was the artist's birthplace, and the church the resting-place of his father, the engraver Jan Saenredam (1565–1607), who was a senior member of the Reformed council and who had engraved a view of the church in 1596.[2] Pieter Saenredam produced no less than ten drawings and paintings of the interior of the late-Gothic church, which later fell into disrepair and was finally demolished in the nineteenth century.

1 On which see recently Leeflang, 1997, especially pp. 78–9.
2 Hollstein 133, in the second state published by Claes Jansz. Visscher.

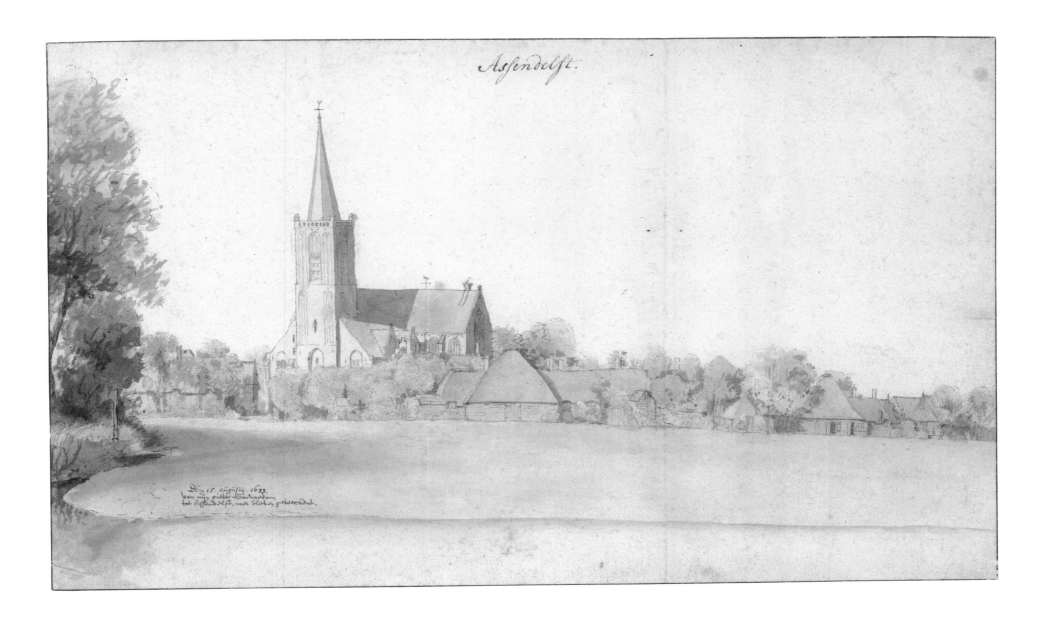

Assendelft.

Aº. 15. Augustij. 1633.
van mijn swager Gasteuschou
tot Assendelft, naer 't leben geteijkent.

39 PIETER JANSZ. SAENREDAM
(Assendelft 1597–1665 Haarlem)

A rhubarb plant

Pen and brown ink with watercolour. 139 × 166 mm.

Inscribed by the artist: *een saetjen allenich* ('one seed alone') and: *Dese plant rhabarber van mij Pr: Saenredam aldus naer 'tleven geteeckent Ao: 1630* ('this plant of rhubarb by me, Pieter Saenredam, thus drawn from life anno 1630')

PROVENANCE: Von Beckerath collection, acquired 1902.

Staatliche Museen zu Berlin – Preussischer Kulturbesitz, Kupferstichkabinett (KdZ.5708; photo: Jörg P. Anders)

SELECTED LITERATURE AND EXHIBITIONS: Berlin, 1930, p. 261; P. T. A. Swillens, *Pieter Janszoon Saenredam*, 1935, no. 43, pl. 5; *Pieter Jansz. Saenredam*, Exh. Utrecht, 1961, no. 206, pl. 207; G. Schwarz and M. J. Bok, *Pieter Saenredam. The painter and his time*, 1990, p. 33, fig. 21.

The recording and illustration of plants by artists was already established as a particular tradition by the time Saenredam drew this rhubarb plant in 1630, as he writes, *naer 'tleven* ('from life'). His approach to the motif contrasts with Van Dyck's and Claude Lorrain's plant studies (cats 4, 19 and 49), which although executed from nature were more obviously made with a view to incorporation in their paintings, rather than as botanical records. Saenredam's more scientific drawing was made as an end in itself; his intentions demanded unremitting precision rather than painterly effects, and the plant is silhouetted against a plain background as if presented for analytical examination.

The drawing probably remained in the artist's possession and shares its provenance with a group of his drawings now in Berlin. Rather than his studio reference material, the drawing could have formed part of his collections: his library was extensive, although no record of a special section of illustrations of fauna and flora has come down to us, along the lines of the encyclopaedic collections of his day.[1] Two further drawings of plants by Saenredam are known, also in Berlin,[2] and another sheet containing two studies of leafless trees is in the same repository.[3]

1 See Schwarz and Bok, *op. cit.*, pp. 181–7, on Saenredam's library and collections, and for encyclopaedic gatherings of the period, the catalogue *De wereld binnen handbereik*, Exh. Amsterdam, Historisch Museum, 1992, especially pp. 125–52.

2 KdZ.5709 and 5710 (Exh. Utrecht 1961, nos 208–9, pls 209–10).

3 KdZ.5707 (Exh. Utrecht 1961, no. 207, pl. 208; the drawing also contains profile views of Leiden and Haarlem).

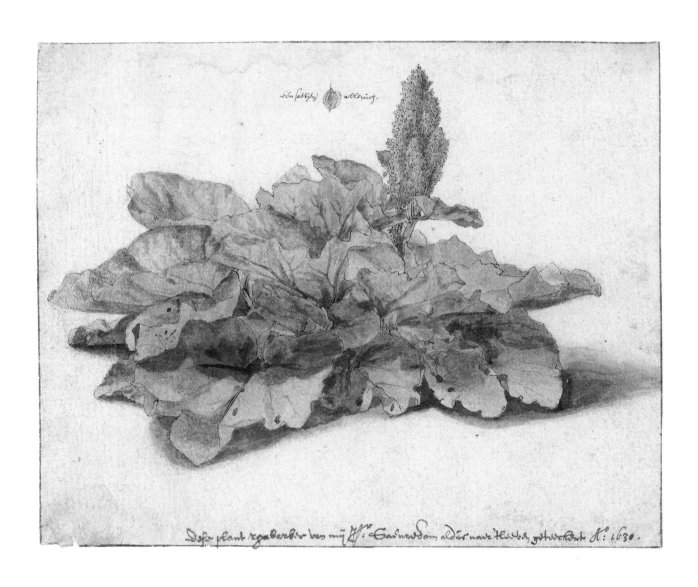

40 Attributed to JACQUES FOUCQUIER
(Antwerp 1590/91–1656 Paris)

Wooded landscape with figures by a sandy road

Brush drawing in gouache and watercolour.
203 × 312 mm.

PROVENANCE: P. J. Mariette (L.1852); acquired at his sale, Paris, 15 November and following days 1775, lot 1240.

Paris, Musée du Louvre, Département des Arts Graphiques (19.969; photo RMN)

SELECTED LITERATURE AND EXHIBITIONS: W. Stechow, 'Drawings and etchings by Jacques Foucquier', *Gazette des Beaux-Arts*, XXXIV, 1948, p. 428; F. Lugt, *Musée du Louvre. Inventaire général des dessins des écoles du nord, école flamande*, I, 1949, p. 63, no. 663; *Le cabinet d'un grand amateur, P. J. Mariette*, Exh. Paris, Louvre, 1967, no. 175.

Although Flemish born, Foucquier's early style, as represented by his signed drawing of a *River with a barge and two figures* (fig. 40a),[1] suggests a knowledge of Dutch models, including works by Willem Buytewech and the Haarlem landscapists of the period. He was recorded as a master of the Antwerp guild of painters in 1614, and as in Brussels two years later. From 1616, according to the German artist and writer Joachim von Sandrart (in his *Teutsche Akademie* of 1675), Foucquier worked in Heidelberg, subsequently settling in France in 1621. There he enjoyed Louis XIII's

patronage, in 1626, for a series of views of French towns, and in c.1640–41 he was considered for the decoration of the Grande Galerie of the Louvre, which led to his reputation as a rival of Poussin.

From his beginnings in the vein of Haarlem artists Foucquier moved towards a more idealized vision of landscape derived from Rubens, with whom he is said to have worked in Paris (although proof for this is lacking).[2] His synthesis of realistic and idealized styles is seen to great effect in the present drawing, the attribution of which to Foucquier, though not entirely certain, can be traced to the eighteenth-century collector and connoisseur Pierre-Jean Mariette. The slightly structured composition is reminiscent of the next generation of Dutch artists such as Anthonie Waterloo (c.1610–90), as well as of French and Flemish painters, including especially Lodewijck de Vadder and Jacques d'Arthois (see cats 43 and 57).[3] As emulators of Foucquier their drawings are sometimes difficult to distinguish from his, and the confrontation here with a work by De Vadder might lead to a reassessment of the attribution.

The informal composition and the placement of the figures in the landscape suggests a work done from nature; yet the balance of the design also

implies a degree of artificial embellishment. Possibly the gouache was added by the artist later. The style falls somewhere between Foucquier's sketchiest drawings in black chalk that were apparently made directly from nature,[4] and his more idyllic compositions that were engraved by Jean Morin (see fig. 40b), Alexander Voet II, Pieter de Jode and others. The technique resembles that of another gouache in the Louvre which is related to a print by Voet.[5] It was doubtless largely through the prints that Foucquier's elegant landscape style became influential.

1 Museum Boijmans Van Beuningen, inv. 1. I am grateful to Laurence Quinchon-Adam, a student working on Foucquier, for her help in compiling this entry. The artist's name is sometimes spelt Fouquier or Fouquières.

2 According to Dézailler-d'Argenville (*Abrégé*, 1762 edn, p. 315), Foucquier assisted Rubens in painting landscape backgrounds for his tapestries before moving to France.

3 According to Stechow, *op. cit.*, an attribution of the present drawing to De Vadder was contemplated. But the traditional, Mariette attribution to Foucquier was adhered to by Lugt.

4 E.g. the signed drawing in Hamburg (21951), repr. by Stechow, *op. cit.*, fig. 10.

5 Lugt, *op. cit.*, no. 662, repr. pl. LXV, which formed the basis for a composition by Foucquier that was engraved by

Voet (Hollstein XLII, p. 67, no. 23, repr). The connection was made by Laurence Quinchon-Adam. She questions the attribution of the present sheet, but acknowledges that of Lugt 662. A more detailed version of the latter in the Biblioteca reale in Turin has quite reasonably been attributed to De Vadder, although it could be by Foucquier (see G. C. Sciolla, *Da Leonardo a Rembrandt. Disegni della Biblioteca reale di Torino*, 1989, no. 143, repr.).

Fig. 40a Foucquier, *River with a barge and two figures*, pen and brown ink, 104 × 146 mm. Rotterdam, Museum Boijmans Van Beuningen.

Fig. 40b Jean Morin after Foucquier, *Landscape*, etching, 215 × 317 mm. London, British Museum (1864-7-14-68).

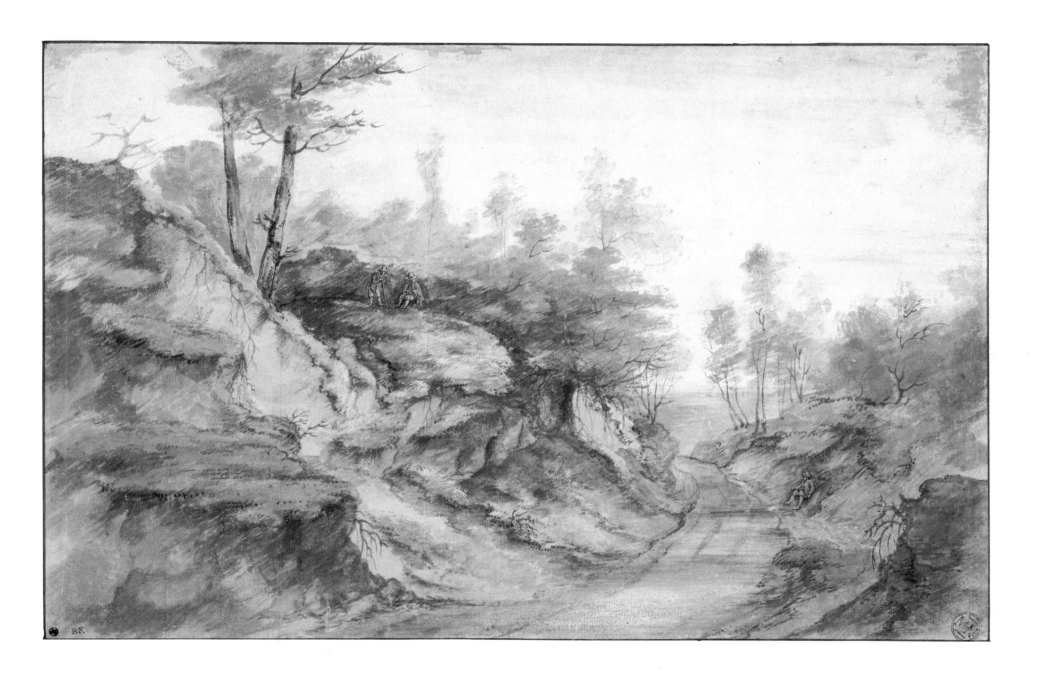

41 LUCAS VAN UDEN

(Antwerp 1595–1672 Antwerp)

Landscape with a village

Pen and brown ink with brown wash and watercolour.
175 × 277 mm.
Inscribed by an early hand: *by V: Dick*
PROVENANCE: R. Houlditch (L.2214); Rev. C. M. Cracherode,
by whom bequeathed, 1799.[1]
London, British Museum (Gg.2–240)
SELECTED LITERATURE AND EXHIBITIONS: Hind II, no. 77,
pl. XXXV (as Van Dyck).

Until as recently as 1957 this drawing was retained
under Van Dyck's name, following the old inscription.
The attribution to Van Uden adopted at that time is
more plausible; the drawing displays his characteristic
mannerisms, which while derived from Rubens simulta-
neously reveal a debt to Jan Bruegel the Elder. The
degree of the latter's influence suggests that this may be
an early work, no later than the 1630s. Two comparable
landscapes with early inscriptions – perhaps signatures –
naming Van Uden as the artist are in Berlin.[2]

Although the scene has not been identified, the free
penwork suggests a drawing executed from nature and
contrasts with Van Uden's more detailed compositions
(see cat. 42). The watercolours may have been applied
as an enhancement in the studio. The artist's early
biographer, Arnold Houbraken, records that the artist,
who specialized in landscape, often rose early to
sketch from nature.[3] This practice enabled him to
develop a personal vision, and it is perhaps Van Uden's
drawings, more than his paintings, that maintain
their independence from the style of his mentor,
Rubens. Their directness of observation links them with
contemporary northern Netherlandish landscapes.

1 Either this drawing or Hind, II, no. 78, was probably bought
 by Cracherode at the Duke of Argyll's sale, London, 3rd day,
 23 May 1798, lot 270: 'one charming ditto [landscape], lightly and
 delicately tinged with colour', bt Thane for Cracherode (according
 to the latter's copy of the catalogue, British Library 679.c.28/2).

2 Kupferstichkabinett, KdZ.4509 and 12052.

3 *De groote schouburgh*, 1718–21, I, p. 158.

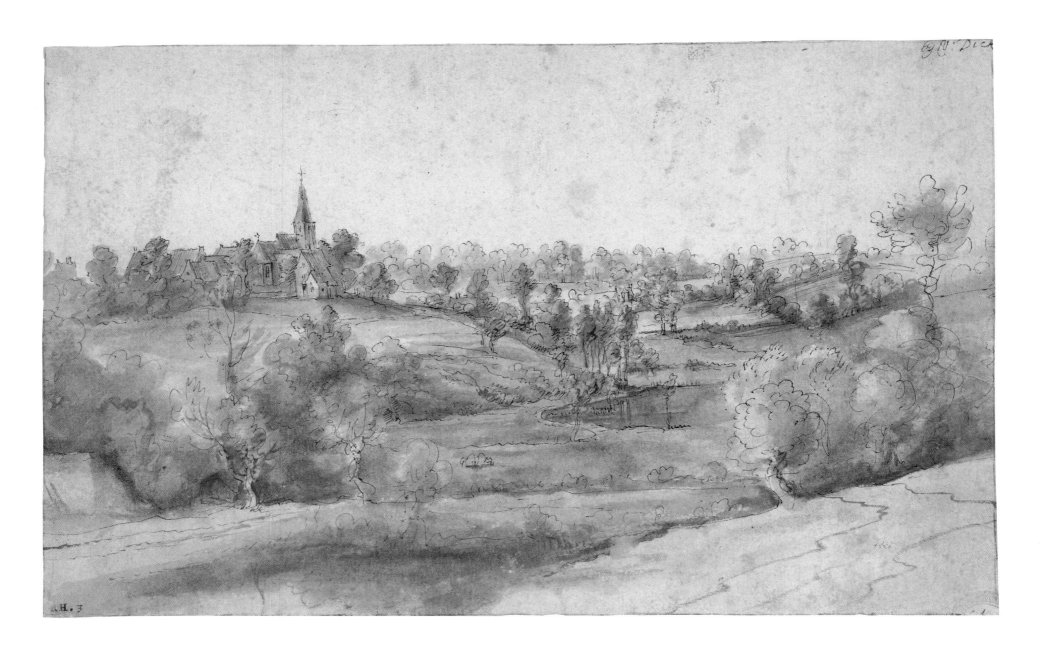

42 LUCAS VAN UDEN

(Antwerp 1595–1672 Antwerp)

Landscape with a walled and moated château

Pen and brown ink, with watercolour. 212 × 345 mm.

Inscribed lower right: *VU*.

PROVENANCE: J. Sheepshanks (L.2333); purchased through Messrs William Smith.

London, British Museum (1836–8–11–526)

LITERATURE: Hind, no. 4.

This detailed drawing was probably based on a sketch from nature and is remarkable for its vivid use of watercolour to convey atmospheric effects. Van Uden, like Van Dyck, worked closely with Rubens, often suppressing his own style in the service of his master, but his drawings and prints reveal the individuality of his vision. From beginnings similar to Van Dyck's, he concentrated on landscape, developing a distinctive manner that simultaneously idealized while describing the Flemish locality in some detail. When working on a modest scale his independent landscapes, whether paintings, drawings or etchings, are among the most alluring to have been produced in Flanders in the seventeenth century.

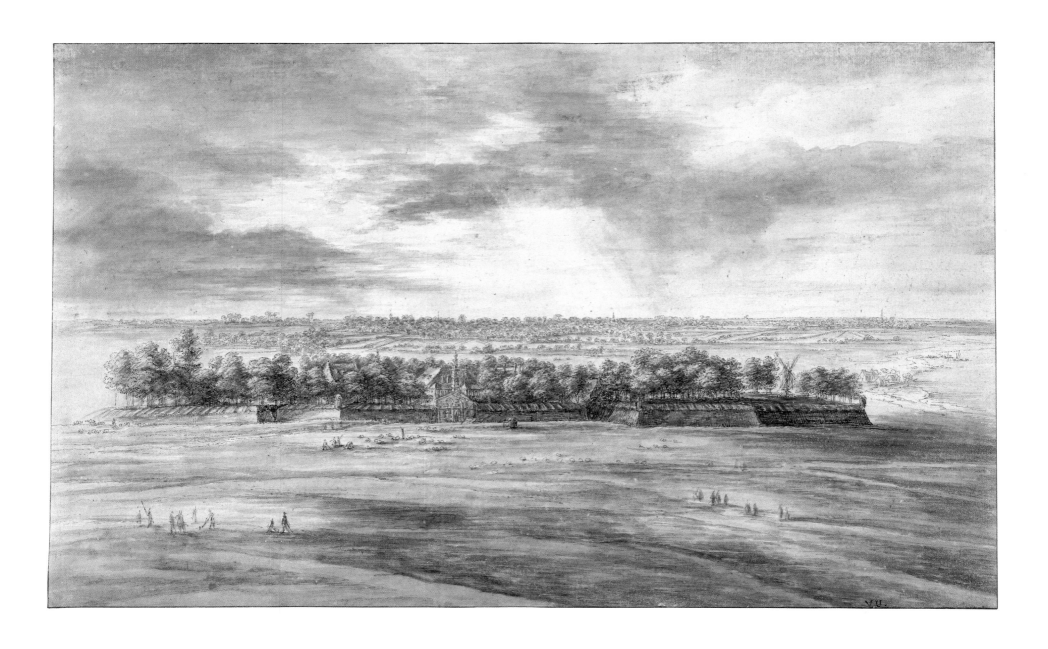

43 LODEWIJK DE VADDER

(Brussels 1605–55 Brussels)

Landscape with two draughtsmen

Black chalk with brown and grey wash and watercolour.
226 × 356 mm.
PROVENANCE: Städel and Hausmann collections, acquired
1875.
*Staatliche Museen zu Berlin – Preussischer Kulturbesitz,
Kupferstichkabinett (KdZ.14071; photo: Jörg P. Anders)*
SELECTED LITERATURE AND EXHIBITIONS: Berlin, 1930,
p. 291, no. 14071; Exh. London–Paris–Berne–Brussels,
1972, p. 146, under no. 113.

De Vadder's drawings are difficult to distinguish
from those of his followers Lucas Achtschellinck
(*c.*1625/6–1699) and Jacques d'Arthois (see cat. 57).
Nonetheless a consensus has emerged that
a group of drawings, including the present sheet,
are by him as they so clearly reflect his interests as
displayed in his oil paintings.

His style resembles that of Jacques Foucquier
(see cat. 40), exhibiting a similar directness of
observed detail combined with the poetic artificiality
of Rubens. Van Dyck's landscapes had similar roots,
but the economy of his touch is here lacking.
In compositions from nature, as the present
drawing appears to be, De Vadder's drawings
resemble more closely the work of Dutch masters
such as Simon de Vlieger (*c.*1600–53) and Anthonie
Waterloo (*c.*1610–90). Some of the washes may
have been elaborated in the studio.

De Vadder was highly regarded in his time, and
devoted part of his energies to designing tapestries.
A weaver, Baudouin van Beveren, referred to him as
the best landscape painter in Flanders, paying him
no less than 1,000 florins in 1644 for a series of
designs depicting the *Story of Diana and Pan*.

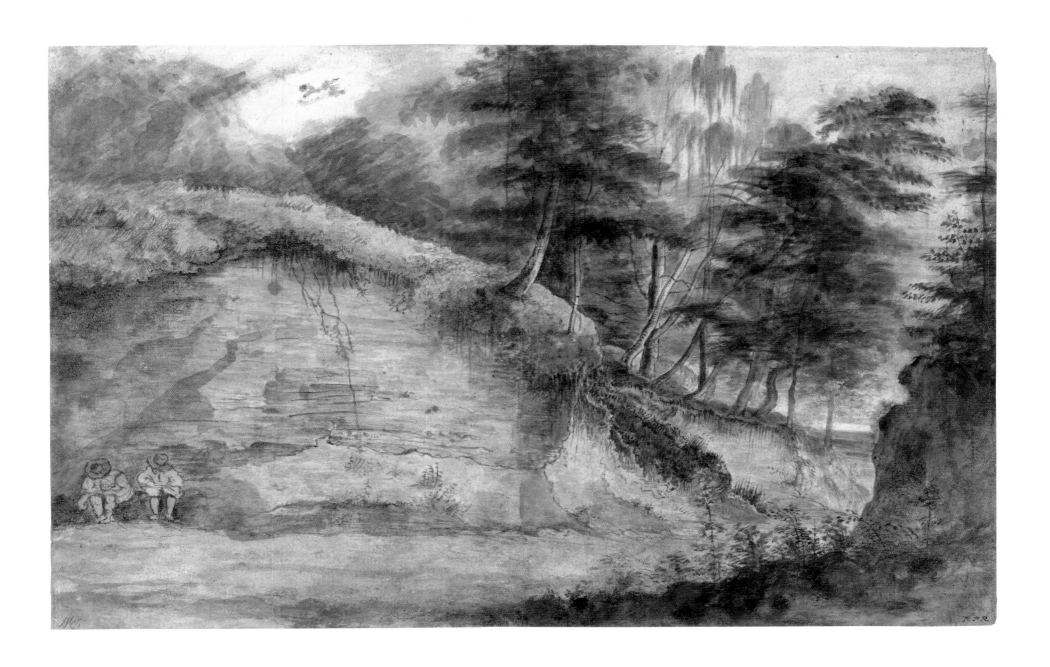

44 CORNELIS VAN POELENBURCH

(Utrecht 1594/5–1667 Utrecht)

View in Tivoli

Pen and brown ink with brown wash over traces of black chalk. 327 × 451 mm.

Inscribed: *te tievele 1620*

PROVENANCE: Earl of Wicklow; purchased 1874 (as by P. Bril).

London, British Museum (1874-8-8-17)

SELECTED LITERATURE AND EXHIBITIONS: Hind, III, 1926, no. 23, pl. 29 (as Breenbergh); Exh. Amsterdam–Boston–Philadelphia, 1987–8, under no. 68; Chong, 1987, p. 25, no. 5, fig. 1 (Poelenburch).

By 1617 Cornelis van Poelenburch, a former pupil of Abraham Bloemart (1564–1651) in Utrecht, had already secured a notable reputation and had arrived in Rome. There he was inspired by Paul Bril (1554–1626), the Carracci, Adam Elsheimer (1578–1610) and also Filippo Napoletano (see cat. 27). The present drawing, dated 1620, is above all dependent on the style of Bril, to whom it was attributed on its acquisition by the British Museum in 1874. Bril was among the first artists to sketch at Tivoli, and Van Poelenburch worked together with him. But none of Bril's drawings made directly from nature there survives, and the present sheet, although stylized to some degree in its calligraphy and composition, is more immediate in effect than almost any of Bril's surviving drawings.[1]

The inscription ('at Tivoli 1620') suggests that the drawing was indeed made on the spot, and it belongs to a series of views, dated between 1619 and 1623, made in this style in Tivoli and Rome.[2] Also personal to Van Poelenburch at this stage of his career are the bold, slashing strokes of the pen, which contrast with the tamer handling of his later works. His pen drawings came to resemble those of Filippo Napoletano, whom he may have met in Florence (where he was patronized by Grand Duke Cosimo II dei Medici), and Bartholomeus Breenbergh, to whom this and other drawings of the same group have sometimes been attributed (see cats 27 and 46). The composition has affinities with a painting of the *Waterfalls at Tivoli* by Van Poelenburch now in Munich (fig. 44a), which although monogrammed *CP* has in the past been ascribed to the other two artists.[3]

Van Poelenburch was in 1618 celebrated enough to be listed by Theodore Rodenburgh as the youngest of eighteen painters who were spreading the fame of Amsterdam as a centre of painting.[4] He probably remained in Italy from 1617 until 1625, becoming in 1623 a founder-member of the Dutch artists' club in Rome, the *Schildersbent*, where he received the nickname *Satir* (Satyr). After settling in Utrecht he was visited in 1627 by Rubens, in the inventory of whose collection two of his paintings

are listed. About three years later he was praised highly by Constantijn Huygens, and in 1637, according to the inscription on the 1649 portrait of him engraved by Meyssens, he went to London to work for Charles I. There he remained until 1641, the year of Van Dyck's death. George Vertue records that Van Poelenburch lodged in Archer Street next door to Geldorp, with whom Van Dyck at first stayed in England.[5] Given the probability of contact between the artists, whether in Rome, London or the Netherlands, or all three, it is unsurprising to find Van Poelenburch's portrait included in Van Dyck's *Iconography*.[6]

1 Perhaps the only known drawing by Bril which was made directly from what he saw is the *Italian farmhouse by a stream* in the Rijksmuseum, 48:574 (see Boon, 1978, no. 92). Its uniqueness in Bril's work is stressed in the *Age of Bruegel*, Exh. Washington–New York, 1986–7, no. 20 (where previous attributions of this type of drawing to Bril are rightly questioned). See further the Introduction, p. 42.

2 Sixteen drawings in the group are listed by Chong, *op. cit.*, nos 1–16. One drawing, in the Bibliothèque Nationale in Paris (Chong no. 9) also has on the *verso* a drawing of the Bastille in Paris, dated 1631. The most similar to the present drawing is that of Tivoli formerly in the Perman collection, Stockholm (Chong no. 9, repr. Exh. Amsterdam–Boston–Philadelphia, 1987–8, p. 405, fig. 2).

3 Inv. 5273, repr. Exh. Amsterdam-Boston-Philadelphia, 1987–8, no. 68.

4 In a poem written for the rhetoricians' group, 'De Eglentier', published in 1618 in the introduction to his play *Melibea*. See Sluijter-Seijffert, 1984, p. 5, and *passim* for biographical details, and recently Marten Jan Bok in J. Spicer and L. Federle Orr, *Masters of Light*, Exh. San Francisco–Baltimore–London, 1997–8, pp. 387–8.

5 See *Walpole Society*, XVIII, 1929–30, Vertue, I, p. 113.

6 Mauquoy-Hendrickx 35.

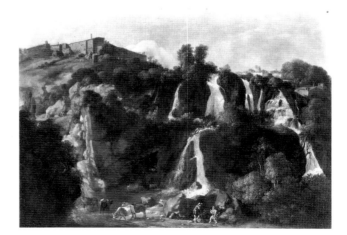

Fig. 44a Van Poelenburch, *Waterfalls at Tivoli*, oil on copper, 241 × 333 mm. Munich, Bayerische Staatsgemäldesammlungen, Alte Pinakothek (5273).

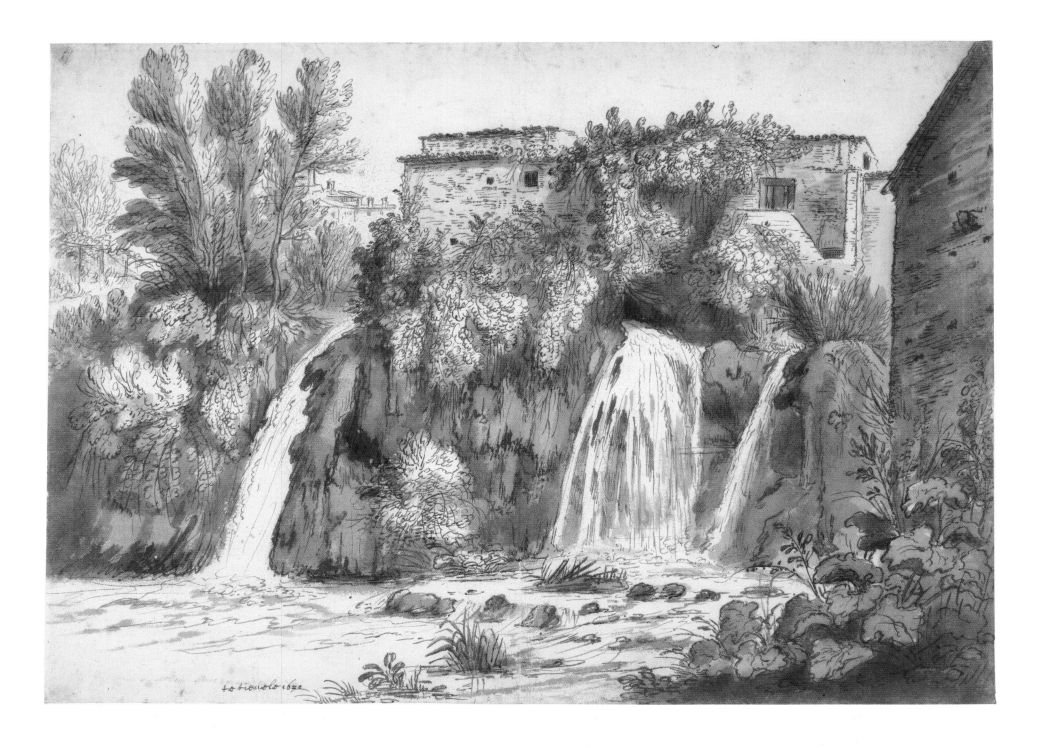

153

45 NICOLAS POUSSIN
(Les Andelys 1594–1665 Rome)

An Italian landscape with distant hills

Brush drawing in brown, with traces of black chalk.
132 × 257 mm.

PROVENANCE: Thomas Coke, 1st Earl of Leicester; by descent until sold by the Trustees of the Holkham Settled Estates, Christie's, 2 July 1991, lot 60; subsequently purchased by the Ashmolean Museum with the assistance of the National Heritage Memorial Fund, the National Art Collections Fund, the Hulme Fund, the Friends of the Ashmolean, the Blakiston Fund and the Madan Fund.

Oxford, Ashmolean Museum (W.A.1992.10)

SELECTED LITERATURE AND EXHIBITIONS: A. Blunt, 'Poussin and his Roman patrons', *Walter Friedländer zum 90. Geburtstag*, 1965, p. 64, fig. 2; A. E. Popham and C. Lloyd, *Old Master Drawings at Holkham Hall*, 1986, no. 286; R. Verdi, *Cézanne and Poussin...*, Exh. Edinburgh, 1990, no. 27; H. Brigstocke, *A loan exhibition of drawings by Nicolas Poussin from British collections*, Exh. Oxford, Ashmolean Museum, 1990–91, no. 56; *Eighteen old master drawings from the collection at Holkham Hall, Norfolk*, Exh. London, British Museum, and elsewhere, 1992–3, no. 15; P. Rosenberg and L.-A. Prat, *Nicolas Poussin 1594–1665. Catalogue raisonné des dessins*, I, 1994, no. 289.

The traditional attribution of this drawing to Claude Lorrain has now generally been rejected in favour of one to Poussin, whose scumbling, abstract touch and geometrical compositional sense it reflects. Its analogies with the backgrounds of some of Poussin's paintings provide further support for his authorship, in particular the *Landscape with a man drinking* in the National Gallery, London. A date around 1645 has been suggested.[1]

The drawing seems likely to have been done from nature in the countryside near Rome (the Roman *campagna*). Together with Poussin's sketch of the *Aventine Hill*, now in the Uffizi,[2] it confirms (assuming the attribution is correct) that the practice of producing sketches from nature could interest an artist whose finished landscapes are especially artificial. The drawing is remarkable for its economy of means, a single brush, perhaps dipped no more than twice into the ink, being sufficient to describe the atmosphere and transitions of light in a broad stretch of landscape. This quality of reticence is shared, for example, by some of Van Dyck's landscapes of the 1630s (e.g. cats 21 and 25), and by Rembrandt's drawings of around 1650 (cat. 53).

A number of other landscape drawings, mostly from Mariette's collection, have been attributed to Poussin and dated to the mid-1620s, including a sheet in the British Museum (fig. 45a). Opinion about their attribution is more divided than over the present work; but in technique, some of them, with their somewhat harsh pen outlines and rich use of wash, are reminiscent not only of Poussin but also of the young Cornelis van Poelenburch and of Bartholomeus Breenbergh (see cats 44 and 46); they are also akin to the Van Dyck drawing in Washington (here cat. 8).[3] Van Dyck could have met Poussin, either in Italy in the 1620s or later in Paris.

Fig. 45a Poussin or his circle, *Study of trees*, pen and brown ink with brown wash, 257 × 186 mm. London, British Museum (Pp.4–71).

1 By Rosenberg and Prat, *op. cit.*

2 Inv.8101S, Rosenberg and Prat, no. 116.

3 Rosenberg and Prat are among those who question the status of these drawings (fig. 45a is their no. R507). For a discussion of some of them see K. Oberhuber, 'Les dessins de paysage du jeune Poussin', in A. Mérot (ed.), *Nicolas Poussin (1594–1665). Actes du colloque, Louvre, 1994*, 1996, vol. I, pp. 101–19 (where fig. 45a is repr. p. 118, fig. 19, as by Poussin), and A. Sutherland Harris, 'À propos de Nicolas Poussin paysagiste', *Revue du Louvre*, XLIV, 2, 1994, pp. 36–40.

46 BARTHOLOMEUS BREENBERGH

(Deventer 1598–1657 Amsterdam)

A castle on a high rock

Pen and brown ink with brown wash over black chalk. 326 × 448 mm.

Inscribed: *Castello della Rocca / Tre miglia de Bra'ciano* and signed and dated: *Bartolomeo Breenborch f. / 1627*

Provenance: purchased from Kunsthandel G. Meijer, Rotterdam, 1979.

Rotterdam, Museum Boijmans Van Beuningen (MB 1979/T5)

SELECTED LITERATURE AND EXHIBITIONS:
G. Janssen and G. Luijten, *Italianisanten en bamboccianten*, Exh. Rotterdam, Museum Boymans-Van Beuningen, 1988, no. 82.

This large drawing was perhaps begun by Breenbergh out of doors, the composition apparently spanning the gutter of a folio sketchbook. However, the balance of the design, with the *repoussoir* of rocks and trees to the left, suggests that it was embellished and completed as an independent work of art. Despite the inscription, by a later hand, describing the drawing as of the castle at Bracciano, the location represented is uncertain. Breenbergh is thought to have worked for the Duke of Bracciano in the late 1620s, when he made numerous drawings of the Duke's estates at Bomarzo, but no castle is recorded near Bracciano. Probably the drawing depicts the Orsini family's castle at Torre de Chia, about three miles south of Bomarzo, seen from another angle in several works by the artist.[1] The castle is observed from the same viewpoint in a drawing of the architecture alone, now in Berlin,[2] and the present composition formed the basis for a painting, in which the elements of the design are subtly adjusted: the cliff is steeper, a river flows under a bridge to the right, and the view into the distance is extended (fig. 46a).[3]

Breenbergh was in Rome from 1619–29, and some contact between him and Van Dyck cannot be ruled out. He was among those landscape artists who, taking Paul Bril as the starting-point for their art, produced an ideal vision of the Roman *campagna* that was to exert an influence, in Breenbergh's case, not only on Claude Lorrain, but on draughtsmen back in his native country, including Constantijn Huygens and Jan de Bisschop. Herman van Swanevelt (see cat. 47 and fig. 47a), whose Roman sojourn began in 1629, the year Breenbergh left the city, also responded to his work (see fig. 46b).

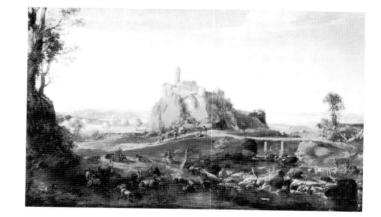

1 See the two drawings in Paris, École des Beaux-Arts (M1576), and St Petersburg, the Hermitage Museum (18354), in Roethlisberger, 1969, nos 13–14.

2 Kupferstichkabinett (KdZ.12465), Roethlisberger, *op. cit.*, no. 22.

3 Sold at Christie's, New York, 2 June 1988, lot 141.

Fig. 46a Breenbergh, *A castle on a high rock*, oil on copper, 33 × 53.5 cm. Formerly at Christie's, New York (photo: Christie's Images).

Fig. 46b H. van Swanevelt, *Italian landscape*, pen and grey ink and wash over black chalk, 264 × 321 mm. Turin, Biblioteca reale (16517).

Castello della Rocca
tre miglia di Bresciano

Bartholmeo Breemberch f.
1627

47 HERMAN VAN SWANEVELT

(Woerden c.1600–55 Paris)

Brushwood on a mountainside

Pen and brown ink with brown wash. 237 × 382 mm.

PROVENANCE: P. Allan Fraser; his sale, Sotheby's, 10 June 1931, part of lot 150, bt Lugt.

Paris, Collection Frits Lugt, Institut Néerlandais (4771)

SELECTED LITERATURE AND EXHIBITIONS:: Exh. Brussels–Rotterdam–Paris–Berne, 1968–9, no. 148, pl. 38; Exh. New York–Paris, 1977–8, no. 106, pl. 114.

Few of Van Swanevelt's surviving drawings appear, like this one, to have been made directly from nature.[1] Reminiscent of Van Poelenburch and Breenbergh in style (see fig. 47a and cats 44, 46 and fig. 46b), the present drawing also resembles Claude Lorrain, alongside whom he worked, to their mutual benefit, in Rome (see cats 48–9).

In style and chronology Van Swanevelt, who left Holland for Paris in around 1623 before living in Rome from 1629–41, links the generation of Van Poelenburch and Breenbergh with later Italianate artists, such as Jan Both (c.1615–52) and Nicolaes Berchem (1620–83). Of the same generation as Van Dyck, Van Swanevelt's approach to nature is analogous to the Fleming's, although the two artists do not appear to have met; the stylistic proximity demonstrates the common sources of the sketches made from nature at this time by an international range of artists (see further the Introduction, section III).

1 Six others are in the Louvre (Lugt, 1931, no. 743, repr. pl. XLVII, and 749), the Albertina in Vienna (8018, Exh. Vienna, *Claude Lorrain und die Meister der römischen Landschaft*, 1964–5, no. 260), the Rijksmuseum (A.4593; I. Q. van Regteren Altena, *Vereeuwigde stad, Rome door Nederlanders getekend*, 1964, no. 61, repr. pl. 4; engraved in reverse, Bartsch 92); the British Museum (Hind 5 as Anonymous Flemish seventeenth century, Oo.10–208; this has not previously been given to Van Swanevelt); and the drawing sold at Christie's, Amsterdam, 25 November 1992, lot 598. The two Louvre drawings were exhibited there in *Cabinet des dessins. Le dessin à Rome au XVII^e siècle*, 1988, nos. 134–5; Lugt 743 was also shown there in Exh. Paris, 1990, no. 85.

Fig. 47a B. Breenbergh, *Brushwood on a mountainside*, pen and brown ink with brown wash, 222 × 342 mm. Staatliche Museen zu Berlin–Preussischer Kulturbesitz, Kupferstichkabinett (KdZ.26316; photo: Jörg P. Anders).

48 CLAUDE LORRAIN

(Chamagne 1600/5?–82 Rome)

View with trees on a ridge

Brown and pink wash over black chalk. 216 × 323 mm.

PROVENANCE: Richard Payne Knight, by whom bequeathed, 1824.

London, British Museum (Oo.6–114)

SELECTED LITERATURE AND EXHIBITIONS:
M. Roethlisberger, *Claude Lorrain. The Drawings*, 1968, no. 177; Exh. Paris, Louvre, *Claude Lorrain. Dessins du British Museum*, 1978, no. 14.

Several hundred nature studies and sketches of the Roman *campagna* by Claude reveal that he made a regular habit of drawing *en plein air* until the late 1660s. His earliest such works, from a small sketchbook thought to date from the end of the 1620s, are freely set down from nature and reminiscent in style of Bartholomeus Breenbergh. The present work is datable on stylistic grounds to *c.*1635–40, once Claude had developed a broad conception of nature, often conveyed as here by a confident use of the brush. It was on the basis of his landscape sketches, combined with the influence of paintings by Paul Bril (1554–1626) and other artists working in Rome, that Claude produced the idealized compositions for which he is chiefly remembered.

Sandrart states that Claude 'tried by every means to penetrate nature, lying in the fields from before daybreak until night in order to learn to represent very exactly the red sky at dawn, sunrise and sunset, and the evening hours'.[1]

1 Sandrart, 1675, p. 331.

49 CLAUDE LORRAIN
(Chamagne 1600/5?–82 Rome)

Study of tall plants

Pen and brown ink. 149 × 214 mm.

Inscribed by the artist: *Claud fecit / 1669*

PROVENANCE: Richard Payne Knight, by whom bequeathed, 1824

London, British Museum (Oo.8–250)

SELECTED LITERATURE AND EXHIBITIONS:
M. Roethlisberger, *Claude Lorrain. The Drawings*, 1968, no. 1002; J. J. L. Whiteley, *Claude Lorrain. Drawings from the collections of the British Museum and the Ashmolean Museum*, Exh. Oxford and London, 1998, no. 94.

The drawing, dated 1669, is included for comparison with Van Dyck's drawings of details from nature (cats 4 and 19; *cf.* also the drawing by Saenredam, cat. 39). No earlier studies of the type by Claude are known, but the foreground vegetation in his paintings suggests that he did indeed make some, and that they were indispensable to his art.

There is a girl among the plants on the left, and a dove nesting below, and the drawing belongs to a small group showing these motifs. In one sketch, the girl, perhaps Claude's ward, Agnese, who was sixteen years old in 1669, holds the dove, probably a pet, on her knees.[1]

1 Haarlem, Teyler Museum, Roethlisberger, *op. cit.*, no. 1001.

50 STEFANO DELLA BELLA
(Florence 1610–64 Florence)

Rustic landscape with a tall tree

Pen and brown ink with grey wash. 142 × 200 mm.

PROVENANCE: Santarelli.

Florence, Gabinetto disegni e stampe degli Uffizi (5923 S)

Exhibited in Antwerp only

SELECTED LITERATURE AND EXHIBITIONS: Chiarini, 1972, no. 48, repr.

Della Bella combined stylistic traits from various sources, including Jacques Callot, who also influenced his work as an etcher, Filippo Napoletano and Herman van Swanevelt (see cats 27 and 47). He was in Rome from 1633–9, and in Paris for much of the 1640s, interrupted by visits to the Levant and to Holland, where he met Rembrandt (cat. 53) in 1647.

The present drawing is probably a late work and clearly reveals the influence of Van Swanevelt. Although, like all of Della Bella's more finished landscapes, not certainly drawn directly from nature – the central tree seems unrealistically tall – the airy impression it conveys retains the quality of a *plein air* sketch, and the motif is comparable to that treated by Van Dyck in his drawing from the J. Paul Getty Museum (cat. 22). Another drawing in the same style is at Windsor,[1] but most of Della Bella's surviving drawings from nature are very slight indeed.[2]

1 Inv. 4593 (see A. Blunt, *The Drawings of G. B. Castiglione and Stefano della Bella ... at Windsor Castle*, 1954, no. 125, pl. 36).

2 For example, see the drawings repr. F. Viatte, *Musée du Louvre: Dessins de Stefano della Bella. Inventaire général des dessins italiens*, II, 1972; M. C. Isola, *Disegni di Stefano della Bella dalle collezioni del Gabinetto Nazionale delle Stampe, Roma*, 1975; and A. F. Tempesti, 'A miscellaneous album by Stefano della Bella at Munich', *Master Drawings*, XIV, 1976, pp. 260–70, pls 16–30.

51 PIER FRANCESCO MOLA

(Coldrerio, nr Lugano 1612–66 Rome)

Landscape with a view near Coldrerio

Pen and brown ink with brown wash (*verso* with grey rather than brown wash). 285 × 210 mm.

Inscribed by the artist: *T monte di S. Maria / Monte + colle Brusada* and on the trunk of the tree: *pianta vechia di mela a Dieci nel nro Cios* and above the church: *Chiesa di S Antonio / genestre* and below, by another hand: *(Mola - F)*

PROVENANCE: J. Richardson, senior (L.2183); Earl of Aylesford (L.58); purchased from J. D. Reigh, 1898.

London, British Museum (1898–12–16–1)

SELECTED LITERATURE AND EXHIBITIONS: Richard Cocke, *Pier Francesco Mola*, 1972, under no. 7; *Pier Francesco Mola (1612–1666)*, Exh. Lugano–Rome, 1989–90, no. III.72; Nicholas Turner, *Italian drawings ... in the British Museum. Roman Baroque Drawings c.1620 to c.1700*, London, 1998. no. 212.

The inscription below includes 'crosses' which refer to two similarly marked points in the landscape, to the left of the tree. The view is of the countryside around Coldrerio in the Ticino, the artist's birthplace, taken from the painter's home, with an apple tree in the foreground in his garden (in the inscription *Cios* i.e. 'chioso', local dialect for a small, walled enclosure by a dwelling).

In style the drawing not only reflects the Bolognese tradition of landscape (the Carracci and Guercino) but may also be compared with drawings by Claude, who made a similar habit of inscribing notes on his drawings from nature (something also encountered in Van Dyck, cats 1, 6 and 12). Another drawing by Mola, showing the nearby *chiesa Rossa* at Castello, is also in the British Museum, and a few other of the artist's studies from nature are known.[1]

The *verso* contains a sketch of *God the Father with angels* (fig. 51a). This is a study for the fresco in the centre of the ceiling of the *Cappella Nuova* in the church of the Madonna del Carmelo at Coldrerio, painted in 1641–2, the years to which the landscape sketch should also be assigned. Mola arrived back at Coldrerio in August 1641 and probably completed his work in the church by 28 April 1642 when the last recorded payment to him was made.

1 1946–7–13–779, Turner. *op. cit.*, no. 213; repr. in Exh. Rome–Lugano (*op. cit.*), no. III.73; see also especially nos III.75–6, 80 and 82.

Fig. 51a *Verso.*

52 CLAUDE DE JONGH

(Utrecht? c.1600–63 Utrecht)

A road through an English village

Pen and brown ink with brown wash. 203 × 290 mm.

Inscribed on the *verso* by the artist: *in Aprill* [1]628

PROVENANCE: Hans Sloane bequest, 1753.

London, British Museum (Sloane 5214–104)

SELECTED LITERATURE AND EXHIBITIONS:
Croft-Murray, 1960, p. 382, no. 2, repr. pl. 179;
Exh. London, British Museum, *The Art of Drawing*,
1972–3, no. 62.

Another drawing of the same village by De Jongh,
inscribed twice with his name and dated 1628, like
the present work, is now in Rotterdam (fig. 52a).
In the 1845 inventory of the Sloane collection the
location is given as Kenilworth (Warwickshire);
and Kenilworth Castle for a second drawing from
the same collection (5214–103, now supposed to
represent Rochester). Evidence to confirm these
identifications is lacking, but the drawing was made
while the artist was in England. There is a minor
sketch of two cottages on the *verso*.

De Jongh's drawings of England, among the
earliest known, are variously dated by him in 1615,
1625 and 1627–8. He was the most sophisticated
topographical draughtsman active in the country at
around the time of Van Dyck's English sojourns.
Although apparently from Utrecht, where he is first
recorded in the painters' guild in 1627, the style of
his drawings is indebted to artists active elsewhere
in Holland, especially to the early work of Claes
Jansz. Visscher of Amsterdam (on whom see cat. 30,
a drawing in his looser manner)[1] and to painters in
Haarlem, where De Jongh is twice noticed in the
early 1630s. His highly wrought drawings may have
been made in the studio but they clearly depend on
direct observation. The contrast with the freedom of
Van Dyck's landscapes could not be greater.

De Jongh's other surviving drawings of identi-
fiable locations in England all depict views in
London or Kent, some of which he worked up into
paintings, possibly when in Holland.[2]

1 *Cf.* for example Visscher's monogrammed drawing in the
 Rijksmuseum, 1919:67, repr. Exh. Amsterdam, 1993–4,
 no. 323. Also particularly close in style is the work of Gilles
 van Scheyndel (active c.1615–30), as in his *River landscape* in
 the Lugt collection, Paris (repr. Exh.
 Brussels–Rotterdam–Paris–Bern, 1968–9, no. 146, pl. 19).

2 See J. Hayes, 'Claude de Jongh', *Burlington Magazine*, XCVIII,
 1956, pp. 3–11.

Fig. 52a
Claude de Jongh,
An English Village,
pen and brown ink
with brown wash,
178 × 388 mm.
Rotterdam, Museum
Boijmans Van
Beuningen.

53 REMBRANDT VAN RIJN
(Leiden 1606–69 Amsterdam)

A sailing-boat on a wide expanse of water

Pen and brown ink with brown wash, on paper prepared with brown wash. 89 × 182mm.

PROVENANCE: N. A. Flinck (L.959); William, 2nd Duke of Devonshire; by descent until sold, Christie's, 3 July 1983, lot 60; New York art market.

Los Angeles, The J. Paul Getty Museum (85.GA.94)

SELECTED LITERATURE AND EXHIBITIONS: O. Benesch, *The Drawings of Rembrandt*, IV, 1955 (2nd edn 1973), no. 847; Exh. Cambridge–Montreal, 1988, no. 70; George R. Goldner, *European Drawings I*, J. Paul Getty Museum, 1988, no. 117; B. Bakker *et al.*, *Landscapes of Rembrandt*, 1998 pp. 337–8, repr. p. 110.

Rembrandt's drawings of the Dutch landscape sometimes produce surprising analogies with the work of Van Dyck: both artists unite a particularized sense of place with a general, baroque compositional sweep. Precise penwork is combined effortlessly with a broad touch, and the technical means employed seem minimal, and in tension with foregone possibilities for further descriptive elaboration. Yet as a comparison with the drawing by Esaias van de Velde demonstrates (cat. 31), with its wedge-shaped composition abutting the distant church tower, Rembrandt's slim horizontal trail of land, crossed by the vertical caesura of the sailing-boat, has antecedents in Dutch art which stand outside the Flemish artist's direct sources of inspiration.

Rembrandt's drawing was probably made in around 1650, in the vicinity of Amsterdam – possibly at the Nieuwe Meer to the south west of the city, where the lake of the Haarlemmer Meer narrowed towards the River Schinkel (the area has now been reclaimed).[1] Despite the economy of touch, the number of details Rembrandt has recorded is impressive: the right-angled edifice in the middle-ground in the centre, probably an inn, the *Huis te Vraag*, and the distant buildings or windmills beyond it; the copse of trees on the right bank with the town on the horizon, including three church spires or towers, probably the Westerkerk, Oude Kerk and Zuiderkerk; the figure in the stern of the boat, holding a rigging line and the tiller as the vessel pushes through the calm water with an almost tangible sense of movement; and the wind-bent reeds to the left.

The pen-and-ink framing lines on three sides of the drawing are missing at the top, where the drawing may have been trimmed.

1 As suggested by F. Lugt, *Mit Rembrandt in Amsterdam*, 1920, p. 155.

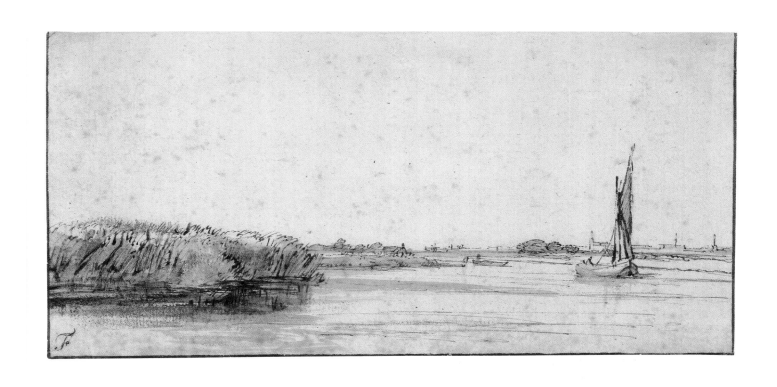

54 JAN LIEVENS

(Leiden 1607–74 Amsterdam)

Forest scene with a large tree by a pool

Pen and brown ink with touches of brown and greyish-brown wash. 260 × 411 mm.

PROVENANCE: J. G. Verstolk van Soelen (according to Leembruggen catalogue); G. Leembruggen; his sale, Amsterdam, 5 March 1866, lot 356; John Malcolm of Poltalloch; purchased with his collection, 1895.

London, British Museum (1895-9-15-1198)

SELECTED LITERATURE AND EXHIBITIONS: Hind, 1915, no. 27; W. Sumowski, *Drawings of the Rembrandt School*, VII, 1983, no. 1680ˣ; Exh. London, 1996–7a, no. 88.

Lievens worked in Leiden with Rembrandt until the latter moved to Amsterdam in around 1631, where both had previously been pupils of Pieter Lastman. Lievens himself settled in England from 1632–c.1635,[1] abandoning his early style, which was initially inspired by Lastman and later by the young Rembrandt, to become an emulator of Van Dyck. He is portrayed in the *Iconography*[2] and like Van Dyck he enjoyed the patronage of Charles I.

His landscape drawings, although sometimes attributed to his son, Jan Andrea Lievens (b. 1644), are also indebted to Van Dyck's example in their choice of motifs and compositional elegance, although Lievens' penwork is considerably broader. From the 1660s his manner was echoed by a number of Amsterdam-based landscape artists, including Abraham Rutgers (1632–99) and Johannes Leupenius (1643–93).

1 The baptism of the child, Maria, of a Jan Lievens is recorded in the Dutch Church in London on 16 May 1637, although this may not refer to the painter, who married in Antwerp in 1638 (see W. J. C. Moens, *The marriage, baptismal, and burial registers … of the Dutch Reformed Church, Austin Friars, London*, 1884, p. 45).

2 Mauquoy-Hendricx 85.

55 WENCESLAUS HOLLAR
(Prague 1607–77 London)

The harbour at Amsterdam

Pen and black ink with grey wash and some coloured washes. 146 × 373 mm.

Signed, dated and inscribed by the artist: *Zu Amsterdam WH 1634* and *Zuyder Kerck*; inscribed *verso*: *of M^r: Hllars Drawing* and by Esdaile: *1834 WE 10* and: *Hollar*

PROVENANCE: Thomas Lawrence (L.2445); William Esdaile (L.2617 *verso*); purchased from P. & D. Colnaghi.

London, British Museum (1862-7-12-193)

SELECTED LITERATURE AND EXHIBITIONS: Croft-Murray, 1960, p.354, no.13, repr. pl.153; Antony Griffiths and Gabriela Kesnerová, *Wenceslaus Hollar. Prints and Drawings*, Exh. London, British Museum (and Prague), 1983, no.26; Richard T. Godfrey, *Wenceslaus Hollar. A Bohemian Artist in England*, Exh. New Haven, 1994–5, no.7.

The view is taken looking west and northwest from a point on the Kadyk just south of the Rijsenhooft bulwark at the north-east corner of Amsterdam. The Zuiderkerk is partly visible on the extreme left, as indicated by the artist's inscription. The stockade by the shipyards dominates the view, with the masts of ships in dry dock at an angle and further shipping under sail on the River IJ beyond to the right.

The precision of Hollar's topographical draughtsmanship, related in style to his work as an etcher, forms a revealing contrast with Van Dyck's more atmospheric readings of Rye, at least one of which dates from the same year (see cat. 13; also fig. 12b for Hollar's own view of Rye, based on Van Dyck). The greater sophistication of Van Dyck's application of watercolour over Hollar's 'tinted drawing' is equally clear (*cf.* cats 20 and 22–4). Yet to disparage the exacting standards of Hollar's penmanship would be unjust: it attracted the attention of several notable patrons, including the Earl of Arundel, with whom he came to England in 1636. Some contact with Van Dyck certainly occurred, and Hollar might have wished, like Van Voerst, to be involved in engraving plates for the *Iconography*. As George Vertue, who was well informed about Hollar, records, Hollar 'could not so well enter into that Master's true Manner of Drawing, in his Grace and Touches, as other Engravers, some in *England*, and others Abroad, who had studied his Way or Manner of Drawing and Painting; for which Reason he could not obtain *Vandyke's* Recommendation, nor that of his Admirers'.[1] Hollar subsequently received commissions from the royal family, but during the Commonwealth he was forced for a time into exile in Antwerp, returning to England in 1652; but his fortunes never recovered, despite prolific activity (he made almost 2,800 prints, mostly for book-illustration).

The present drawing was made on a tour of the Netherlands in 1634, when Hollar was employed by the Cologne publishers Abraham Hogenberg and Gerhardt Altzenbach. There is a sketch of two Dutch East-Indiamen on the *verso* (fig. 55a).

1 George Vertue, *A Description of the Works of the Ingenious Delineator and Engraver Wenceslaus Hollar*, London 1759 (*ed. princ.* 1745), p.140 (my thanks to Antony Griffiths for this reference). John Aubrey was told by Hollar that Van Dyck's mistress, Margaret Lemon, was 'a dangerous woman' and 'a demon of jealousy who caused the most horrible scenes when ladies belonging to London society had been sitting, without chaperone, to her lover for their portraits' (see Graham Reynolds, *English Portrait Miniatures*, 1988, pp.48–9). Hollar also seems to have made sketches in Van Dyck's studio, deriving at least four of the figures for his prints of *Ornatus Muliebris Anglicanus* of 1638–40 from the Flemish painter's portraits (as noticed by Oliver Millar, quoted by Godfrey, *op. cit.*, p.13). Perhaps it was there, too, that he saw Van Dyck's 1633 drawing of Rye (see cat. 12).

Fig. 55a *Verso* (detail).

56 DAVID TENIERS THE YOUNGER

(Antwerp 1610–90 Brussels)

Landscape with a church behind trees

Graphite. 167 × 253 mm.

PROVENANCE: R. Houlditch (L.2214); J. Richardson, senior
(L.2184); Uvedale Price; his sale, Sotheby's, 4 May 1854, lot 236,
purchased for British Museum by W. B. Tiffin (with another
drawing by Teniers, 1854–5–13–14).

London, British Museum (1854–5–13–13)

SELECTED LITERATURE AND EXHIBITIONS: Hind, no. 16;
M. Klinge, *David Teniers the Younger. Paintings. Drawings*,
Exh. Antwerp, 1991, no. 127, repr.; M. Klinge, 'David Teniers
der Jüngere als Zeichner. Die Antwerpener Schaffenzeit', *Jaarboek
Koninklijk Museum voor Schone Kunsten Antwerpen*, 1997,
p. 200, fig. 73.

Teniers based the background of a painting of the later
1640s on this sketch, the *Peasants dancing before an inn*,
now at Lotherton Hall near Leeds (fig. 56a), and the
drawing was probably made during the same period. It is
a typical example of Teniers' lively notational style in
graphite, which he employed to great effect in capturing
the tonal values of the landscape, almost always directly
observed from nature, as well as for figure studies and
other compositions. The presence of the harvesters here
helps to define the quality of light that the artist sought to
depict, and there is an almost palpable sense of movement.

As the celebrated collector and connoisseur Pierre-Jean
Mariette observed in 1741: 'Teniers' drawing style is very
ingenious; using little effort, he renders the objects he
wishes to imitate with the utmost truth. Ordinarily he used
lead pencil, which gave his drawings much airiness and
lightness; but as pencil marks easily rub out, his drawings
are hard to find in a well preserved state'.[1]

The origins of Teniers' style are uncertain, and seem to
derive as much from Dutch as from Flemish models.
In composition they sometimes relate to Van Dyck, as may
be seen by comparing his *Group of trees* in Besançon
(fig. 56b)[2] with Van Dyck's *Study of trees* (here cat. 20).

1 Quoted from the Crozat sale catalogue of 1741 in Exh. Antwerp,
1991 (*op. cit.*), p. 299. Under no. 127, the author suggests that the
church in the British Museum drawing could be that of the village of
Zandhoven.

2 Exh. Antwerp, 1991, no. 126.

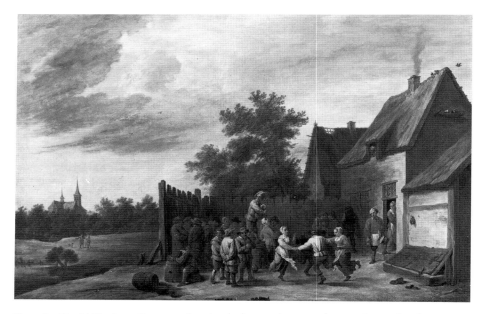

Fig. 56a David Teniers, *Peasants dancing before an inn*, panel. 43 × 62 cm. Leeds
Museums and Galleries (Lotherton Hall, Aberford); photo: Courtauld Institute.

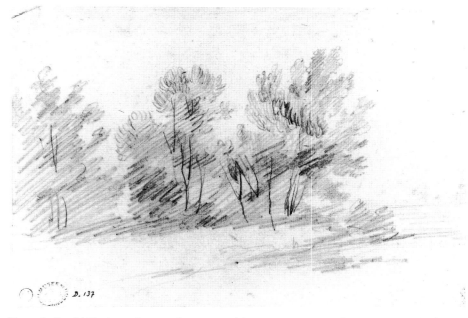

Fig. 56b David Teniers, *Group of trees*, graphite, 128 × 185 mm. Besançon, Musée des
Beaux-Arts et d'Archéologie (D137).

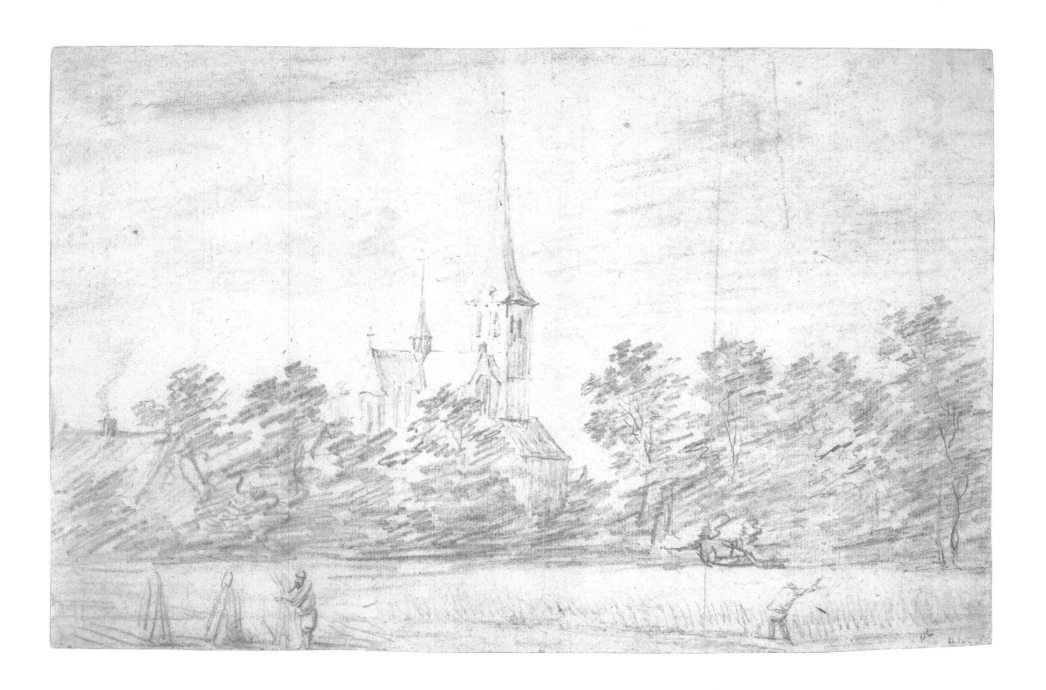

57 Attributed to JACQUES D'ARTHOIS
(Brussels 1613–86 Brussels)

Landscape with trees near water

Black chalk, heightened with white, on pale buff paper.
335 × 522 mm.

Inscribed by J. Richardson, senior: *Zc.30.n VDyck* and lower right, by another hand(?): *Fo* [?]

PROVENANCE: J. Richardson, senior (L.2983–4); Joshua Reynolds (L.2364, *verso*); G. Bellingham Smith; his sale, Amsterdam, Muller, 5 July 1927, lot 21; F. Koenigs; gift of D. G. van Beuningen, 1941.

Rotterdam, Museum Boijmans Van Beuningen (V55 as Van Dyck)

SELECTED LITERATURE AND EXHIBITIONS: Exh. London, Royal Academy, *Flemish Art*, 1927, no. 598; A. M. Hind, 'Van Dyck and English Landscape', *Burlington Magazine*, LI, 1927, pp. 296–7, pl. B (as Van Dyck).

The attribution of the drawing to Jacques d'Arthois, here suggested for the first time, depends on its resemblance, which is close, to a work in the Kunsthalle in Hamburg, which has long been attributed to him (fig. 57a).[1] It is difficult to judge whether they were made from nature, although the informality and untempered angularity of the central tree in the present drawing rather suggests that it was. The white heightening and perhaps the background may have been elaborated in the studio.

D'Arthois is best remembered for his painted landscapes, although he was employed for altarpieces and also to supply tapestry cartoons. His woodland and forest scenes were inspired by the Forest of Soignes, a location to the south and east of Brussels frequented by several landscape painters based in the city in the seventeenth century, including Lodewijck de Vadder (on whom see cat. 43), among whose followers D'Arthois was a leading spirit (although he was not a pupil of De Vadder, but of Jan Mertens). His work also contains qualities reminiscent both of Van Uden (see cats 41–2) and, ultimately, of Rubens, as is suggested by the technique and scale of the present sheet.[2]

It is worthy of note that Jonathan Richardson senior inscribed the drawing with Van Dyck's name. The latter's landscapes were strongly represented in his collection.[3]

1 I am grateful to Dr Hanna Hohl for confirming that the attribution of the Hamburg drawing to D'Arthois is the traditional one.

2 Compare also d'Arthois' paintings (several are repr. Y. Thiery and M. Kervyn de Meerendre, *Les peintres flamands de paysage au XVIIᵉ siècle*, Brussels, 1987, pp. 125–44). For his biography, see M. Kervyn de Meerendre, in *An. fed. cerc. archéologie et histoire belge*, XLIV, 1976, pp. 841–7. Hollar was among those who engraved his work.

3 Twelve of the landscape drawings catalogued by Vey were owned by Richardson senior: nos. 283 (here cat. 7), 286, 288 (here cat. 12), 290 (here cat. 14), 292 (here cat. 16), 293 (here cat. 18), 294 (here cat. 17), 296 (here cat. 19), 297 (here cat. 4), 302 (here cat. 8), 303 (here cat. 20), and 304 (here cat. 24). For his handwriting, see L.2983–4; a similar inscription, unusual for Richardson in being on the *recto*, is on cat. 4.

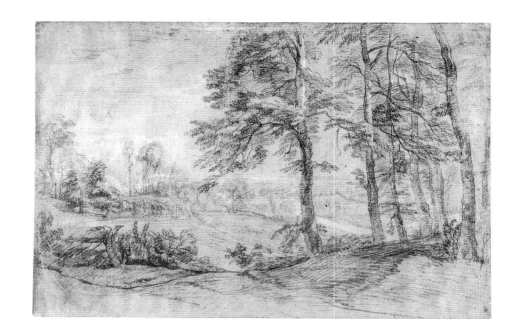

Fig. 57a
Jacques d'Arthois,
Landscape with trees,
black and white chalk
on pale buff paper,
335 × 522 mm.
Hamburg, Kunsthalle
(21635; photo: Elke
Walford).

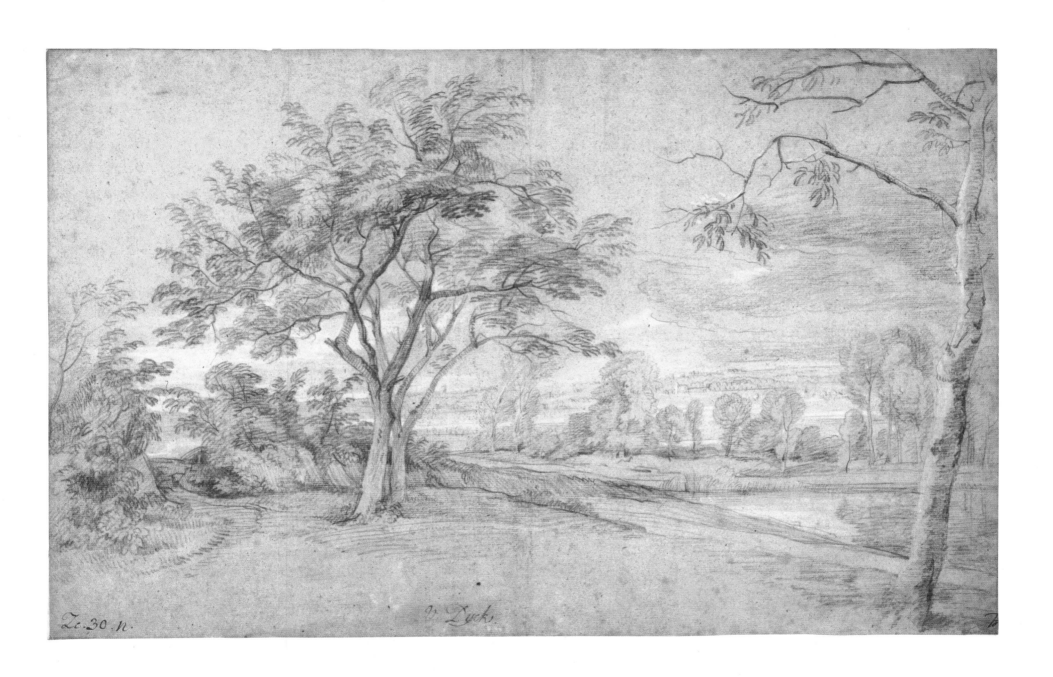

Z. 30. n. v Dyck.

58 FOLLOWER OF VAN DYCK

Landscape with trees by a ditch

Watercolour and bodycolour on blue paper.
240 × 388 mm.

Inscribed lower right: *A. Vandyck*

PROVENANCE: Brett; H. Oppenheimer sale, Christie's,
10–14 July, 1936, lot 236; presented by the National Art
Collections Fund.

London, British Museum (1936–10–10–22)

SELECTED LITERATURE AND EXHIBITIONS:
A. E. Popham, 'Acquisitions at the Oppenheimer sale',
British Museum Quarterly, XI, 1936, p. 128; Brown, 1982,
p. 216; Exh. London, 1987, no. 59.

The drawing belongs to a group of twelve landscape
studies, all apparently by the same artist, four of
which are in the British Museum.[1] Six are annotated,
like this one, with Van Dyck's name. Three others,
two of them in the Yale University Art Gallery and
another recently on the art market, bear the name of

Frans Wouters (1612–59), and one of those in the
British Museum that of 'I. Rademaker'. All these
inscriptions are apparently in the same handwriting.[2]
Clearly not by Van Dyck, their resemblance to the
backgrounds of Wouters' oil-paintings has prompted
support for an attribution to him. Wouters worked
in England from c.1637–41; yet the acidic colour
strikes a discordant note and the presence, in one
of the British Museum's drawings, of almost
Rococo figures suggests that the drawings are later
derivations from Van Dyck's landscape style,
perhaps made during the later seventeenth century.[3]
Lely has also been put forward as the
possible draughtsman.[4] The present sheet is arguably
the subtlest of the group; the others at times
resemble the crude landscape backgrounds turned
out by Van Dyck's studio assistants.[5]

1 There are twelve drawings in the group (ten are listed by
Logan in Exh. Wellesley–Cleveland, 1993–4, under no. 53),
as follows: six inscribed with the name of Van Dyck (the
present sheet; two more in the British Museum, Hind
nos 86–7; a fourth in the Albertina, from the Bonn sale,
formerly at Sotheby's, 15 November 1922, lot 8; another in
the Clark Institute, Williamstown, Mass. [E. Haverkamp-
Begemann et al. *Drawings from the Clark Institute*, 1964,
no. 24]; the sixth in the Pierpont Morgan Library [inv. I,
245; see Stampfle, 1991, no. 275, repr.]); three inscribed
with attributions to Wouters (two in the Yale University Art
Gallery, Haverkamp-Begemann and Logan, 1970, nos
621–2, a third sold in London, Sotheby's, 22 November
1974, lot 88, repr.); the one inscribed as by *Rademaker* in
the British Museum, mentioned at the beginning of the next
note; and two uninscribed drawings, one in the Van
Regteren Altena collection (repr. P. Clarijs, *Anthonie van
Dyck*, 1947, p. 51) and one in Dresden (C1967–346, repr.
Haverkamp-Begemann and Logan, p. 331 and C. Dittrich,
Van Eyck – Bruegel – Rembrandt, Exh. Dresden and Vienna
1997–8, no. 72). A third drawing at Yale, though also
inscribed with Wouters' name, seems to be by another hand
altogether (Haverkamp-Begemann and Logan no. 623).
Haverkamp-Begemann and Logan refer to five 'possible
candidates' for the group in the Hermitage (published by
Dobroklonsky, 1955, nos 340–43 and 664). Stampfle,
loc. cit., refers to two other possible additions from
the Hermitage which are generally assigned to Rubens,

Dobroklonsky, *op. cit.*, no. 659 (which is discussed in *Dessins
flamands et hollandais*, Exh. Brussels–Rotterdam–Paris
1972–3, no. 85) and, more tentatively, no. 660. In fact all the
Hermitage drawings seem closer to Rubens in style (to judge,
for the most part, from reproductions).

2 Inscribed *I. Rademaker fecit*, 1932–10–12–2. This untrust-
worthy hand seems also to have been responsible for wrongly
attributing the set of drawings of *Farm Landscapes* to Rubens
and, in one case, Abraham Bloemaert (Adler nos 2–13; see
Introduction and n. 131).

3 The earliest recorded provenance among the drawings in the
group appears to be that of the Dresden drawing, which was
owned by Gottfried Wagner of Leipzig in 1728; one of the
British Museum sheets (Hind 87) belonged to John Bouverie
(c.1722–50; on his mark, L.325, see most recently N. Turner
in *Burlington Magazine*, CXXXVI, 1994, pp. 90–99); six years
ago J. S. Held reiterated his belief in the attribution to Wouters
(*Master Drawings*, XXXI, 1993, p. 296, under no. 275).

4 Christopher White compares the background of the *Portrait
of Viscount Townshend* in the Twiston-Davies collection,
R. B. Beckett, *Lely*, London, 1951, pl. 91, with the British
Museum drawing, Hind 86 (note to the compiler, 9 December
1997).

5 In particular the drawing in the Clark Institute, Williamstown,
Mass. (on which see n. 1 above).

59 PETER LELY

(Soest 1618–80 London)

Landscape with trees and small figures

Brush drawing in grey wash. 160 × 217 mm.

Signed and dated: *PLelij 1643*

PROVENANCE: George Knapton; bequeathed by him to General Morrison; his sale, Philipe, 25 May 1807 where bought by William Esdaile (L.2617 on old backing, from which recently removed); anon. sale, London, Sotheby's, 16 January 1958, lot 187, bt Alfred Scharf; by descent until sold, Sotheby's, 9 April 1992, lot 32 (purchased for the British Museum by Hazlitt, Gooden and Fox Ltd).

London, British Museum (1992-5-16-13)

SELECTED LITERATURE AND EXHIBITIONS: Oliver Millar, *Sir Peter Lely*, Exh. London, National Portrait Gallery, 1978–9, no. 60.

The drawing is one of just three by Lely from around the time of his arrival in England, where he arrived probably in 1641 or 1643, the date on the present sheet. When he settled in England, Lely 'pursu'd the natural bent of his *Genius* in *Lantschapes* with *small Figures*, and *Historical Compositions*', according to an early source,[1] a pattern to which the exhibited drawing conforms.

In another landscape study, now in the Birmingham Museum and Art Gallery, Lely employed black chalk as well as wash, but in the British Museum drawing he restricted himself to the brush to capture a detailed landscape scene in what amounts to an exceptional display of technical control. The distances here to the right are handled with extraordinary subtlety and dexterity. The third surviving drawing, in the same medium but only recently added to Lely's oeuvre, shows the *Haarlem church of St Bavo* and is here published as his work for the first time (fig. 59a).[2]

Although it is not possible to relate the style of these drawings to that practised by Lely's master, Pieter de Grebber (1573–1649), with whom he was studying in 1637 but by whom no landscape studies are known, there are links with the work of other Dutch artists, including the early drawings of Jan van Goyen (on whom see cats 36–7). At this stage of Lely's career his style was still far removed from Van Dyck's; yet it seems unlikely that he was

responsible, as has been suggested, for the series of gouache landscapes to which cat. 58 belongs. Those drawings have a superficial allure, largely due to their colour, but lack the sensitivity that Lely displays both here and in the landscape backgrounds of his paintings, as indeed in all of his autograph output.

Van Dyck's influence was to determine the course of Lely's art from the 1640s, when he may have already begun to collect the older master's drawings, including his Italian Sketchbook (now in the British Museum) and the *grisailles* relating to the *Iconography* now in the Duke of Buccleuch's collection at Boughton House. Lely also owned Van Dyck's *Portrait of Dorothy, Viscountess Andover and her sister, Lady Thimbleby*, until 1976 for almost 300 years in the picture gallery at Althorp, for which it was purchased at Lely's posthumous sale in 1682 by the Earl of Sunderland. It is now in the National Gallery.[3]

1 Richard Graham in C. A. Dufresnoy's *De arte graphica / The Art of Painting*, London, 1695, pp. 343–4.

2 The attribution was made by the compiler in 1993 on the basis of a comparison with the present work. The drawing entered the British Museum with the C. M. Cracherode bequest of 1799, and was attributed to Jacob van Ruisdael in the inventory of 1837. It was published as by an anonymous seventeenth century Dutch artist by Hind, vol. IV, p. 131, no. 34.

3 Larsen 981.

Fig. 59a. Peter Lely, *Haarlem with the church of St Bavo*, brush drawing in grey wash, 148 × 273 mm. British Museum (Gg.2–287).

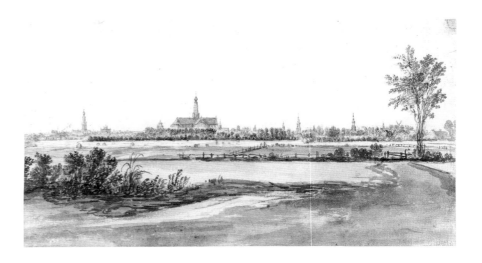

60 JACOB ESSELENS
(Amsterdam 1626–87 Amsterdam)

A view of Rye from the north east

Pen and brown ink with grey wash, over black chalk.
250 × 370 mm.

Inscribed or probably signed by the artist, lower right:
J Esselens

PROVENANCE: Colnaghi's, where purchased in 1936 by
Bruce Ingram; Bruce Ingram bequest, 1963.

Cambridge, Fitzwilliam Museum (PD.298–1963)

SELECTED LITERATURE AND EXHIBITIONS: D. Scrase,
*Das Goldene Jahrhundert. Meisterzeichnungen aus dem
Fitzwilliam Museum Cambridge*, Exh. Munich, Cambridge
and elsewhere, 1995–6, no. 42.

Three other views of Rye by Esselens, one taken
from a similar vantage-point, are in the Atlas van
der Hem, a seventeenth-century compilation of
topographical drawings now in the Österreichische
Nationalbibliothek, Vienna.[1] The composition here
resembles that of Van Dyck's view of 1633 (cat. 12,
q.v.). The style of the earlier artist has also clearly
left its mark on Esselens, whose draughtsmanship is,
however, less delicate, relying on an underdrawing
in black chalk and producing a harsher line. His
view was taken from a position some yards to the
east of Van Dyck's.

Presumably Esselens, like his predecessor, passed
through Rye on his travels to and from the
Continent, but the date of the drawing has not been
established. Based in Amsterdam, he was a merchant
as well as an artist, owning a texile company with
dealings throughout Europe. He made drawings
while travelling, probably on business, in France and
the Alps as well as in England, which he certainly
visited in 1665–6 and perhaps at other times.

1 See P. Hulton, *Walpole Society*, XXXV, 1954–6, nos 37–9,
repr. The Atlas is in course of publication (Peter van der
Krogt and Erlend de Groot, *The Atlas Blaeu-Van der Hem*, I,
1996).

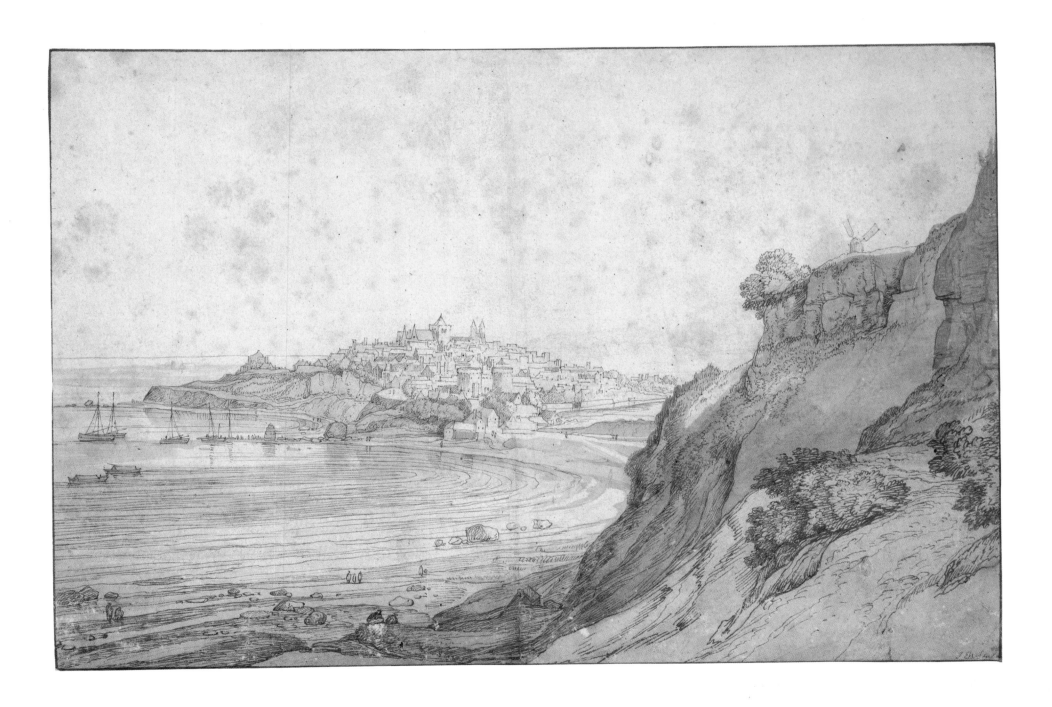

BIBLIOGRAPHY AND ABBREVIATIONS
(items mentioned more than once)

Sources

Baglione, Giovanni, *Vite*, Rome, 1642.

Baldinucci, Filippo, *Notizie de' professori del disegno da Cimabue in qua...*, Florence, 1696.

Bellori, G.P., *Le vite de' pittori et architetti moderni*, Rome, 1672.

Bie, Cornelis de, *Het Gulden Cabinet*, Lier, 1661.

Félibien, A., *Entretiens sur les vies et sur les ouvrages des plus excellents peintres anciens et modernes*, Trevoux, 1688.

Goeree, Willem, *Inleydinghe tot de algemeene teyken-konst*, Amsterdam, 1697.

Hoogstraten, Samuel van, *Inleyding tot de hooge schoole der Schilderkonst*, Rotterdam, 1678 (reprinted, Doornspijk, 1969).

Houbraken, A., *De groote schouburgh der nederlandse konstschilders en schilderessen*, 3 vols, The Hague, 1718–21 (1753 edn, The Hague, reprinted Amsterdam, 1976).

Mander, Karel van, *Het Schilder-Boeck*, Haarlem, 1604 (includes *Den Grondt der edel vry schilder-const*, H. Miedema (ed.), 2 vols, Utrecht, 1973; *The lives of the illustrious Netherlandish and German painters*, H. Miedema (ed.), 4 vols (in progress), Doornspijk, 1994–7).

Michiel, Marcantonio, *Notizia d'opere di disegno*, Bassano, 1800 edn.

Norgate, E., *Miniatura or the Art of Limning*, 1649, J.M. Muller and J. Murrell (eds), New Haven and London, 1997.

Peacham, Henry, *The Art of Drawing with the Pen and Limning in Water Colours*, London, 1606 2nd edn [*Graphice: on the most Auncient and Excellent Art of Drawing and Limning*], 1612.

Piles, Roger de, *Cours de peinture par principes*, Paris, 1708.

Sandrart, Joachim von, *Teutsche Akademie der edlen Bau-, Bild- und Mahlerey-Künste*, 2 vols, Nuremberg, 1675 (A.R. Peltzer [ed.], Munich, 1925).

Soprani, R., *Le vite de' pittori, scultori ed architetti genovesi e de' forastieri che in Genova operavano*, Genoa, 1674.

Vasari, Giorgio, *Le vite dei più eccellenti pittori, scultori ed architettori*, 2nd edn, 3 vols, Florence, 1568.

Modern literature

Adler, W., *Jan Wildens. Der Landschaftsmitarbeiter des Rubens*, Fridlingen, 1980.

Adler, W., *Rubens landscapes. Corpus Rubenianum*, XVIII, part I, Oxford, 1982.

Adriani, G., *Anton van Dyck: Italienisches Skizzenbuch*, Vienna, 1940 (2nd edn 1965).

Baer, C.O., *Landscape drawings*, New York, n.d. (1973).

Baer, R. *Paul Bril: Studien zur Entwicklungsgeschichte der Landschaftsmalerei um 1600*, Munich, 1930.

Bakker, B., 'Levenspilgrimage of vrome wandeling? Claes Jansz. Visscher en zijn serie *Plaisante plaetsen*', *Oud Holland*, CVII, 1993, pp.97–115.

Balis, A., *Rubens landscapes. Corpus Rubenianum*, XVIII, part II, Oxford, 1986.

Balis, A., 'Fatto da un mio discepolo': Rubens's studio practices reviewed', in T. Nahamura (ed.), *Rubens and his workshop. The Flight of Lot and his family from Sodom*', Exh. Tokyo, National Museum of Western Art, 1993, pp.97–127.

Bartsch, A., *Le Peintre-Graveur*, 21 vols, Vienna, 1803–21.

Beck, H.–U., *Jan van Goyen, 1596–1656*, vols 1–3; vol. 4, *Künstler um Jan van Goyen*, Amsterdam and Doornspijk, 1972; 1991.

Benesch, O., *The drawings of Rembrandt: A critical and chronological catalogue*, 2nd edn, Eva Benesch (ed.), 6 vols, London, 1973.

Berenson, B., *The drawings of the Florentine painters*, 3 vols, Chicago, 1938.

Berlin 1930 = E. Bock and J. Rosenberg, *Staatliche Museen zu Berlin. Die Zeichnungen alter Meister im Kupferstichkabinett: die niederländischen Meister*, 2 vols.

Blunt, A., *Artistic theory in Italy 1450–1600*, 1962 edn (*ed. princ.*, 1940).

Boon, K.G., *Catalogue of the Dutch and Flemish drawings in the Rijksmuseum*, II, *Netherlandish drawings of the fifteenth and sixteenth centuries*, 2 vols, The Hague, 1978.

Boon, K..G., 'Notes on early landscape art in the Southern Netherlands', *The Netherlandish and German drawings of the XVth and XVIth centuries of the Frits Lugt Collection*, Paris, 1992, I, pp.xvii–xxvi.

Brown, C., *Van Dyck*, Oxford, 1982.

Brown, C., see also Exh. London, 1996–7 and Exh. New York–Fort Worth, 1991.

Bruyn, J., 'Toward a scriptural reading of seventeenth-century Dutch landscape paintings', in Exh. Amsterdam–Boston–Philadelphia, 1987–8, pp.84–103.

Bruyn, J., 'Le paysage hollandais du XVIIe siècle comme métaphore religieuse', in *Le paysage en Europe du XVIe au XVIIIe siècle. Actes du colloque, Louvre 1990*, 1994, pp.65–88.

Buijsen, E., 'Between fantasy and reality: 17th century Dutch landscape painting', in *Tussen fantasie en werkelijkheid*, Exh. Tokyo–Leiden, 1992–3, pp.45–63.

Burchard, L. and d'Hulst, R.-A., *Rubens Drawings*, Brussels, 1963.

Buscaroli, R., *La pittura di paesaggio in Italia*, Bologna, 1935.

Carpenter, W.H., *Pictorial notices, consisting of a memoir of Sir Anthony van Dyck with a descriptive catalogue of the etchings executed by him ...*, London, 1844.

Chiarini, M., *I disegni italiani di paesaggio dal 1600 al 1750*, Canova, 1972.

Chong, A. 'The Drawings of Cornelis van Poelenburch', *Master Drawings*, XXV, 1987, pp.3–62.

Chong, A., 'Les dessinateurs néerlandais à Rome dans la première moitié du XVIIe siècle', in *Le paysage en Europe du XVIe au XVIIIe siècle. Actes du colloque, Louvre 1990*, 1994, pp.91–103.

Clark, K., *Landscape into art*, London, 1949.

Clark, K., and C. Pedretti, *The Drawings of Leonardo da Vinci in the collections of Her Majesty the Queen at Windsor Castle*, 3 vols, London, 1968.

Croft-Murray, E., and P. Hulton, *Catalogue of British drawings. British Museum*, I, London, 1960.

Cust, L., *Anthony van Dyck. An historical study of his life and works*, London, 1900.

Dobroklonsky, M.V., *Catalogue of the Hermitage collections: Risunki flamadskoj schkoli XVII–XVIII vekov*, Moscow, 1955.

Franz, H.G., *Niederländische Landschaftsmalerei im Zeitalter des Manierismus*, 2 vols, Graz, 1969.

Freedberg, D., *Dutch landscape prints of the seventeenth century*, London, 1980.

Gerszi, T. 'Bruegels Nachwirkung auf die niederländischen Landschaftsmaler um 1600', *Oud Holland*, XC, 1976, pp.201–29.

Gerszi, T. 'L'influence de Pieter Bruegel sur l'Art du paysage de David Vinckboons et de Gillis d'Hondecoeter', *Bulletin du Musée Hongrois des Beaux-Arts*, LIII, 1979, pp.125–36.

Gombrich, E.H., 'The Renaissance theory of art and the rise of landscape', *Norm and Form*, London and New York, 2nd edn, 1971, pp.107–21.

Grosse, R., *Die holländische Landschaft*, Berlin and Leipzig, 1925.

Haverkamp-Begemann, E., and A.-M.Logan, *European drawings and watercolours in the Yale University Art Gallery*, 2 vols, New Haven and London, 1970.

Held, J.S., *Rubens. Selected drawings*, 2 vols, London, 1959 (2nd edn, Oxford, 1986).

Held, J.S., 'The early appreciation of drawings', *Studies in western art. Acts of the 20th international congress of the history of art, 1961, 1963.*

Hind = Hind, A.M., *Catalogue of drawings by Dutch and Flemish masters ... in the British Museum*, Vol.II, *Drawings by Rubens, Van Dyck and other artists of the Flemish school of the XVIIth century*, London, 1923; vol.III, 1926; vol.IV, 1931.

Hollstein. F.W.H., *Dutch and Flemish Etchings, Engravings and Woodcuts, c.1400–1700*, Amsterdam, 1949– (in progress).

Jaffé, M., *Van Dyck's Antwerp Sketchbook*, 2 vols, London, 1966.

Jaffé, 1966a = Jaffé, M., 'A landscape by Rubens, and another by Van Dyck', *Burlington Magazine*, CVIII, 1966, pp.410–16.

Klijn, M.de, *De invloed van het Calvinisme op de Noord-Nederlandse landschapschilderkunst*, Apeldoorn, 1982.

Kloek, W.Th., *Beknopte catalogus van de nederlandse tekeningen ... van de Uffizi te Florence*, Utrecht, 1975.

Knab, E., 'De genio loci', in *Miscellanea: I.Q. van Regteren Altena*, Amsterdam, 1969, pp.326–32.

L. = Lugt, 1921 and 1956 (see below).

Larsen, E., *The paintings of Anthony van Dyck*, 2 vols, Freren, 1988.

Leeflang, H., 'Dutch landscape: the urban view. Haarlem and its environs in literature and art, 15th–17th century', *Nederlands Kunsthistorisch Jaarboek*, XLVIII, 1997, pp.52–115.

Levey, M., Review of Exh. London, 1982–3, *Burlington Magazine*, CXXV, 1983, pp.106–110.

Lugt, F., *Les marques de collections de dessins et d'estampes*, Amsterdam, 1921 (suppl. vol., The Hague, 1956; reprinted San Francisco, respectively 1975 and 1988).

Lugt, F., *Musée du Louvre. Inventaire général des dessins des écoles du nord: école hollandaise*, II, Paris, 1931.

Lugt, F., *Musée du Louvre. Inventaire général des dessins des écoles du nord: école flamande*, 2 vols, Paris, 1949.

Magurn, C.S., *The letters of Peter Paul Rubens*, Cambridge (Mass.), 1955.

Mahon, D., *Studies in seicento art and theory*, London, 1947.

Mauquoy-Hendrickx, M., *L'iconographie d'Antoine van Dyck. Catalogue raisonné*, 2 vols, Brussels, 1991.

Miedema, H., 1973, and 1994–, see Mander, Karel van (in Sources above).

Mielke, H., *Pieter Bruegel. Die Zeichnungen*, Turnhout, 1996.

Muller, J.M., 'The quality of grace in the art of Anthony van Dyck', in Exh. Washington, 1990–91, pp.27–36.

Oehler, L. 'Einige frühe Naturstudien von Paul Bril', *Marburger Jahrbuch für Kunstwissenschaft*, XVI, 1955, pp.199–206.

Ogden, H.V and M.S., *English taste in landscape in the seventeenth century*, Ann Arbor, 1955.

Oppé, P., 'Sir Anthony van Dyck in England', *Burlington Magazine*, LXXIX, 1941, pp.186–91.

Popham, A.E., *Catalogue of drawings by Dutch and Flemish artists ... in the British Museum, vol.V, ... the XV and XVI centuries*, London, 1932.

Popham, A.E., *The drawings of Leonardo da Vinci*, London, 1946.

Regteren Altena, I.Q. van, *Vereeuwigde stad: Rome door Nederlanders getekend*, Amsterdam, 1964.

Richter, J.P., *Scritti letterari de Leonardo da Vinci*, Oxford and elsewhere, 1939.

Roethlisberger, M. *Bartholomäus Breenbergh: Handzeichnungen*, Berlin, 1969.

Schatborn, P., 'La naissance du paysage naturaliste aux Pays-Bas et l'influence de la topographie aux environs de 1600', in *Le paysage en Europe du XVIe au XVIIIe siècle. Actes du colloque, Louvre 1990*, 1994, pp.65–88.

Schneider, H., *Jan Lievens: Sein Leben und seine Werke*, Leiden, 1932 (reprint, R.E.O.Ekkart (ed.), Amsterdam, 1973).

Sluijter-Seijffert, N.C. *Cornelis van Poelenburch (c.1593–1667)*, diss., Leiden, 1984.

Stampfle, F., *Netherlandish drawings ... in the Pierpont Morgan Library*, New York and Princeton, 1991.

Turner, N., *Italian Baroque drawings*, London, 1980.

Vaes, M., 'Le séjour de Van Dyck en Italie (mi–Novembre 1621 – Automne 1627)', *Bulletin de l'institut historique belge de Rome*, IV, 1924, pp.163–234.

Vergara, L. *Rubens and the poetics of landscape*, London, 1982.

Vey, H., *Die Zeichnungen Anton van Dycks*, 2 vols, Brussels, 1962.

Westfehling, U., *Zeichnen in der Renaissance*, Cologne, 1993.

White, C., and Crawley, C., *The Dutch and Flemish drawings at Windsor Castle*, Cambridge, 1994.

Winkler, F., *Die Zeichnungen Albrecht Dürers*, 4 vols, Berlin, 1936–8.

Winner, M., 'Vedute in Flemish landscape drawings of the 16th century' in G. Cavalli-Björkman (ed.), *Netherlandish Mannerism. Papers given at a symposium in the Nationalmuseum, Stockholm, September 21–22, 1984*, Stockholm, 1985, pp.85–96.

Wood, C.S., *Albrecht Altdorfer and the origins of landscape*, London, 1993.

EXHIBITIONS

Amsterdam 1987
Land & water, M. Schapelhouman and P. Schatborn, Rijksmuseum.

Amsterdam–Boston–Philadelphia 1987–8
Masters of 17th-Century Dutch Landscape Painting, P. C. Sutton (ed.), Rijksmuseum-Museum of Fine Arts–Philadelphia Museum of Art.

Amsterdam 1993–4
Dawn of the Golden Age. Northern Netherlandish art 1580–1620, G. Luijten, A. van Suchtelen et al., Rijksmuseum.

Amsterdam–Toronto 1977
Opkomst en bloei van het Nordnederlandse stadsgezicht in de 17de eeuw/The Dutch cityscape in the 17th century and its sources, B. Haak, R. J. Wattenmaker and B. Bakker, Amsterdam Historisch Museum–Art Gallery of Ontario.

Antwerp 1991
Antoon van Dyck (1599–1641) en Antwerpen, A. Moir, F. de Nave and C. Depauw, Plantin-Moretus Museum.

Berlin 1974
Die holländische Landschaftszeichnung, 1600–1740: Hauptwerke aus dem Berliner Kupferstichkabinett, Wolfgang Schulz, Kupferstichkabinett, Staatliche Museen Preussischer Kulturbesitz.

Berlin 1975
Pieter Bruegel d. Ä. als Zeichner, M. Winner, H. Mielke, et al., Kupferstichkabinett, Staatliche Museen Preussischer Kulturbesitz.

Berlin 1977
Peter Paul Rubens. Kritischer Katalog der Zeichnungen, H. Mielke, M. Winner, et al., Kupferstichkabinett, Staatliche Museen Preussischer Kulturbesitz.

Boston–Toledo 1993–4
The Age of Rubens, Peter C. Sutton, Museum of Fine Arts–Toledo Museum of Art

Brussels–Rotterdam–Paris–Bern 1968–9
Dessins de paysagistes hollandais du XVIIe siècle, C. van Hasselt, Bibliothèque Albert I- Museum Boymans Van Beuningen–Institut Néerlandais–Kunstmuseum.

Cambridge–Montreal 1988
Landscape in perspective: drawings by Rembrandt and his contemporaries, F. J. Duparc.
Arthur M. Sackler Museum, Harvard University Art Museums–Montreal Museum of Fine Arts.

Genoa 1997
Van Dyck a Genova, S. J. Barnes, P. Boccardo, C. Di Fabio and L. Tagliaferro, Palazzo Ducale.

Haarlem 1986
Portretten van echt en trouw, E. de Jongh, Frans Halsmuseum.

Leiden 1996
Jan van Goyen, C. Vogelaar, et al., Lakenhal Museum.

London 1972
The Age of Charles I. Painting in England 1620–1649, O. Millar, Tate Gallery.

London 1977
Rubens, drawings and sketches, J. K. Rowlands, British Museum.

London, 1982–3
Van Dyck in England, O. Millar, National Portrait Gallery.

London 1986
Dutch landscape, the early years: Haarlem and Amsterdam, 1590–1650, C. Brown, National Gallery.

London 1987
Drawings in England from Hilliard to Hogarth, L. Stainton and C. White, British Museum.

London 1996–97
Making and meaning. Rubens's landscapes, C. Brown, National Gallery.

London 1996–7a
Old master drawings from the Malcolm collection, M. Royalton-Kisch, H. Chapman, S. Coppel, British Museum.

London–New York 1986
The Northern Landscape: Flemish, Dutch and British drawings from the Courtauld collections. D. Farr and W. Bradford, Courtauld Institute Galleries–Drawing Center.

London–Paris–Bern–Brussels 1972
Flemish drawings of the seventeenth century, C. van Hasselt, Victoria and Albert Museum-Institut Néerlandais–Kunstmuseum–Koninklijke Bibliotheek.

Munich–Bonn 1993
Das Land am Meer: holländische Landschaft im 17. Jahrhundert, T. Vignau-Wilberg, Staatliche Graphische Sammlung–Rheinisches Landesmuseum.

New York–Fort Worth–Cleveland 1990–91
Von Pisanello to Cézanne: Master Drawings from the Museum Boymans-van Beuningen, Rotterdam, G. Luijten

and A. W. F. M. Meij, Pierpont Morgan Library–Kimball Art Museum-Cleveland Museum of Art.

New York–Fort Worth 1991
The drawings of Anthony van Dyck, C. Brown, Pierpont Morgan Library–Kimball Art Museum.

New York–Paris 1977–8
Rembrandt et ses contemporains: dessins hollandais du dix-septième siècle, collection Frits Lugt, Institut Néerlandais, Paris, C. van Hasselt, Pierpont Morgan Library–Institut Néerlandais.

Paris 1990
Le paysage en Europe du XVIe au XVIIIe siècle, C. Legrand, J.-F. Méjanès, E. Starcky, Cabinet des dessins, Musée du Louvre.

Paris–Antwerp–London–New York 1979–80
Rubens and Rembrandt in their century, F. Stampfle, Institut Néerlandais–Koninklijk Museum–British Museum–Pierpont Morgan Library.

Rotterdam–Paris–Brussels 1976–7
Kabinet van tekeningen – 16e en 17e eeuwse hollandse en vlaamse tekeningen uit een Amsterdamse verzameling, C. Van Hasselt, A. W. F. M. Meij, J. Giltay, Museum Boymans Van Beuningen-Institut Néerlandais-Koninklijke Bibliotheek Albert I.

San Francisco–Baltimore–London 1997–8
Masters of light, J. A. Spicer and L. Federle Orr, Fine Art Museums-Walters Art Gallery-National Gallery.

Tokyo-Hiroshima 1989
The prints of Pieter Bruegel the Elder, David Freedberg et al. (Ishibashi Foundation).

Vienna 1993
Die Landschaft im Jahrhundert Rembrandts: Niederländische Zeichnungen des 17. Jahrhundert aus der Graphischen Sammlung Albertina, M. Bisanz-Prakken, Albertina.

Washington 1990
Rembrandt's Landscapes: Drawings and Prints, C. P. Schneider et al., National Gallery of Art, 1990.

Washington 1990–91
Anthony van Dyck, A. K. Wheelock, jr., S. J. Barnes et al., National Gallery of Art.

Wellesley–Cleveland 1993–4
Flemish drawings in the age of Rubens. Selected works from American collections, A.-M. Logan, Davis Museum–Cleveland Museum of Art.

LIST OF LENDERS

INDEX OF ARTISTS

GENERAL INDEX